XTREME SPORTS PHOTOGRAPHY

Simon Fraser

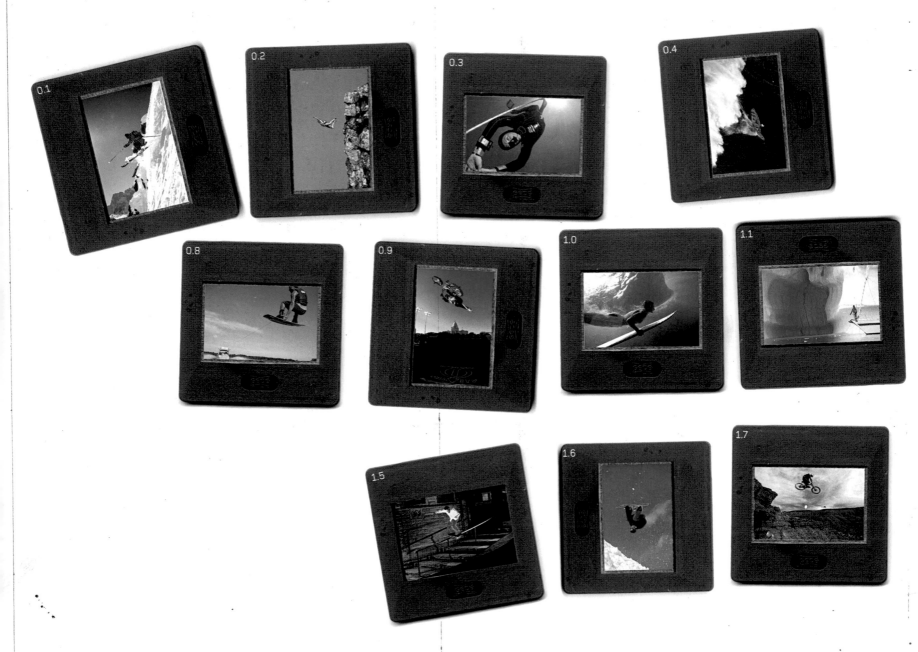

APHY

RotoVision

Published and distributed by RotoVision SA
Route Suisse 9
CH-1295 Mies
Switzerland

A RotoVision Book
RotoVision SA
Sales & Editorial Office
Sheridan House
112/116A Western Road
Hove
BN3 1DD
UK

Tel: +44 (0)1273 72 72 68
Fax: +44 (0)1273 72 72 69
Email: sales@rotovision.com
Web: www.rotovision.com

Copyright © RotoVision SA 2004

10 9 8 7 6 5 4 3 2 1

ISBN: 2-88046-755-1

Designed by Plan-B Studio
Art Director Luke Herriott
Project Editors Kylie Johnston and Nicola Hodgson
Editorial Assistant Jane Roe

Reprographics in Singapore by ProVision Pte. Ltd
Tel: +65 6334 7720
Fax: +65 6334 7721

Printing and binding in Singapore by ProVision Pte. Ltd

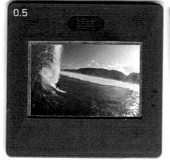
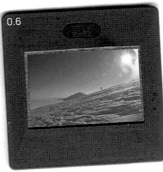
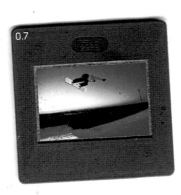
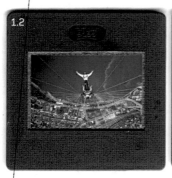
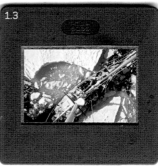
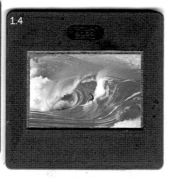
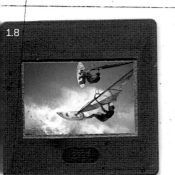
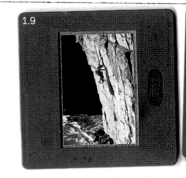
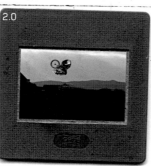

CONTENTS

APHY

Xtreme sports photographers have produced some of the most spectacular images of athletic achievement ever seen. Skydivers plummeting earthward at terminal velocity, surfers riding giant ocean waves, or skiers tackling the steepest mountain faces—whatever the sport, there are motivated and talented photographers who have devoted their skills to capturing the moment. Many of these photographers are also very adept in the sports they photograph, which is often essential in order to carry out their work safely and effectively.

"Extreme" is a description that is sometimes used reluctantly by some of the participants in these sports. Some regard the term "alternative" to be a more accurate label, to distinguish these activities from traditional sports. Rock climbers, free divers, or skateboarders do not usually regard their chosen field as extreme, or as an aberration of the natural human instinct for safety, survival, and security. They are generally well balanced, focused, and enthusiastic individuals, who find tremendous satisfaction and fulfillment in applying their skills and meeting formidable challenges. Part of the enjoyment of extreme activities is the satisfaction of developing good judgment and refining technical skills in order to reduce the risks to a minimum.

Surfers, climbers, and others practiced their sports for years before they were placed under the "extreme" umbrella. Many xtreme sports started as recreational activities, only becoming competitive much later, and in some cases forming national and international governing bodies. The term "xtreme sports" came into common parlance after the Extreme Games, or X Games, were first held in 1995. Most people would probably agree on what is or is not an xtreme sport. Generally, xtreme sports are performed by individuals rather than teams; often involve challenges presented by the natural environment such as sky, snow, mountain, and ocean; and in many cases the sports develop within their own anarchic subculture before merging later with the mainstream. All xtreme sports involve the acceptance of a certain level of risk, and the chance of personal injury or even death.

The personal rewards of xtreme sports are evident from the superb collection of images assembled in this book, by some of the world's best photographers. A sense of achievement at mastering skills and overcoming fear, a sense of joy and exhilaration at the beauty of nature, the stimulus of an adrenalin rush in moments of danger, the satisfaction of redefining performance boundaries, and, above all, a sense of fun.

Despite all the hard knocks, the potential and actual risks, and the moments of self-doubt and uncertainty in the face of a difficult trick on a bike or a skateboard, a record-breaking dive, a towering ocean wave, or an unclimbed rock face, the activists in these sports mostly do it because they love doing it. The diverse blend of gravity, ingenuity, and technology that defines xtreme sports can be highly addictive. Anyone who has been on a surfboard, climbed a rock face, or skied down a slope—even at a modest level—will have tasted that intoxicating blend of excitement, joy, and fear. Xtreme sports have a life-affirming quality, and are full of energy and spirit, as shown in the magnificent images presented in this book. The work of xtreme sports photographers spans the world, and in these pages some of them describe their motives, their working methods, and the highs and lows of this challenging field. From high in the sky to far beneath the waves, from the most powerful surf to the stormiest oceans, from climbs of extreme difficulty to spectacular aerial maneuvers on two wheels, these photographers were there to capture the action.

culturesk8 **etnies**
QUALITY FOOTWEAR

TIMBARNETTSKIING**X**PERT

SKIING IS ONE OF THE WORLD'S PREMIER OUTDOOR SPORTS, ENJOYED BY ALL AGE GROUPS AT MANY DIFFERENT LEVELS OF PERFORMANCE. HOWEVER, THE CHALLENGE AND ADVENTURE OF SKIING HAS GRADUALLY BEEN DILUTED BY THE INFRASTRUCTURE OF THE MODERN SKI INDUSTRY, TO THE EXTENT THAT MANY SKIERS HAVE DIVERSIFIED INTO OFF–PISTE AND BACK–COUNTRY SKIING, OR HAVE DISCOVERED SNOWBOARDING.

0.1 TIM B

EXTREME SPORTS PHOTOGRAPHY. AND NOT JUST SKIING OR CLIMBING

0.1 TIM BARNETT

0.1 TIM BARNETT 09

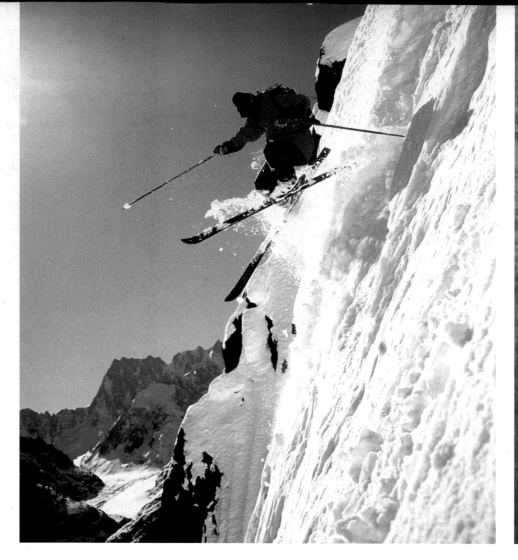

A select few have pushed the limits of what is possible on skis on very steep terrain, and have perfected techniques and skills that enable them to descend slopes that were previously considered unthinkable. The best xtreme skiers now regularly descend 60-degree slopes. Some of the descent routes are so serious that they would involve considerable technical difficulty to climb up, let alone ski down.

Tim Barnett has devoted his life to mountains, reaching a high level of competence in skiing and mountaineering. Living in the French Alps, he is very aware of the risks involved in steep skiing, and takes great care not to place the skiers he works with in unreasonable danger. To ski the steepest terrain requires complete technical mastery and the ability to remain in control, however steep the slope is. Even the best skiers can have serious, even fatal, accidents. "I have to find athletes willing to be directed and to do as I ask," says Tim. "They have to be very talented as there are high risks in all xtreme sports photography, not just skiing or climbing. Security is the first consideration, and one way to reduce risks is to work with the best athletes. Years ago, we would just go out into the mountains with the models and clients and get the shots with minimum hassle. Now when I'm on a commissioned shoot with a client, I will not ski away from the controlled ski area, or climb without the presence of a mountain guide. The clients' attitudes toward the dangers can sometimes be like a disaster waiting to happen, but I would ultimately be the one who is responsible. Other photographers continue to take risks. When I look at some ski and snowboard photographers, I think they are just very lucky. Far too many of the skiers and climbers I have worked with have died in the mountains. When I am shooting, safety is paramount. I work with great athletes and we have a mutual respect that allows us to work as a tight team in tricky situations."

The start of Tim's career is a classic example of someone following an instinct and seizing the moment. "I started a course in business studies, but felt very frustrated as I simply wanted to climb, ski, and be in the mountains. At the age of 19, I launched into professional photography, as a means to an end. Looking at the magazines and tour brochures, full of very tame and uninspiring skiing pictures, I just thought 'I can do better than that.' I called up the tour operators and the equipment people and asked if they would buy ski pictures. They all said yes, so I promised to supply them with images. I borrowed money for a car, quit business school, and bought a lightweight camera and zoom lens, because I knew I would have to ski and climb with it. It was a good early season in Chamonix, and I hooked up with some Swedish skiers. After reading the camera manual, I dressed them in bright clothing and sold pictures from my first film. The money didn't come in until after the winter, so I sublet floor and bunk space to other skiers in a mobile home to keep me in food and film." Since those early days, Tim has created thousands of superb images of many mountain sports, as well as shooting sports clothing catalogs and starting the successful magazine *Fall-Line* in 1991.

Mont Blanc, the highest mountain in the Alps, made a profound impression on Tim. This great mountain has shaped the course of Tim's life. "I first saw Mont Blanc from a plane when I was three years old, flying over the summit whilst returning from a holiday in Britain to my home in South Africa. I was so fascinated that I have always just wanted to be in the mountains ever since. I headed for Chamonix as soon as my parents allowed me, and have lived there since the age of 18. My climbing progressed from hiking through to rock climbing and mountaineering. I started skiing at 18 and learnt fast. It soon became my main sport, as I wanted to ski the steepest slopes and the deepest snow. It was very obvious from the beginning that I had to become a good skier just to get to the locations I wanted to photograph."

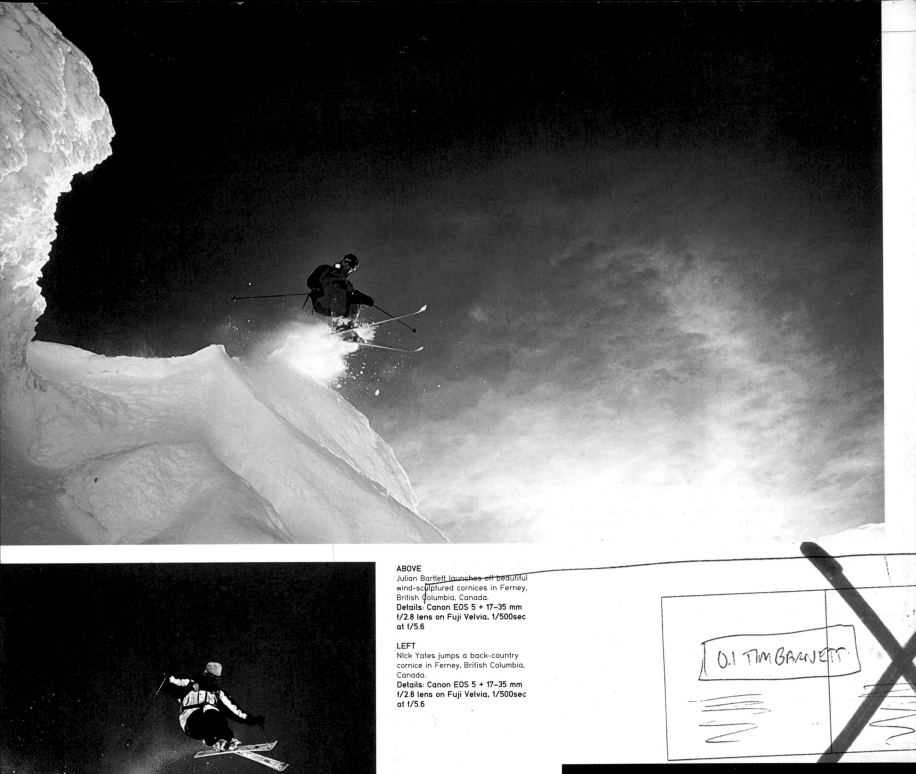

ABOVE
Julian Bartlett launches off beautiful
wind-sculptured cornices in Ferney,
British Columbia, Canada.
**Details: Canon EOS 5 + 17–35 mm
f/2.8 lens on Fuji Velvia, 1/500sec
at f/5.6**

LEFT
Nick Yates jumps a back-country
cornice in Ferney, British Columbia,
Canada.
**Details: Canon EOS 5 + 17–35 mm
f/2.8 lens on Fuji Velvia, 1/500sec
at f/5.6**

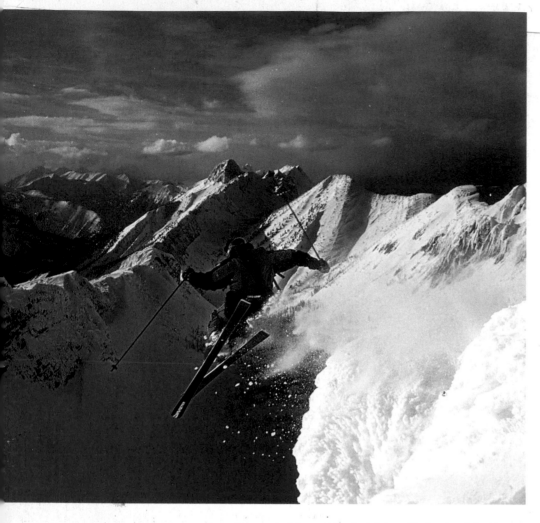

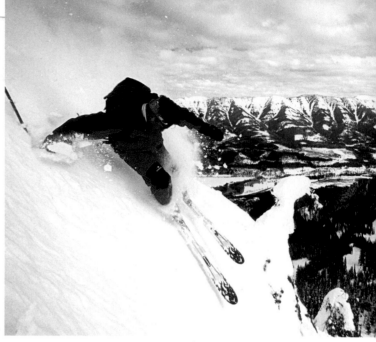

Soon, Tim was building up his client list, and trying to strike the right balance between photography, business, and living in the mountains. "Very soon, I had worked for almost everybody in the British ski industry, as well as clients in France and Sweden. From the beginning, I realized that taking the pictures was the easy part. It was the business side that was hard, and it has become harder over the years. I decided that I would play the business game as long as it didn't affect my reasons for doing photography in the first place—as a means of being in the mountains."

Despite his professional success as a photographer, Tim is a ruthless critic of his own work and allows himself no illusions that his photography is anything but a job. "I have never taken myself too seriously as a photographer, have never made a print of any of my pictures to put on the wall, and have never sold prints of my work. When I have a camera, I am working, although I hope I can also have fun in beautiful locations while I am doing it!"

Tim's adaptability is reflected in the way he devotes energy to exploring innovative ways of delivering images to clients and distributing stock, by using and developing the new technologies. "Just as I used autofocus as soon it was available, I started shooting digitally with the first SLR digital camera that came out, and I continue to upgrade as the equipment improves. Needing to distribute my images online, I also designed and wrote much of the software behind my website, www.digitalphotosonline.com.

Unfortunately, digital photography has many disadvantages, such as the huge investment in equipment, and an increased workload. Time is saved from shooting to print, but more of the workflow is put on to the photographer. Sorting digital images on a computer is far slower than sorting slides on a lightbox. Of course, there are also big advantages, such as the reduced costs for shooting stock, and the creativity and interaction when working with models. Now that I have my workflow sorted out, from shooting to backing up, viewing and selecting digital images, both on location and in the office, I have become more efficient, and will not be going back to film. I feel more in control of my images and no magazine will lose an original image again!"

Tim continues to enjoy his work despite a relentlessly busy schedule. Surprisingly for a highly motivated and talented photographer, he does not anticipate significant steps forward in photographic standards in the future, but gives generous credit to those who perform in the sports he photographs. "In terms of new and exciting pictures, it really depends on developments in the sport and equipment rather than the creativity of the photographer. Crazy mountain-bike jumps became possible with the development of motocross suspensions for specialist downhill bikes. The photos might look amazing, but it's the rider and the machine making those shots. The photographer is just recording a stunt. I haven't seen anything new in photography for years. What remains is to be able to keep on doing it over and over again, quicker and cheaper than everyone else, and yet still to be able to make a living. That might require some very creative thinking!"

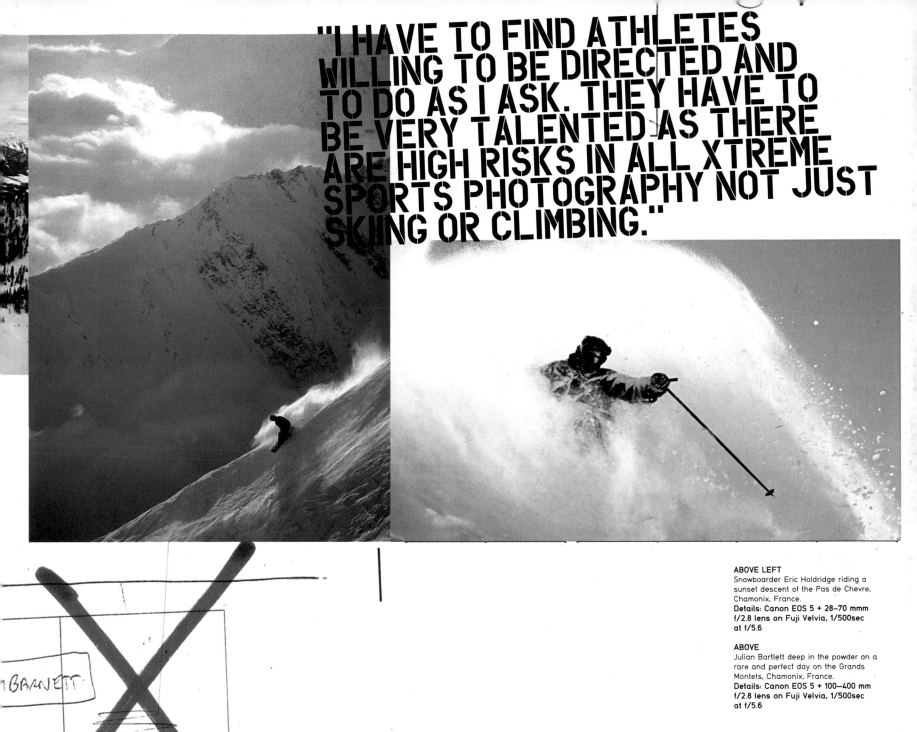

"I HAVE TO FIND ATHLETES WILLING TO BE DIRECTED AND TO DO AS I ASK. THEY HAVE TO BE VERY TALENTED AS THERE ARE HIGH RISKS IN ALL XTREME SPORTS PHOTOGRAPHY NOT JUST SKIING OR CLIMBING."

ABOVE LEFT
Snowboarder Eric Holdridge riding a sunset descent of the Pas de Chevre, Chamonix, France.
Details: Canon EOS 5 + 28–70 mmm f/2.8 lens on Fuji Velvia, 1/500sec at f/5.6

ABOVE
Julian Bartlett deep in the powder on a rare and perfect day on the Grands Montets, Chamonix, France.
Details: Canon EOS 5 + 100–400 mm f/2.8 lens on Fuji Velvia, 1/500sec at f/5.6

DOUGBLANEBASEJUMPING**X**PERT
FEW OBSERVERS WOULD HAVE ANY HESITATION IN PLACING BASE
JUMPING FIRMLY WITHIN THE XTREME SPORTS BRACKET. IT HAS A
MYSTIQUE THAT SETS IT APART. ALONG WITH CAVE DIVING, BASE
JUMPING HAS EARNED A REPUTATION FOR BEING ONE OF THE
WORLD'S MOST DANGEROUS SPORTS.

0.2 DOUG BLANE

In a few short seconds, BASE jumping packs a greater rush of adrenalin than any other activity. As well as the risks of the jump, the sport often involves a sharp exit in order to avoid confrontations with the local authorities.

Doug Blane is a photographer specializing in adventurous action sports: rock climbing, mountaineering, mountain biking, and BASE jumping. "I had very little formal photographic training and am mainly self-taught. I studied Computer Aided Design and applied the design and perspective principles I learnt at college to my photography. During my final year at college, I placed a series of adverts in a magazine for rock climbers, mountaineers, and BASE jumpers. I had a telephone call one night from a BASE jumper who wouldn't give me his name or any contact details but said that he 'might' contact me soon. A few weeks later, I received another phone call. 'Doug, we are going to jump the Hilton tonight, get yourself down and take a few pics.' The clandestine sport of BASE jumping is hard to penetrate, so I leaped at the opportunity."

Doug explained the complexities of photographing BASE jumping, a sport where meticulous, military-style preparation is essential. "One of the main challenges in taking BASE jumping pictures is that you only get one chance to get it right. A single hesitation on my part and the picture will be lost. BASE jumping is a team activity, with the main goal being to ensure that the BASE jumper survives. The other challenge is the legal side, to avoid any team members being arrested."

Doug takes a pragmatic approach to equipment, and, like many professionals, he is not swayed by persuasive marketing campaigns to invest in the latest and most sophisticated products. "I need sturdy and reliable equipment that can take a few knocks and still function. From an early age I realized that photography is about capturing light on film. Therefore, put simply, a camera body is just a box to hold the film and the type of body isn't nearly as important as the quality of the lenses. In the early days I invested in good-quality lenses, and figured that I could always buy a better camera body later.

I use a range of Nikkor lenses from 20mm to 300mm. Weight is a real issue for me when I choose camera equipment. My main camera body is a Nikon F100, and I am happy to hike up a mountain with it. My other camera is the bomb-proof Nikon FM, a totally mechanical body that still works even without any batteries. I also have a small Minox (Leica) for very lightweight travel. I don't think that digital camera technology is quite up to the specifications I need for adventure sports and travel photography, but I am sure in a few years I will have to reconsider. I use a high-resolution film scanner so that I can supply my pictures to customers throughout the world quickly and easily. The Internet has been an invaluable marketing tool to me since the early 1990s and I have been at the forefront as the technology develops."

Doug explained the intricacies of BASE jumping, starting with the name. "BASE is an acronym meaning Building, Antenna (aerial), Span (bridge, dam, etc.), Earth (cliff). These are the four objects to parachute from in order to qualify as a BASE jumper. BASE jumping is the xtreme sport of 'object-relative parachuting,' and is the final frontier in parachuting. A regular phrase used by BASE jumpers sums up their obsession: 'How low can you go?'. BASE jumpers tend not to want their names known, so they use their BASE numbers as a way of getting recognition for the jumps they do whilst hiding their identities."

Doug recalled the London Hilton Hotel BASE jump with "UK Naked Base # 1" (otherwise known as Rupert). "One Sunday lunch time, both dressed in suits, and carrying large briefcases (concealing our gear), we entered the Hilton. We drank tea in the lounge in order to get a receipt. If we were caught, this could be produced as evidence of being hotel customers and therefore prevent prosecution for trespass. We then made our way to the lift and exited a few floors below the penthouse suite, so as not to attract any attention. We walked up the stairwell to the top floor and checked that our way was clear to the roof."

BELOW
Mark Scott making the first-ever BASE jump from Canary Wharf Tower, Docklands, London, UK. "I had three still cameras and one video camera for this jump. One was handheld and the others were on tripods triggered to shoot continuously until the film ran out."
Details: Nikon FM + MD-11 + Nikkor 135mm f/2.8 lens on Fujichrome 100, 1/250sec at f/8

BELOW
"UK Naked BASE #1" BASE jumping naked off an antenna in Dartford, UK.
Details: Nikon FM + MD-11 + Nikkor 28mm f/2.8 lens on Fujichrome 100, 1/60sec at f/2.8

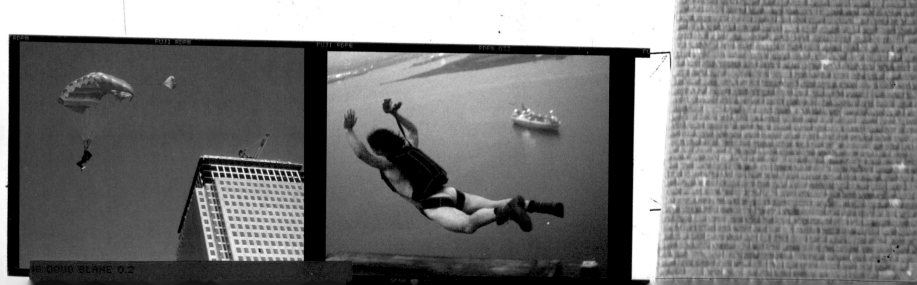

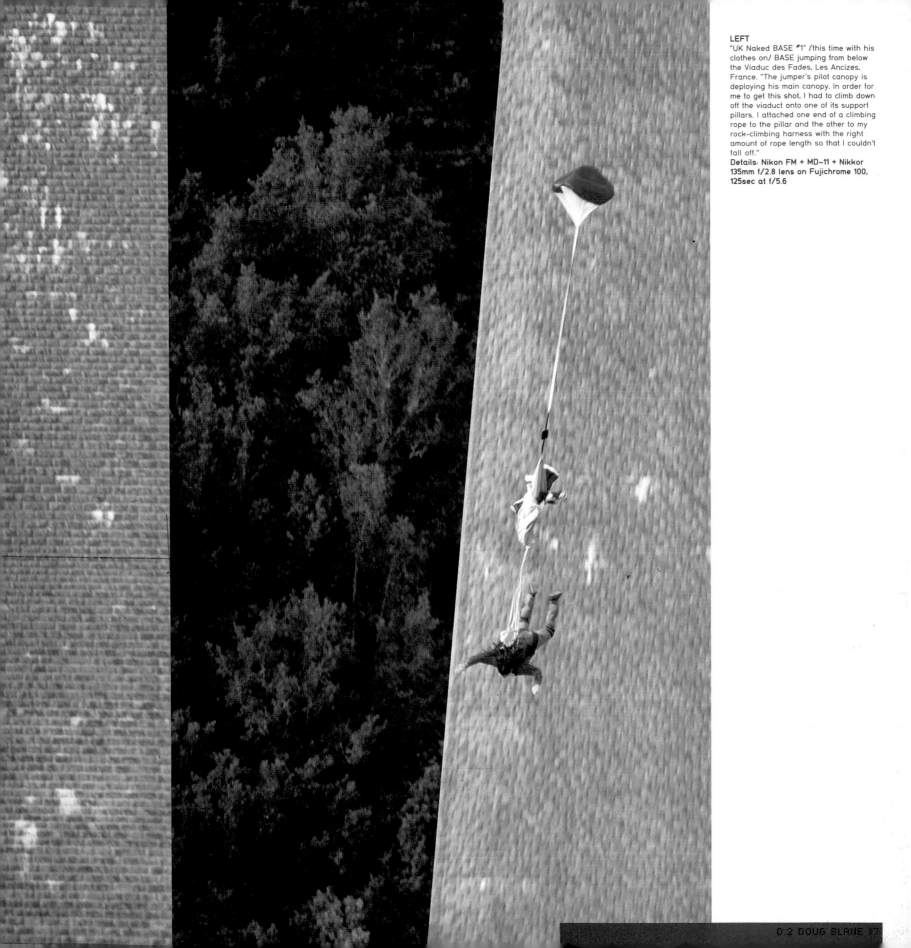

LEFT
"UK Naked BASE #1" /this time with his clothes on/ BASE jumping from below the Viaduc des Fades, Les Ancizes, France. "The jumper's pilot canopy is deploying his main canopy. In order for me to get this shot, I had to climb down off the viaduct onto one of its support pillars. I attached one end of a climbing rope to the pillar and the other to my rock-climbing harness with the right amount of rope length so that I couldn't fall off."
Details: Nikon FM + MD-11 + Nikkor 135mm f/2.8 lens on Fujichrome 100, 125sec at f/5.6

Russell Powell BASE jumping off
Cheddar Gorge, Avon, UK. "This picture
was taken after I had abseiled off the
top of the 350ft (107m) high cliff and
climbed onto a prominent pinnacle. From
there I was in the perfect position to
take one of the best photos I have ever
taken of BASE jumping."
**Details: Nikon FM + MD-11 + Nikkor
135mm f/2.8 lens on Fujichrome 100,
1/250sec at f/8**

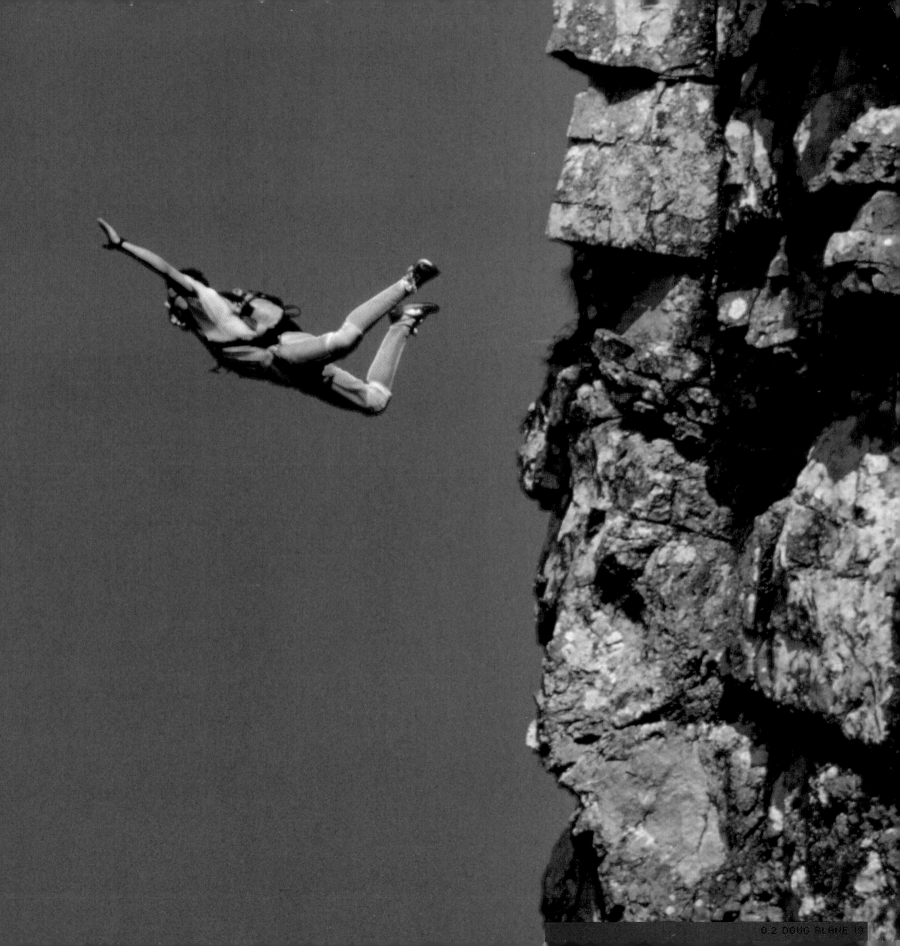

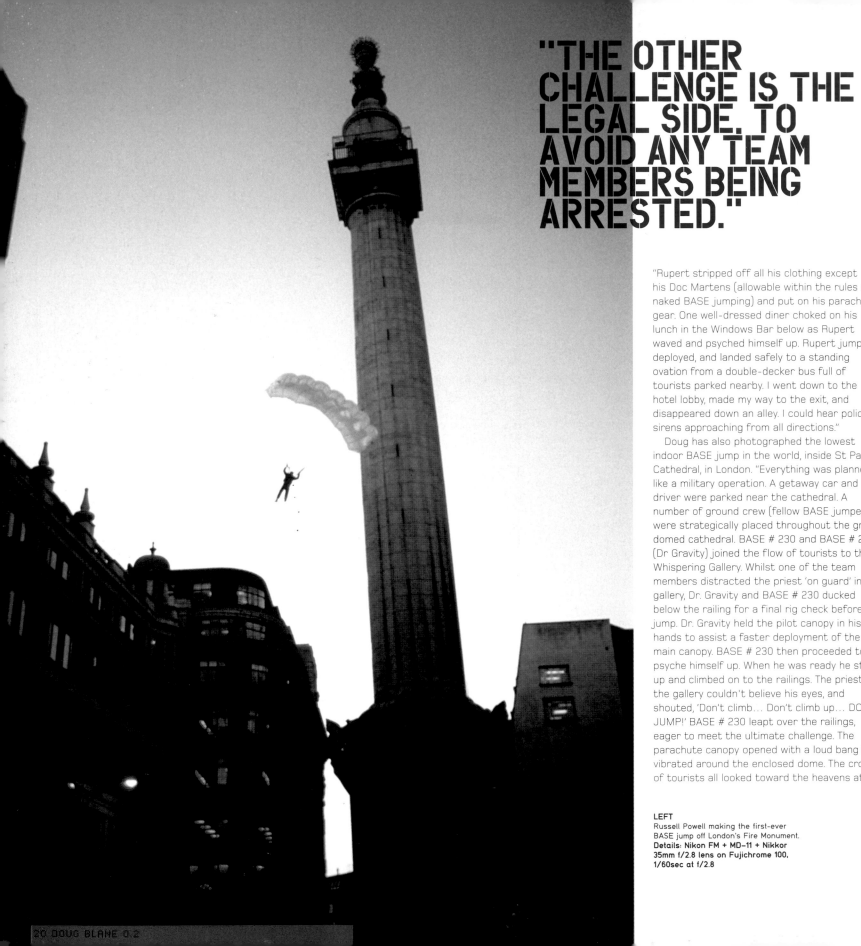

"THE OTHER CHALLENGE IS THE LEGAL SIDE. TO AVOID ANY TEAM MEMBERS BEING ARRESTED."

"Rupert stripped off all his clothing except his Doc Martens (allowable within the rules of naked BASE jumping) and put on his parachute gear. One well-dressed diner choked on his lunch in the Windows Bar below as Rupert waved and psyched himself up. Rupert jumped, deployed, and landed safely to a standing ovation from a double-decker bus full of tourists parked nearby. I went down to the hotel lobby, made my way to the exit, and disappeared down an alley. I could hear police sirens approaching from all directions."

Doug has also photographed the lowest indoor BASE jump in the world, inside St Paul's Cathedral, in London. "Everything was planned like a military operation. A getaway car and driver were parked near the cathedral. A number of ground crew (fellow BASE jumpers) were strategically placed throughout the great domed cathedral. BASE # 230 and BASE # 229 (Dr Gravity) joined the flow of tourists to the Whispering Gallery. Whilst one of the team members distracted the priest 'on guard' in the gallery, Dr. Gravity and BASE # 230 ducked below the railing for a final rig check before the jump. Dr. Gravity held the pilot canopy in his hands to assist a faster deployment of the main canopy. BASE # 230 then proceeded to psyche himself up. When he was ready he stood up and climbed on to the railings. The priest in the gallery couldn't believe his eyes, and shouted, 'Don't climb... Don't climb up... DON'T... JUMP!' BASE # 230 leapt over the railings, eager to meet the ultimate challenge. The parachute canopy opened with a loud bang that vibrated around the enclosed dome. The crowd of tourists all looked toward the heavens at the

LEFT
Russell Powell making the first-ever BASE jump off London's Fire Monument.
Details: Nikon FM + MD–11 + Nikkor 35mm f/2.8 lens on Fujichrome 100, 1/60sec at f/2.8

RIGHT
"UK Naked BASE #1" making the first-ever naked BASE jump off the Hilton Hotel, Hyde Park, London, UK. "I had two motor-driven Nikon cameras taped together, allowing me to shoot them both simultaneously. After the BASE jump, I rewound the films, took them out of my cameras, and hid them on me, and put fresh film in the cameras and wound it on, just in case the police stopped me and confiscated the film."
Details: Nikon FM + MD-11 + Nikkor 28mm f/2.8 lens on Fujichrome 100, 1/250sec at f/5.6

FAR RIGHT
Russell Powell making the first-ever BASE jump from the Whispering Gallery, St Paul's Cathedral, London, UK. This was the lowest indoor BASE jump in the world, at only 102ft /31m/.
Details: Nikon FM + MD-11 + Nikkor 35mm f/2.8 lens on Ilford XP1 400, 125sec at f/2.8

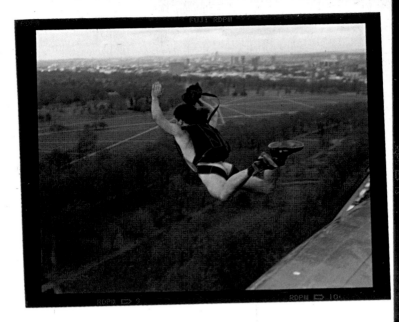

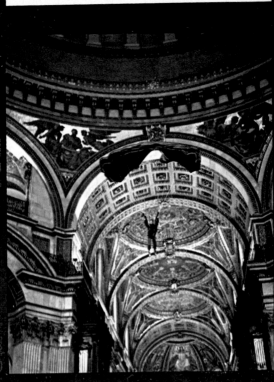

descending figure. The canopy had just enough time to inflate before BASE # 230 hit the drop zone, landing among the chairs but luckily escaping without breaking a leg. A team member ran over to the canopy, pulled the parachute breakaway cord, grabbed BASE # 230 and ran out of the cathedral with him. In hot pursuit was a quick-reacting nun brandishing a walkie-talkie shouting 'stop!' We all managed to vacate the premises before the police arrived. BASE # 230 had set a new indoor low-altitude parachuting world record of 102ft (31m). Nobody was hurt. The pastor of the cathedral prayed for our forgiveness, and my photographs were published in the national and international press."

BASE jumping at this level leaves absolutely no margin for error and yet some BASE jumpers deliberately choose to take it to the limit and tread the fine line between success and disaster.

Doug photographed Mark Scott making the first-ever BASE jump from Canary Wharf Tower, Britain's tallest building. "Mark dropped like a stone gaining speed as he descended. He wanted to 'smoke' the building, which means deploying the canopy at the very last moment in order to maximize the ground-rush effect and the adrenalin surging around his body."

Doug is always looking for ways to stretch himself and achieve the best possible results. "One of my ambitions is to be published on the cover of *National Geographic* magazine. I know it's a cliché, but it's a good one. I aim and take pictures on-camera rather than relying on digital photographic software to correct sloppy photographic techniques. I am always looking to better my photography, to take the ultimate picture."

BELOW
"UK Naked BASE #1" BASE jumping an antenna in Ledbury, UK. "I had two cameras for this jump. One was handheld and the other was on a tripod triggered with a locking cable release."
Details: Nikon FM + MD-11 + Nikkor 135mm f/2.8 lens on Fujichrome 100, 125sec at f/4

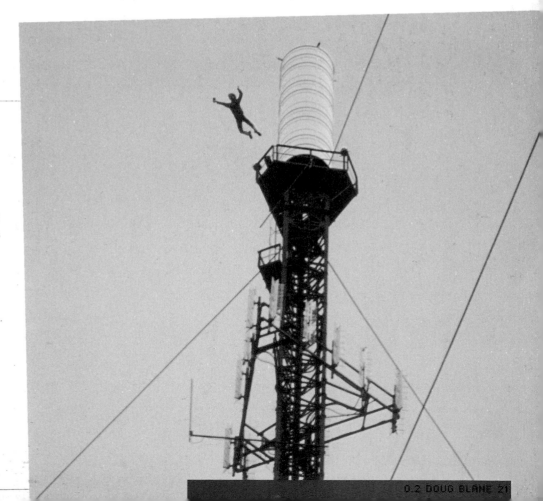

0.3DANBURTONDIVING**X**PERT

AN INTEREST IN XTREME SPORTS CAN START EARLY. FOR
DAN BURTON IT ALL STARTED AT THE AGE OF FOUR, AND AS A
CHILD HE BECAME AN EXCELLENT SKIER AND SKI RACER, MAKING
REGULAR VISITS TO THE ALPS FOR RACING EVENTS WHEN HE WAS
JUST 11 YEARS OLD.

0.3 DAN BURTON

DAN BURTON
INTRO

3X OPS.
DIVING
CLIMING
-29578

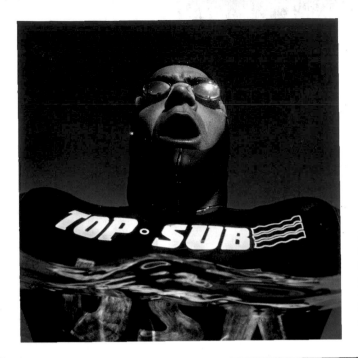

Damaged knees brought a premature end to Dan's ski-racing ambitions at 16, and two years later he decided it was time to see the world. "In 1988 I bought a one-year ticket and headed off to Australasia. After a year I decided to continue my travels, and worked my way through South East Asia to my final destination, Taiwan, where I was offered as job as a divemaster. I was fortunate enough to meet one of Taiwan's leading underwater photographers, who taught me about the field of underwater photography. After 18 months there, I decided to pursue photography seriously and returned to the UK, enrolling on a photography course at Plymouth College of Art and Design. I spent five years there, and specialized in underwater photography in my last year."

Underwater photography has been Dan's main focus of interest ever since, although, unusually, he has steered away from marine wildlife and has discovered a passion for the process of diving itself, and the various extremes such as deep diving, freediving, and cave diving. Scuba diving has been a popular sport since Jacques Cousteau and Emil Gagnan invented the aqualung in 1943, but is still dangerous without proper training—almost all diving fatalities are caused by human error. Dan is an expert diver who enjoys applying his skills and experience to photographing the most challenging aspects of diving. "There are many underwater photographers in the world, but most shoot marine life. I got involved in technical diving (scuba diving, using mixed gases for deep diving) in the early 1990s. It got me involved with pioneers in technical diving, and allowed me to shoot images in deep water that other divers had never done before. Since then, I have been involved in many deep-diving expeditions as a photographer and videographer. In the last five years I have started to cover other xtreme sports, including freediving and cave diving."

This kind of diving involves an extremely complex array of specialized equipment before the diver even begins to think about taking a photograph. By the time Dan is ready to explore deep water with his camera gear, he is more enveloped in equipment than the average astronaut on a space walk, and the environment he is heading for is almost as alien and unforgiving as outer space.

TOP LEFT
US spearfishing champion preparing for a record static apnea dive, in which divers see how long they can hold their breath underwater.
Details: Nikon F90X in Sea & Sea housing with 8in port + 16mm fisheye lens on Velvia, 1/250sec at f/11

LEFT
Diver descending into freshwater springs through the tannic acid layer.
Details: Nikon F90X + 16mm fisheye lens, two flashguns on Provia 400 film.

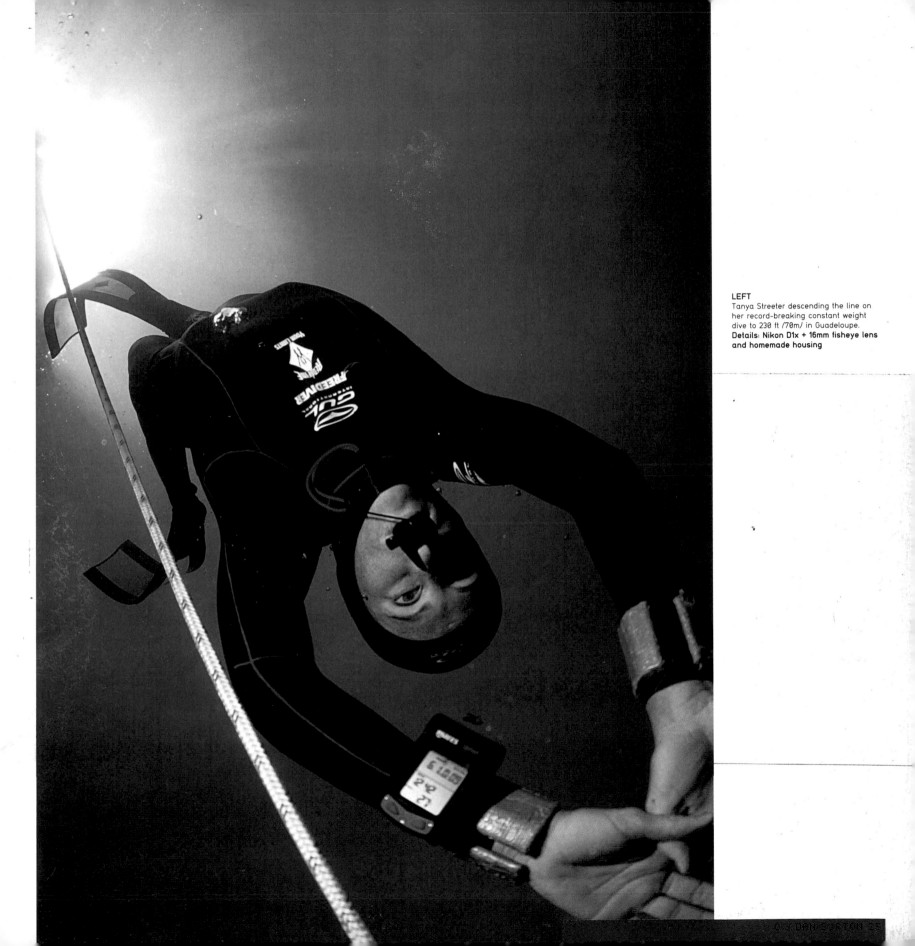

Tanya Streeter descending the line on her record-breaking constant weight dive to 230 ft /70m/ in Guadeloupe.
Details: Nikon D1x + 16mm fisheye lens and homemade housing

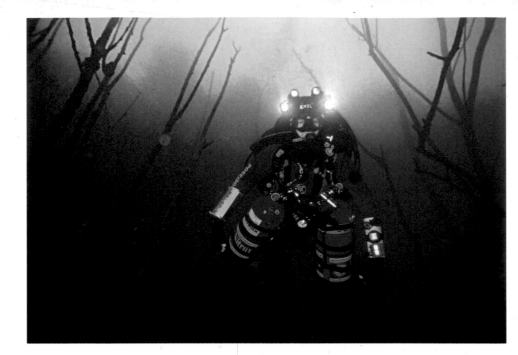

"The main challenge of my work is coming back with an image that
few people can take, or have ever seen. In a deep-water
environment, taking the photograph is hard as you have very little
time to get the shot. You carry a lot of equipment on you, as many
as four to six tanks, two cameras, a video, and an underwater DPV
(Diver Propulsion Vehicle). The biggest challenge is to stay alive and
get home safe. Other challenges are the lack of light, the pressure
on the equipment, and the low ambient temperature."

Dan's equipment list makes an interesting story in itself, ·
especially as he designs and builds some of his own specialist
underwater housings. "I have a vast selection of equipment, which
includes a Nikon F90X in a waterproof housing with an assortment
of lenses, and a Nikonos 5 compact and lightweight film camera. I
also use a Nikon D1x in a homemade housing (built in 1999 when
the D1 was released), and to my knowledge this is one of the first
digital SLR housings in Europe, or in the world. Since building my
D1x housing, I have built housings for other cameras including my
Hasselblad XPan, Hasselblad SWC, and I'm now building a housing
for a rotating 360-degree film camera. I have also built and
successfully produced a number of 360-degree underwater iPIX
images. These are complete 360-degree sphere images, which
allow the viewer to see everything!"

When Dan first started deep diving, he was attracted by the
challenge of depth, to see how far it was possible to go, perhaps
in a similar way to some climbers who are magnetized by the lure
of very high altitudes and who seek to climb the highest peaks.
"In my earlier days of deep diving, depth itself was a fascination,
so I always wanted to go deep. I learned deep diving from an
American pioneer of technical diving, Billy Deans. He has an
excellent safety record, and many divers look to him for advice.
I go as deep as needed for the assignment. The deeper I go—
sometimes in excess of 425ft (130m)—the more planning is
required. On deep dives I use a mixed gas (Trimix) of helium,
oxygen, and nitrogen. The camera housings need to withstand
enormous pressures, but there is always a risk of imploding lights,
or an implosion of the buoyancy tanks of video equipment. I have
had three implosions and it's not a nice experience.

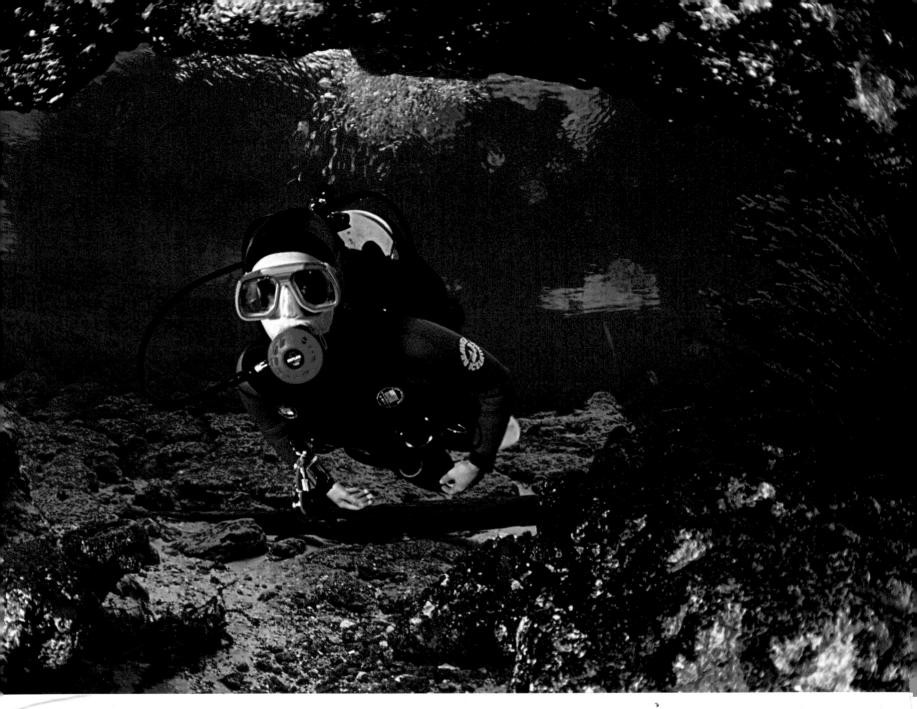

But the attraction of exploring new wrecks, seeing things that others haven't seen, and coming back with some special pictures makes it all worth it."

To most of us, the deep sea world is about as remote from normal reality as the dark side of the moon. I asked Dan to try to put into words what it feels like to be in such an extreme environment, hundreds of feet beneath the waves. "It's different every day you go in. Some days it's easy, some days you feel apprehension. It's not a matter of just going down, and coming up. The easy part of the dive is the dive. The decompression part can be the hardest. If you make a mistake, you are either dead, or have the bends. So many things can go wrong. Your equipment can fail, you can run out of gas, or you can get lost or stuck. You can never be blasé, otherwise it will turn around and bite you, as has happened to some friends of mine."

ABOVE
A diver enters Ginnie Springs freshwater cave system. The system is a labyrinth of more than 100 miles /160km/ of underground tunnels.
Details: Nikon F90x in Sea & Sea housing with 8in port + 16mm fisheye lens on Fuji Velvia, 1/125sec at f/11, two flashes

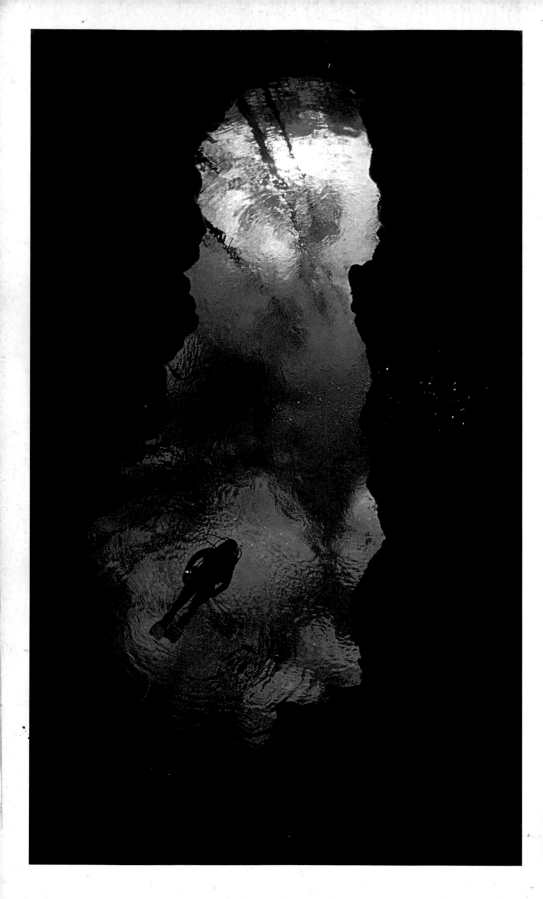

Apart from his expertise as a technical diver, Dan has been involved in freediving since 1998, when competitions started in this extreme branch of diving. Freediving is the sport of diving as deep as possible, but without any artificial breathing aid. There are different categories of freediving depending on whether or not ballast is used to descend and whether inflatable aids are used to return to the surface. This kind of diving is the preserve of the few, requiring extraordinary inner control, swimming skills, and mental and physical preparation. "I was asked to join as an official photographer. Many of the athletes ask me to shoot their record dives, and over the past six years they've gone deeper and deeper. The deepest I've been to date has been working with Tanya Streeter [pictured on page 25], when she got her No Limits world record of 525ft (160m) in 2002. Getting the shot takes careful planning, as the freediver will be starting at a designated time. The safety team and I have to leave a few minutes early. When I get to the right depth, I check my kit for water, see if it's shooting properly, and choose the best angle for the shot. You don't have much time before the freediver arrives. There are only a few shots to take as they are descending, and then ascending, or on the bottom getting their tags. You then spend the next few hours coming up, while the freediver is celebrating the record! As long as it's within my 'comfort zone,' I go as deep as needed."

Cave diving is another branch within the extreme category of diving, and has the awesome reputation of being the world's most dangerous sport. There is no margin for error, and meticulous preparation and considerable diving expertise are essential. For Dan, the attraction is the exploration of the unknown, the challenge of creating images in an environment totally without daylight, and the opportunity to share the beauty of these hidden worlds through superb photography.

Dan's work has taken him increasingly into filming projects. "I've been involved with a lot of deep-water filming, and recently I shot a new series of [British television show] *Wreck Detectives*. I've done all sorts of work for National Geographic TV and other satellite television stations. My stills work has been published in most of the magazines that I've ever wanted to work for, and I supply to a number of stock agencies around the world." Looking to the future, Dan is not short of ideas. "I would love to spend time in the polar regions, and to dive under the sea ice. I hope to get involved in more expeditions, to explore remote areas on the planet where no one has dived before, and also to build more specialist cameras. There is so much to see under the sea, and so little has been seen."

LEFT
Diver descending into freshwater springs in Florida.
Details: Nikon F90X in Sea & Sea housing with 8in port + 16mm fisheye lens, 1/125sec at f/8, no flash

RIGHT
300 freedivers prepare to descend to the bottom of the sea at the Sardinia freediving world championships, 1998.
Details: Nikon F90X in Sea & Sea housing with 8in port+ 16mm fisheye lens on Velvia, 1/125sec at f/11, no flash

04

0.4JOHNCARTERWINDSURFING**X**PERT

WINDSURFING IS PERHAPS THE ULTIMATE CHALLENGE IN THE QUEST FOR MASTERY OF THE INTERFACE BETWEEN AIR AND WATER. THE SPEED AND MANEUVERABILITY OF WINDSURFERS MAKE THIS AN EXTREMELY EXCITING SPORT FOR BOTH PERFORMERS AND PHOTOGRAPHERS. TOP EXPONENTS HAVE HONED THEIR SKILLS TO THE POINT WHERE THEY CAN SAIL AT FULL SPEED INTO HUGE WAVES AND SHOOT 30FT INTO THE AIR, CONTROLLING THEIR DESCENT BY USING THE SAIL AS A WING TO FLOAT BACK DOWN TO THE WATER.

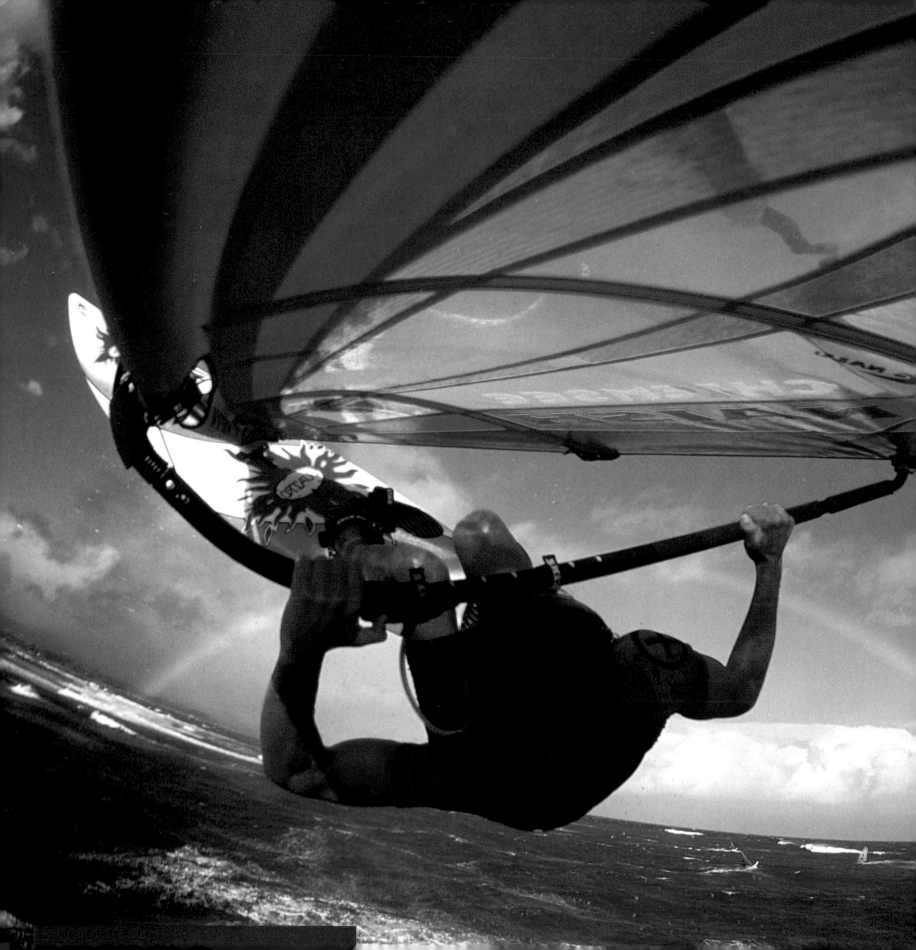

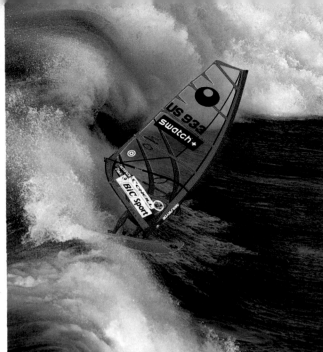

FAR LEFT
Francisco Goya at Sprekelsville, Maui,
Hawaii.
Details: Mast–mounted Canon EOS 50
+ 16mm fisheye lens on Fuji Velvia 50
ASA, 1/500sec at f/4.5, shot triggered
by rider

LEFT
Kevin Pritchard the year he won the
world title at Hookipa Beach Park, Maui,
Hawaii. The shot was taken from a
helicopter with an image stabilizer quite
late in the afternoon.
Details: 300m f/4 lens on Fuji Provia
ASA 100, 1/500sec at f/5.6

The outstanding career of British windsurfing photographer John Carter is a classic example of achievement through motivation and enthusiasm; of deciding to seize the moment and turn opportunity into action. "After leaving school, I ended up in a boring nine-to-five job working in the Post Office. When I was 20, one of my best friends, Nigel Howell, quit his job and spent six months in Australia to follow his passion for windsurfing. There was no way I was going to sit back home on the Isle of Wight while he was 'Down Under' sending me postcards, so I also quit. I ended up traveling around Australia for ten months, where I developed a keen interest in photography. During the next two years I traveled around America, Thailand, and Bali, recording all my travels with a camera."

Windsurfing became more than just a good excuse to follow his best friend to Australia, but little did John realize at the time that windsurfing would propel him into a successful career that has taken him to the top of the profession. "Back at home, Nigel had become the UK windsurfing champion and was in constant need of high-quality action images. I decided to invest in a water housing, a new camera (a Canon T90), and a couple of lenses and to give action sports a try. I was immediately hooked. I had a big break in 1990 when Nigel's sponsors offered to pay for a trip to Maui, Hawaii, and Australia. To cut a long story short, I haven't looked back since. I have been involved with windsurfing photography for 15 years and have loved every moment of it. It took about eight years of hard graft to become full-time, but since about 1997 I have managed to make a living just taking windsurfing shots.

My main occupation these days is working on a full-time basis for *Windsurf Magazine* as well as being one of the main photographers used by the Professional Windsurfing Association World Tour."

Success as a freelance almost always needs tenacity and persistence as well as the skills and talent to survive in a competitive business. John was determined to pursue his goals, but was also prepared to take on almost any kind of job to support his photography in the early years. "Partly to avoid the British winter and partly to further my photography career, I spent four consecutive winters in Maui. In 1993, myself, Richie Foster, and Nigel Howell rented a house in Paia on the North Shore and we all found jobs to help pay our rent. Most mornings I was painting or gardening and on top of that working six nights a week dish-washing in a restaurant called Charlie's. I actually made more money from the part-time jobs than from my photography, but that work gave me the chance to pursue my goal of making it as a full-time photographer. Back in those days, camera gear was still largely manual-focus and I was using the Canon T90 and a bunch of FD lenses, ranging from a 28mm f/2.8 to the 800mm f/5.6 big gun. I was well behind the times in the journalistic department and painstakingly wrote all of my articles by hand and either faxed them to the magazines or sent them by post."

John's determination meant that he was prepared to take considerable financial risks in order to get the shots he needed, despite the uncertain future. It's this kind of total commitment and refusal to give in that paves the way to success, but without the benefit of hindsight, the risks at the time seemed very real. "After five years in the game, I decided to take a big financial gamble and buy a Canon 600mm f/4 autofocus lens, which cost me nearly $8,000… ouch! The gamble paid off, however, when I scooped the first-ever shots of [windsurfing champion Robby] Naish riding Jaws [location of the world's biggest waves, off Hawaii] on 18 December 1994, just six months after my purchase. Those shots sold in loads of magazines and netted me over $3,000. All of a sudden, I felt my career was starting to take off."

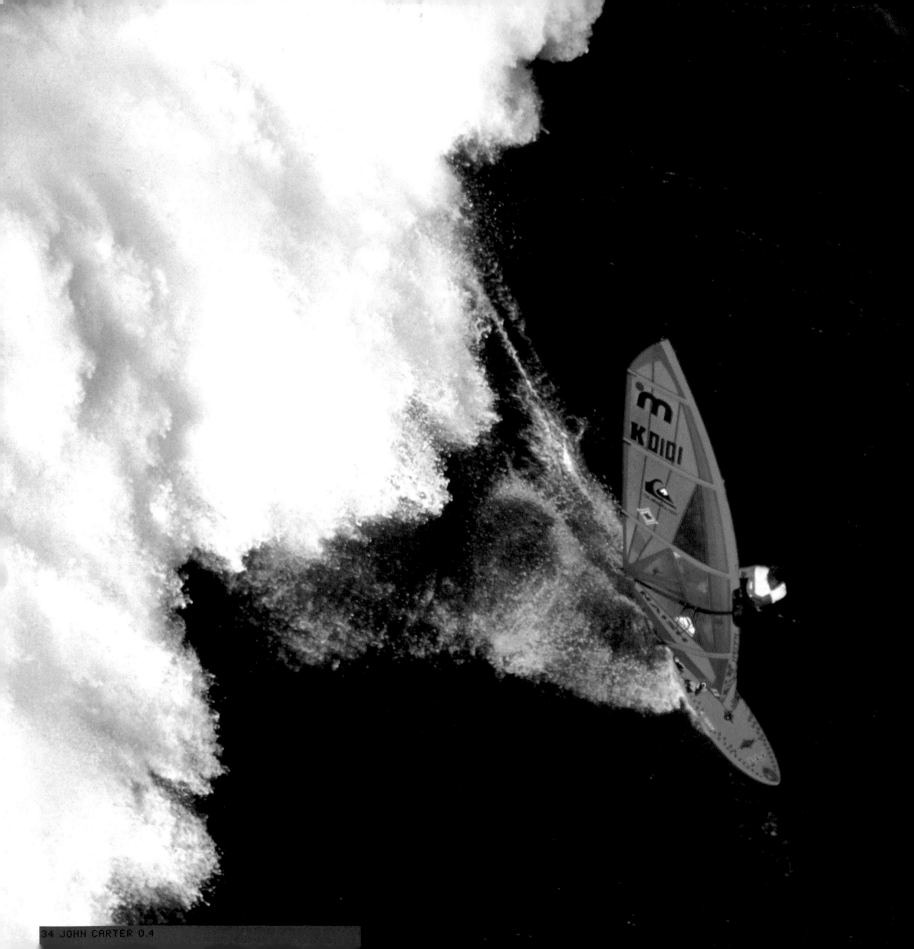

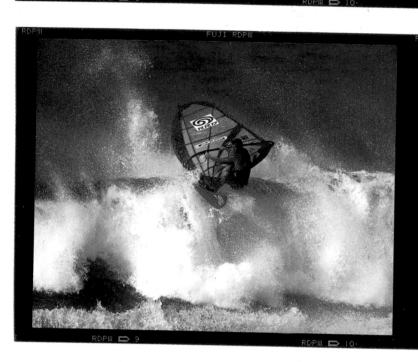

Even then, things did not always go to plan, and John faced some testing situations. "My last day on a trip to Maui in 1995 ended in disaster—my car was stolen. I had made the fatal mistake of leaving the keys in the petrol cap cover and the even bigger mistake of leaving all my camera gear, including my $8,000 big lens, in the boot. That night I flew home and I don't mind admitting that I started to cry on the plane. In all, over £15,000 ($9,804) worth of hard-earned camera kit had been stolen and I never received any money from my insurance company. I came home devastated. The only thing I still had was the water housing and the camera that was inside it, the good old Canon T90. Six months later, I had a double spread from that fateful Maui shoot published, which netted me a cheque for £100, making a net loss for the shoot of £14,900 ($9,734)! Desperate to earn some money after the loss of all my gear, I spent the following summer on the Isle of Wight, gardening, window cleaning, and painting, backed up with a bar job six nights a week in a local hotel."

To work at the highest levels in this job, the best equipment is essential, and since those early setbacks John has built up a solid range of lenses covering almost every conceivable focal length. "I have always used Canon gear and I guess the main workhorse of my range of lenses is the Canon 600mm f/4. It's a heavy beast to travel with, and also needs a sturdy tripod, but it is essential for windsurfing where the action often takes place 200–230ft (60–70m) from the beach. I also have a 100–400mm IS zoom,

70–200mm zoom, 17–35mm zoom, 35–135mm zoom, and a fisheye lens. The fisheye is used for all my mast-mounted and board-mounted shots. The mast-mount rig is controlled from the beach by a radio signal, which triggers the shutter on the camera while the sailor is in mid-action. I guess you can say that the times are changing. I have been using digital cameras since 2002. I have Canon D10 and Canon D1 digital cameras, which I use mainly when shooting events for the PWA. Competition organizers these days want immediate results and often need shots to go out on the Internet straight after the finals. This is where digital is superb."

The xtreme sport of kite sailing came into the equation back in the late 1990s, adding a new dimension to John's career. The beauty of kite sailing is that it doesn't need very strong winds or huge waves for the riders to bust out huge jumps and sensational action. "Kite sailing is a superb sport to photograph, although the fact that the rider and his kite are separated by 200ft (60m) of string makes it difficult to get the whole package in one single shot. The only way it can be done effectively is from the water with a super wide-angle lens and the rider jumping straight over the top of you. In the early days, when most guys were having trouble sailing in a straight line, this could be quite precarious. Many windsurfers have taken up kite sailing as their sister sport and it was a natural progression for me to become involved."

It is obvious to the outsider that great water-sports photography takes a lot of persistence and some highly developed technical skills, as well as expensive kit.

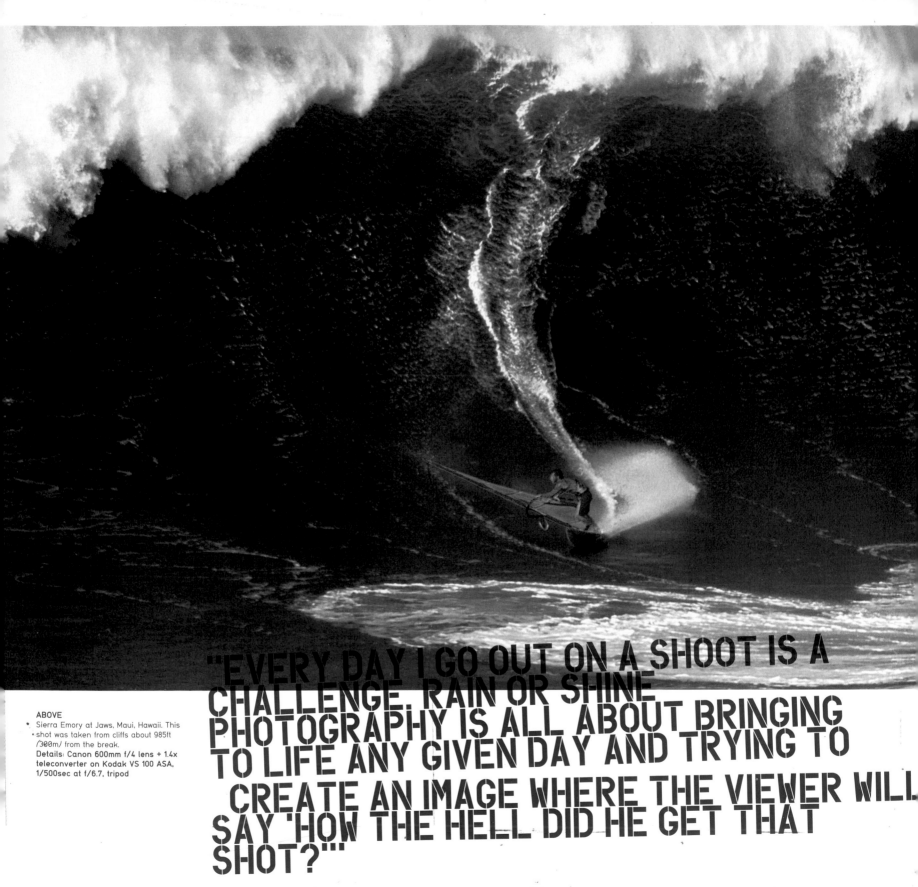

ABOVE
- Sierra Emory at Jaws, Maui, Hawaii. This shot was taken from cliffs about 985ft /300m/ from the break.
- **Details:** Canon 600mm f/4 lens + 1.4x teleconverter on Kodak VS 100 ASA, 1/500sec at f/6.7, tripod

"EVERY DAY I GO OUT ON A SHOOT IS A CHALLENGE. RAIN OR SHINE PHOTOGRAPHY IS ALL ABOUT BRINGING TO LIFE ANY GIVEN DAY AND TRYING TO CREATE AN IMAGE WHERE THE VIEWER WILL SAY 'HOW THE HELL DID HE GET THAT SHOT?'"

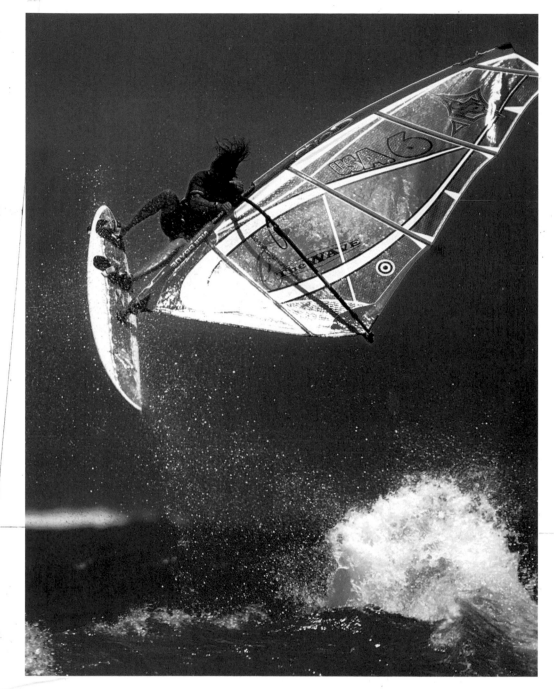

ABOVE
Josh Stone at Baby Beach, Maui, Hawaii.
Details: Canon 600mm f/4 lens + 1.4x
teleconverter on Kodak VS 100 ASA,
1/500sec at f/8, tripod

For those who shoot international competitions, it also means relentless traveling all over the world, and year after year John has worked in far-flung locations in America, Australia, Brazil, China, the Caribbean, South Africa, New Zealand, and the South Pacific. There is also the constant challenge of working in fickle conditions. "Windsurfing is a sport of ever-changing variables. The wind and waves are very difficult to predict, especially in the UK, so quite often a 250-mile (400km) trip down to the West Country can be a total waste of time. On any given day, you are looking to get the most exciting possible perspective of the action, perhaps trying to find the best backdrop, or an unusual angle. There are so many things I always want to try, but there's rarely enough time during my window of opportunity to cover all angles. It's also about getting all the right filler shots and not just the radical action, so you always have to be thinking laterally as to what your picture editor will want as a complete set of pictures, rather than one blistering action shot. Working in extremely windy locations can be tough on gear and make it difficult to get pin-sharp images. Every year the world tour descends on Pozo, Gran Canaria, where the wind is directly onshore and blowing up to 50 knots. Every time you point the big 600 f/4 lens in the direction of the action the lens gets covered in spray, which can be a real pain!"

John is still passionate about his work, and is dedicated to coming up with new ideas and producing stunning images. "Every day I go out on a shoot is a challenge. Rain or shine, photography is all about bringing to life any given day, and trying to create an image where the viewer will say 'How the hell did he get that shot?' Windsurfing is a colorful, fast-moving sport that can be shot from hundreds of different angles. Water shots, big lenses, mast mounts, pole mounts, and helicopters—most of the angles have certainly been covered. But there are always new angles within those angles to be discovered, and that's what it is all about."

0.5SEANDAVEYSURFING**X**PERT

SURFING DATES BACK FOR CENTURIES IN THE ANCIENT CULTURES
OF POLYNESIA. THERE IS NO DOUBT THAT THE SPORT OF HE'E NALU
(WAVE–SLIDING) WAS PERFECTED IN HAWAII SEVERAL HUNDRED
YEARS AGO, BUT IT ALMOST DIED OUT DURING THE NINETEENTH
CENTURY BEFORE UNDERGOING A FORTUNATE REVIVAL BETWEEN
1903 AND 1908.

0.5 SEAN DAVEY

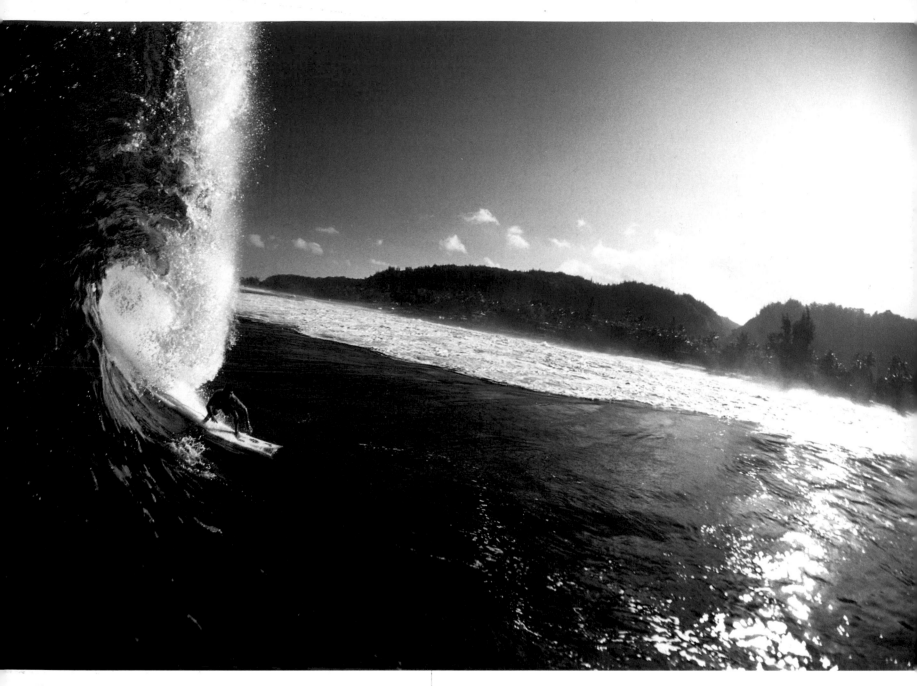

There are few subjects more photogenic than the sight of an expert surfer riding a huge ocean wave. The infinitely varied size and shape of the waves, the raw, elemental power of the ocean, and the consummate grace, skill, and sheer nerve of the best surfers provide the raw material for some of the most exciting of all sports images.

Hawaii is the adopted home of Sean Davey, widely regarded as one of the world's top surfing photographers. He has a love for the sport that goes back to his school days in Australia. "I spent my teens in and around the surf scene of Sydney's city beaches through the late 1970s and early 1980s and got into photography when I was 16. I was a typical 'surf

grommet,' straight out into the surf after school every day. Then there was a day when the surf was tiny—only about 4–6in [10–15cm] in height—but perfectly shaped. I was sitting there, wishing that I could shrink down to the size of a cockroach, so that I could surf. Then I remembered the old battered Kodak Instamatic camera that had been sitting in the back of the wardrobe for the past four years, so I ran up to the house and grabbed it. Once back at the beach, I squeezed off just one frame, which turned out to be a real gem of a shot (at least, I thought so at the time). I was hooked.

"I moved back to my homeland of Tasmania, where my passion for photography was fuelled by the abundant natural beauty and great surf there. Chasing the dream of making this my profession, I spent several more years back in Sydney, this time on the northern beaches, shooting a host of world champions and local pro surfers."

Sean is a surf specialist, but his unique photographic style is applied to all the subjects he shoots, and he is driven by a profound artistic sensitivity. His award-winning work has been widely exhibited, and his book *Oceans* is a superb collection of beautiful images that are a testament to his creative vision. "My main interest has always been not only to document but also to capture artistically what I see, regardless of whether it is surf, portraits, or sunrises. Often it's simple stuff like the way the morning sun might hit a certain tree. Technique plays a large part in my work.

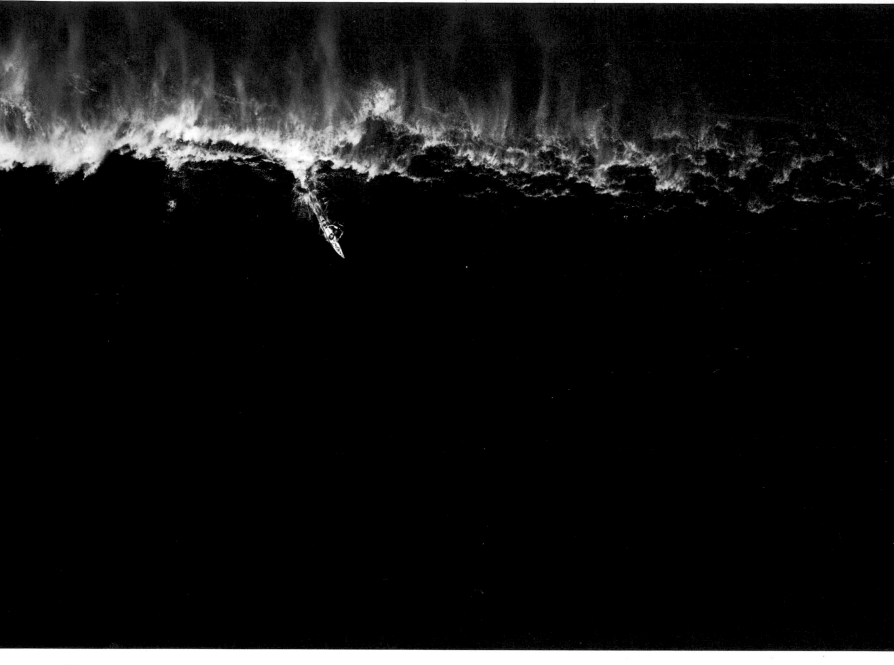

For example, most photographers when shooting surf on a big lens will freeze the action with a high shutter speed such as 1/1000sec. I do this from time to time, but I much prefer to shoot at a slower shutter speed, sometimes as slow as 1/10sec, and the results can be really stunning. The slower shutter speed records more movement so it captures velocity (the angle of trajectory), which is eliminated at higher shutter speeds.

As a surfer himself, Sean is well qualified to shoot surfing subjects, and is in a good position to know what it takes to get the best shots. "I had no real interest in photography until I took that first picture. I'd say that shooting water shots at Big Pipeline and Backdoor with a fisheye lens is probably the most extreme of all when it comes to radical places to put yourself and your equipment, and all for the sake of a picture. It really is amazing what lengths people go to in order to get that extra-special picture. For example, in Tahiti in 2004, there were surfers using jet skis to tow-in to the largest, most dangerous, tubes ever ridden at one of the world's most dangerous surf breaks, Teahupoo. Everybody who was there that day said that it was a miracle that no-one died. It was pretty ridiculous to see how far they pushed their luck that day."

LEFT
Brazilian surfer Carlos Burle at Off The Wall on Oahu's famed north shore, Hawaii. "This was shot on a day when I was definitely having second thoughts about shooting on. Once the surf gets to about 6–8ft [1.8–2.4m] at Off The Wall, it can get pretty dangerous; the water moves around a lot and you can end up in the impact zone and not know it till it's too late... it was a very physically demanding shoot."
Details: Canon EOS 1n camera in Aquatech water housing + 15mm fisheye lens on Fuji Velvia pushed 1 stop to 100 ASA, 1/1500sec at f/4

ABOVE
This is Jamie O'Brien, photographed from a helicopter at the famous Tahitian reef break Teahupoo. I was almost directly above him, which is why the angle looks so unique.

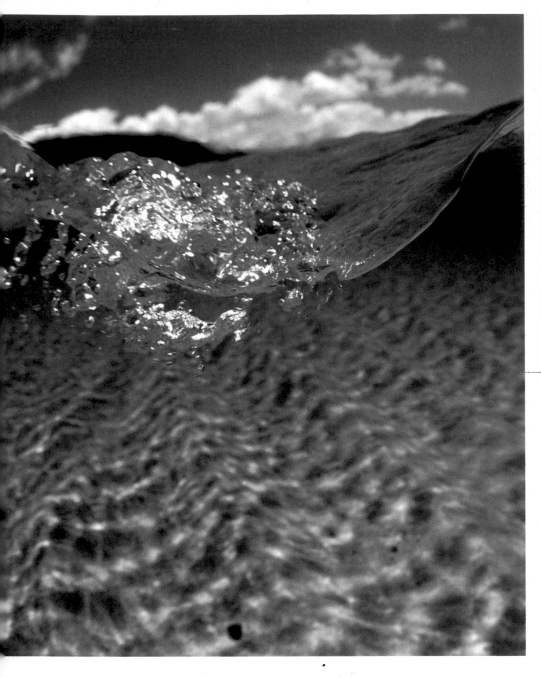

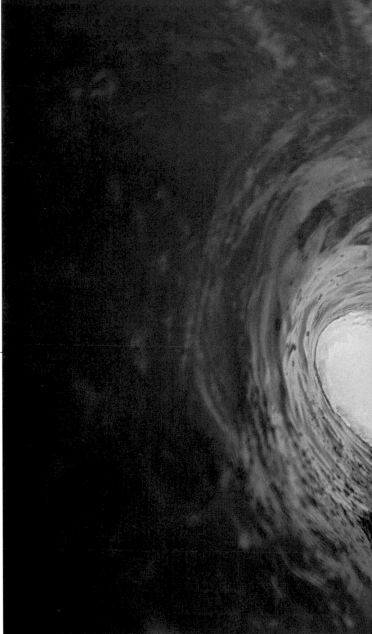

"Even the photographers were in great danger just because of the size of the waves and the unpredictable nature of the surf break. One boat nearly got trashed and its photographer was thrown overboard, losing a $7,000 camera rig.

"I think surf photographers may well have the most intimate access to the A-grade athletes (when actually surfing) than in any other sports photo profession. Here on the north shore of Oahu, it's the norm for surfers to have water housings, fitted with 15mm fisheye lenses, thrust at them from several different directions and only a couple of feet away. I've seen days at Off The Wall where there were almost 20 water photographers with fisheyes all shooting the same wave. Probably none of those photographers got a decent shot because there were so many others in the picture."

Sean uses pretty much the whole range of kit available in a 35mm camera system. Surfing is a sport where a photographer will at some point need to use focal lengths ranging from fisheye to long telephoto, and everything in between. Add in the development of digital equipment, and the choice of kit begins to get even wider, and very expensive. "I use the Canon EOS system and have a pretty wide array of gear including the EOS 1V camera, 15mm, 17–35mm zoom, 28–70mm zoom, 70–200mm zoom,

300mm f/2.8, 600mm f/4, 1.4x and 2x teleconverters, along with two custom water housings from Aquatech for the water shots. I also have a couple of medium-format cameras. So far, I have managed to avoid the confusion of going digital, mainly because there is next to no demand for digital imagery from the surf magazines, and the fact that digital cameras lose their value quicker than anything else out there. My reasoning is that if no-one wants me to shoot digitally, then I'm going to continue shooting film until it becomes necessary to switch. I'm also able to produce scans from my slides that far exceed the size and quality of all 35mm digital cameras. It is interesting to note that we went through this same scenario 15 to 20 years ago, when Canon changed their system from the old 'FD' manual-focus mount to the now standard 'EF' auto-focus mount. We all had these complex

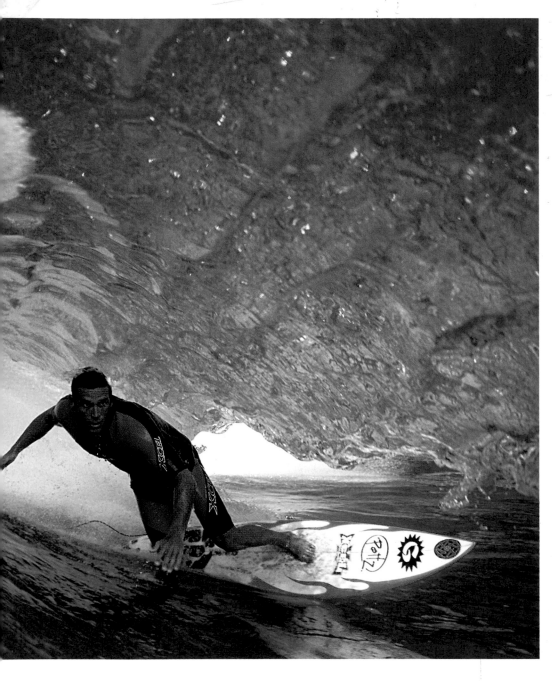

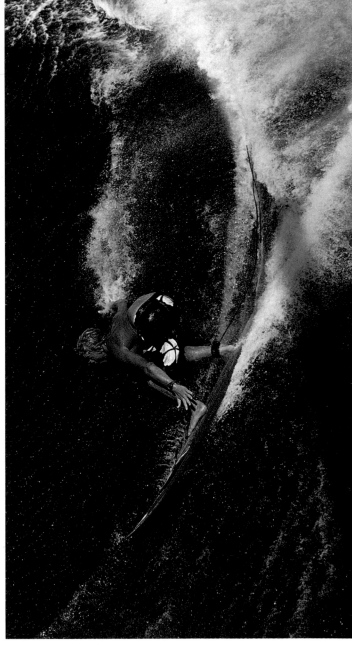

and expensive camera systems that became obsolete overnight because FD lenses can't be used on EF (EOS) systems. At least this time around we can take our lenses and accessories with us."

Travel is also a major theme running through Sean's work, and he has had assignments in a wide range of locations all over the Pacific region, as well as in Europe. "I really enjoy the travel aspect of my work too, not so much the traveling itself, but shooting new locations is always of great interest, especially rugged, out-of-the-way locations with extensive mountain backdrops.

FAR LEFT
This is a split-level view above and below the water at the same time. Technically, this is a very difficult view to obtain. The image was shot at Waimea Bay on the north shore of Oahu, Hawaii, during the calm summer months.

ABOVE LEFT
Martin Potter at Whale Beach, Sydney, Australia. "This photograph was obtained by swimming in the surf zone with my camera equipment inside a protective water housing. I was particularly stoked because Martin has always been a difficult surfer to get pictures of as he tends to keep to himself and avoid the better-known surf locations."
Details: Canon EOS 630 in underwater housing + f/2.8 24mm lens on Fuji Velvia, pushed 1 stop to 100 ASA, 1000sec at f/4.

ABOVE
This is Garrett McNamara dropping into a very large wave on the outer reefs of Oahu, Hawaii. He was towed into this wave, as paddling into them is nearly impossible. This shot was taken from a helicopter.

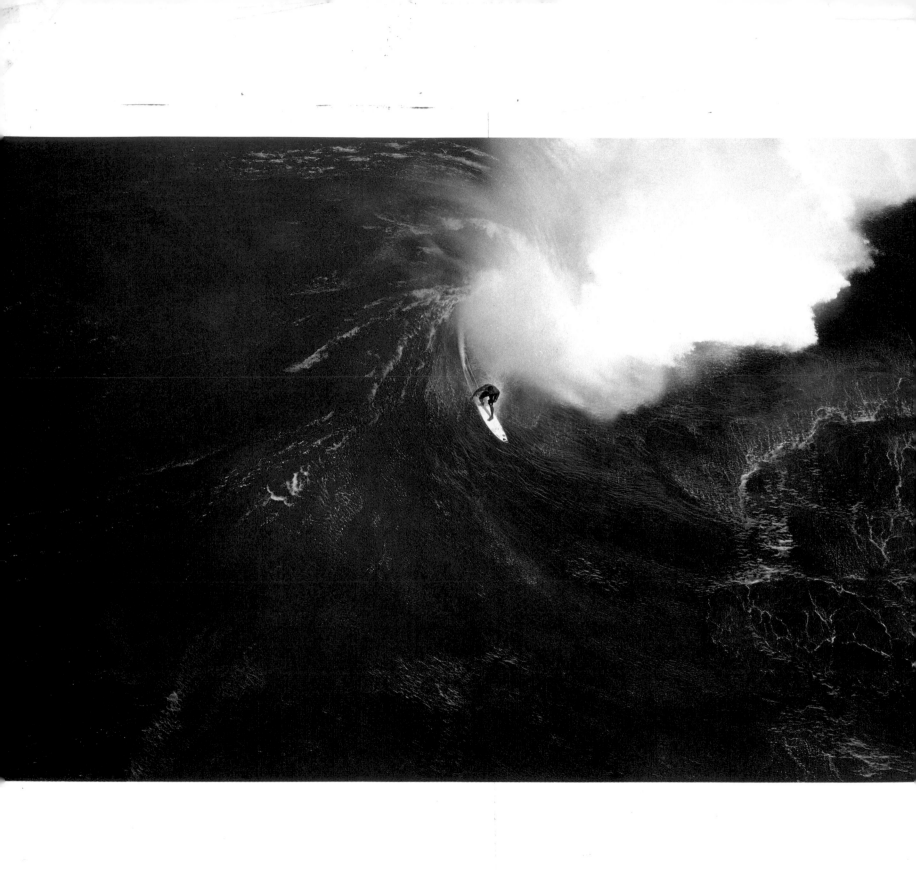

"I THINK SURF PHOTOGRAPHERS MAY WELL HAVE THE MOST INTIMATE ACCESS TO THE A-GRADE ATHLETES (WHEN ACTUALLY SURFING) THAN IN ANY OTHER SPORTS PHOTO PROFESSION."

"To me, the backdrops are often more important than the wave itself, as they ultimately determine the individuality of the image, way more than any wave can on its own. A good example of this is the Mentawai Islands of Indonesia. They are probably the most reliable quality waves on the planet, but have no really interesting backdrops except for the occasional palm tree. So many magazines have been there and shot brilliant surfers in perfect waves, but it all just looks the same."

With his wide-ranging interests in the world around him, as well as a passion for surfing, Sean continues to retain the enthusiasm and creative ideas that are the mark of all great photographers. "I've always said that photography truly is an endless canvas. There are always many different ways to translate an idea into an image on film. There is a popular American surf magazine, Transworld Surf, where you'll see that the creative envelope has really been torn open recently.

That magazine is single-handedly pushing the limits of photography, and photography as art. It's more like a photo magazine than a surf magazine, and it's definitely got people fired up creatively. It's this sort of thing that makes me think that photography is just as alive, vibrant, and refreshing as it's ever been. I've personally always been driven to shoot very different views of things that are seen every day, from a new perspective.

The recent arrival of remote flash-to-water photography has created a whole new realm of surf photography. The photographer works from the beach with a 400–600mm lens while an assistant swims in the surf with a waterproofed, radio-controlled flash. All he has to do is shoot the surfer if he's in range of the flash. As long as the assistant has aimed the flash at the surfer, it can result in a killer image. I'm still in the early days of developing a reliable set-up, as it's quite difficult to do and you usually only have about an hour to work with. It's not a situation where you can always expect amazing results. There are other ideas in my head that I've yet to pursue. It's a matter of thinking of something and applying it physically, which isn't always so easy—but then that's the beauty of it."

LEFT
Sunny Garcia at Backdoor Pipe, north shore of Oahu, Hawaii. "I shot this from a hired helicopter, almost vertically above the surfer. I like to shoot almost directly above the surfer as this is a unique angle usually obtained only from a helicopter."
Details: Canon EOS 1V + Canon f/2.8 70–200mm zoom lens on Fuji Velvia film pushed one stop to 100 ASA, 1/250sec at f/4

0.6 SIMON FRASER WILDERNESS SKIING XPERT

MY INTEREST IN BOTH PHOTOGRAPHY AND WILDERNESS SKIING
STEMS FROM A LOVE OF MOUNTAINEERING. I STARTED TAKING
PICTURES OF MY EARLY CLIMBS AND TRAVELS PURELY AS A
RECORD, BUT AS I BEGAN TO TRAVEL FURTHER AFIELD IN
MOUNTAINOUS REGIONS OF ASIA AND SOUTH AMERICA, MY
PHOTOGRAPHIC INTEREST GRADUALLY DEVELOPED, MAINLY
AS A RESPONSE TO THE FASCINATING PEOPLE AND PLACES
THAT I ENCOUNTERED.

0.6 SIMON FRASER

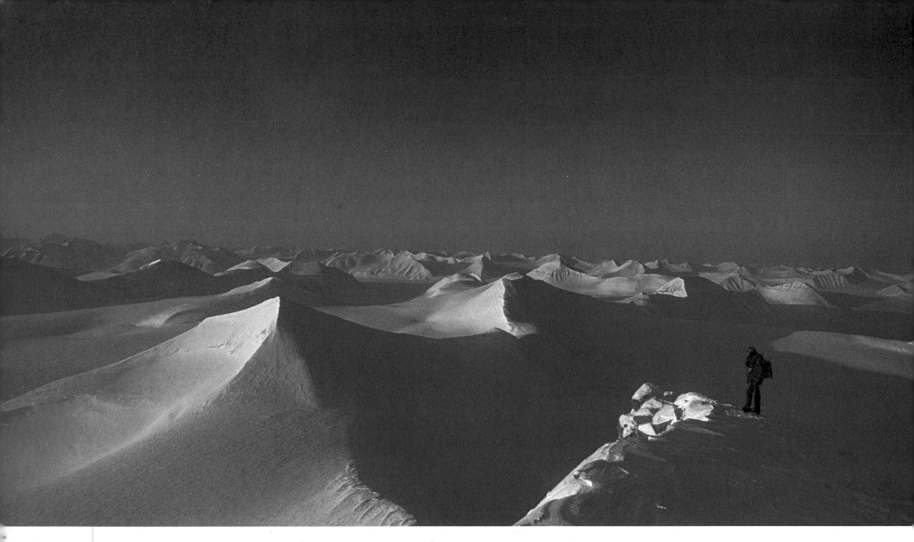

The turning point in my photography came during a two-year stint with the British Antarctic Survey, which employs mountaineers to work as field safety assistants, escorting scientists in remote locations in Antarctica. Living and traveling in the world's greatest wilderness was an inspirational experience. When I returned to Britain, I decided to take up photography professionally, and now cover a wide range of science, nature, and environmental subjects, for stock and on commission.

Wilderness and backcountry skiing is very close in spirit to the true source of all skiing, which originated in Scandinavia more than 4,000 years ago. Since 1986, I have been on numerous expeditions to the Arctic, mostly to Greenland, Svalbard, and the Canadian Arctic, usually guiding clients on ski journeys in remote mountainous regions. Photographing skiing expeditions means being a participant rather than an observer, but the photography remains secondary to my overall responsibility of completing the journey safely, and ensuring the wellbeing of the group in sometimes adverse conditions.

This inevitably means compromising on camera equipment, as there is a limit to how much can be carried in a rucksack or pulled on a sledge.

When photographing wilderness skiing, I tend to concentrate on the wilderness element more than the actual skiing. I like to place the figure of a skier within the landscape as a reference point, to emphasize the vast scale of the land, and the insignificance of a human presence. I especially enjoy photography that evokes a sense of awe at the beauty and grandeur of wild nature.

One of the main challenges in any photography in extreme cold is to ensure that the equipment works reliably. For this reason, I have used the Nikon FM for many years; it is a simple, robust camera with a mechanical shutter. I've used the FM in temperatures below -40°C, and have also used a Nikon F90X down to about -20°C. The lightweight F80 is excellent for ski trips, but I have yet to test its performance in really cold conditions. In severe cold, the moving parts of any camera can malfunction. In Baffin Island, my Mamiya 7 seized up at -35°C, despite having full battery power from an external battery case kept warm inside my clothing. As for lenses, I currently use the Nikkor 24–120mm. I also like using a 20mm for dramatic views of powerful landscapes, and the superb 70–300mm ED zoom.

I still shoot exclusively with film cameras, using Fuji Velvia, Sensia, and Provia films. Since I shoot a lot of stock, I'm waiting for the day when a 35mm digital camera can truly deliver medium-format quality, and the Canon EOS 1Ds seems to be the main candidate for that achievement at the moment. But on a cold-climate expedition, the power supply for a digital camera could present problems, and I would also be concerned with dust on the CCD, and the extra computer time required later for cleaning up the image.

ABOVE
Ski mountaineer on a remote summit in eastern Spitsbergen on a late winter evening, with mountains stretching away as far as the eye can see. Winter temperatures here can sometimes fall well below -40°C. This is an important polar bear denning area, and bears and their tracks are frequently seen well inland, even crossing passes 1640ft /500m/ above sea level.
Details: Nikon FM + 35–70mm f/3.5 zoom lens on Kodachrome 64, 1/125sec at f/11

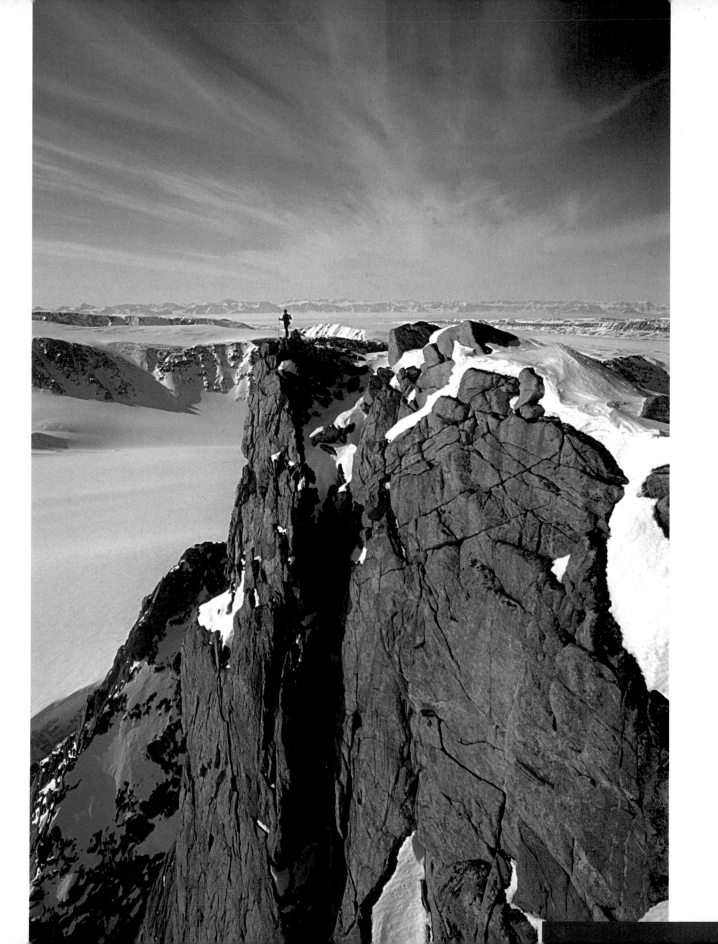

LEFT
A ski mountaineer on the summit of a
peak in east Greenland. This peak was
easily ascended on skis from the far
side and gave a tremendous view over
the surrounding peaks and glaciers.
Wisps of cirrus clouds converging
toward the far horizon enhanced the
sense of vast space and distance
behind the solitary human figure.
**Details: Nikon FM + 24mm f/2.8 lens
on Fuji Velvia 50, 1/125sec at f/11**

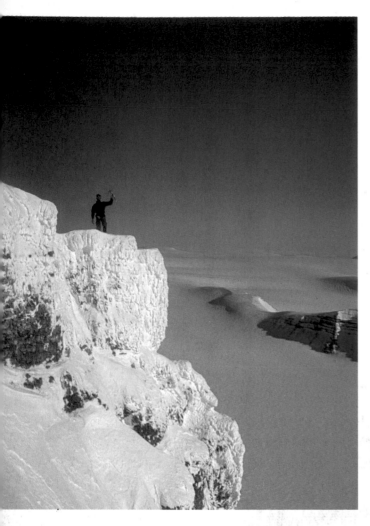

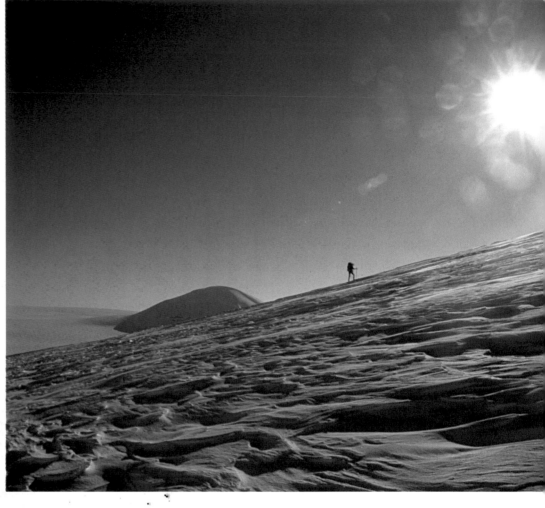

Then there is the question of the long-term stability of digital media, and the fact that in 20 years' time the software will probably have changed beyond recognition, whereas a piece of film will still be a piece of film. For the moment, I'm happy to shoot film, but in the future I expect that I will use digital capture for some of my work.

Traveling on skis through a pristine wilderness for days or weeks at a time is a profound experience. It requires considerable physical fitness and stamina, the willingness to put up with small hardships, competent navigational skills, knowledge of crevasse rescue techniques, and self-sufficiency. One of the most satisfying aspects is the sense of commitment in a challenging environment where days of sustained effort may be required to reach warmth and safety. Satellite phones are a useful safety back-up, but undoubtedly dilute the level of commitment and isolation. On my first wilderness ski expedition, with Ben Osborne (see chapter 1.3) in the Zanskar Range of the Himalayas, we were totally dependent on our own judgment and decision-making. If anything went wrong there was no hope of rescue. This is the purest form of adventure where self-reliance and good judgment are paramount. Skiing in the Himalayan winter through deep powder snow at altitudes from 13,120ft (4,000m) to over 16,400ft (5,000m) is extremely arduous. Once we had to clamber over massive walls of avalanche debris

that completely choked a deep, V-shaped valley leading to a high mountain pass. We tried to assess the risks correctly, rationalizing that every slope that could possibly avalanche had already done so, and that the valley was safe until the next heavy snowfall. The adrenalin kept us moving rapidly through the danger zone despite the thin air of high altitude, as we anxiously kept an eye on the steep slopes above us. We reached the top of the pass as night fell, physically and mentally drained. The next day we descended the far side and soon found ourselves desperately ploughing through depth hoar down a narrow gorge. Every step became a grinding effort as we broke through a thin crust and sank into bottomless, unconsolidated crystals of rotten snow. There was no possibility of retreat, and with limited food supplies, we were compelled to keep going.

Potential hazards on skiing expeditions in regions such as the Arctic can include fickle sea ice conditions, unexpected encounters with polar bears, and the problems of navigating in a white-out. Once in Greenland, in very poor visibility and contrast, and mistakenly believing we were on safe ground, two of my companions suddenly vanished in front of my eyes, having skied over a 30ft (10m) ice cliff at the end of the glacier. The ice cliff was totally invisible due to the white-out, but luckily they landed in a snow drift on the sea ice below, with only minor injuries.

ABOVE LEFT
A ski mountaineer on the summit of a remote peak in northern Spitsbergen at latitude 79 degrees North. Ice-covered areas in polar regions have countless remote peaks such as this one, often referred to as *nunataks*. Many are so remote that they have rarely, if ever, been climbed. The steep rock face is encrusted with snow and ice from winter storms, still deeply frozen in April, before the summer thaw.
Details: Nikon FM + 24mm f/2.8 lens on Kodachrome 25, 1/125sec at f/8

ABOVE
A skier ascends a remote snow peak in northern Spitsbergen. The cold dry winds of winter have scoured the snow surface to form patterns of ridges and furrows known as *sastrugi*, a common feature in polar regions. A small lens aperture created the star-burst effect in the sun, partially diffused by thin cloud.
Details: Nikon FM + 20mm f/2.8 lens on Kodachrome 25, 1/15sec at f/22

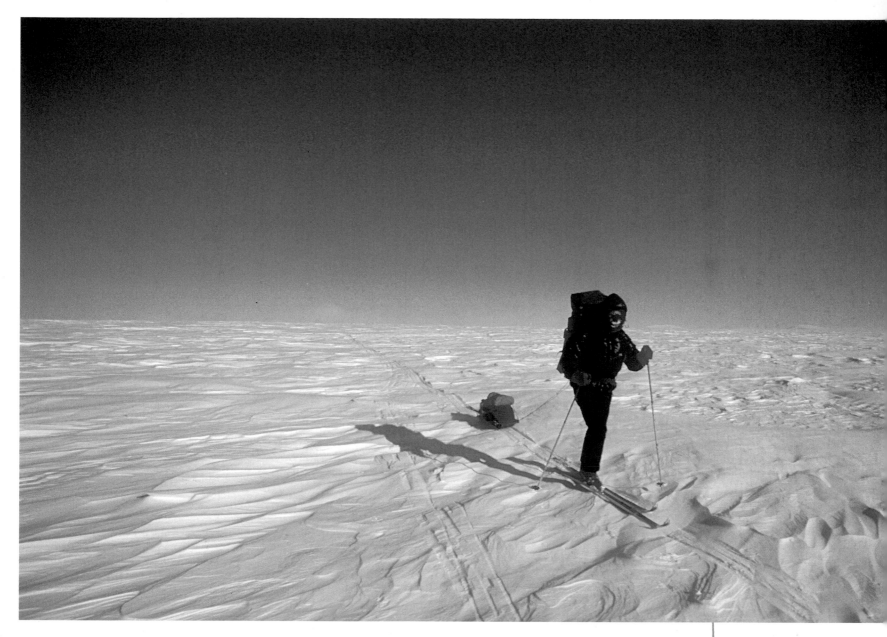

It would have been a very different outcome if it had been a 90ft (30m) ice cliff on to bare sea ice.

Wilderness skiing may appear to be an exhausting exercise in an unforgiving environment. But the effort and discomfort are forgotten on magical days when the weather is glorious and the snow conditions are perfect. Exploring a little-known mountain range in Greenland, crossing high passes, climbing new peaks, skiing for miles down untouched glaciers, and camping in stunning locations are ample rewards for the days of toil. Capturing these unique places on film is also very satisfying. The work of outstanding photographers such as the late Galen Rowell has raised the standard of adventure and wilderness photography to a new level, which can only help to promote an awareness of the importance of wild places. Photography, like exploration, is a kind of journey with no final destination, searching for the perfect image. There are always new places to see and new ways of seeing.

ABOVE
A skier hauling a pulk on an icecap at latitude 79 degrees North, in northern Spitsbergen in bitterly cold weather. Despite the bright sunshine, the steady 20-knot wind and an air temperature in the -20s made a considerable windchill. The skier's face and beard are covered in ice from his breath condensing and then freezing. This is the kind of featureless view and endless horizon familiar to those who ski across the huge interior plateaus of Antarctica and Greenland.
Details: Nikon FM + 24mm f/2.8 lens on Kodachrome 25, 1/125sec at f/8

0.7

"...SNOWBOARDING IS STILL A PRETTY
YOUNG SPORT OR THE SPORT AS
WELL AND THE BOARDING ...
ARE STILL EVOLVING ..."

0.7NICKHAMILTONSNOWBOARDING**X**PERT
AROUND 1990, SOME 25 YEARS AFTER THE VERY FIRST
SNOWBOARD WAS IMPROVISED, SNOWBOARDING BEGAN
TO INCREASE IN POPULARITY EXPONENTIALLY. IN MANY
WAYS, THE SNOWBOARDING BOOM REVITALIZED THE SKI
INDUSTRY ACROSS THE WORLD, WHICH HAD BECOME
SATURATED BY MASS SKI TOURISM IN THE WAKE OF
LOW—COST INTERNATIONAL AIR TRAVEL.

0.7NICK HAMILTON

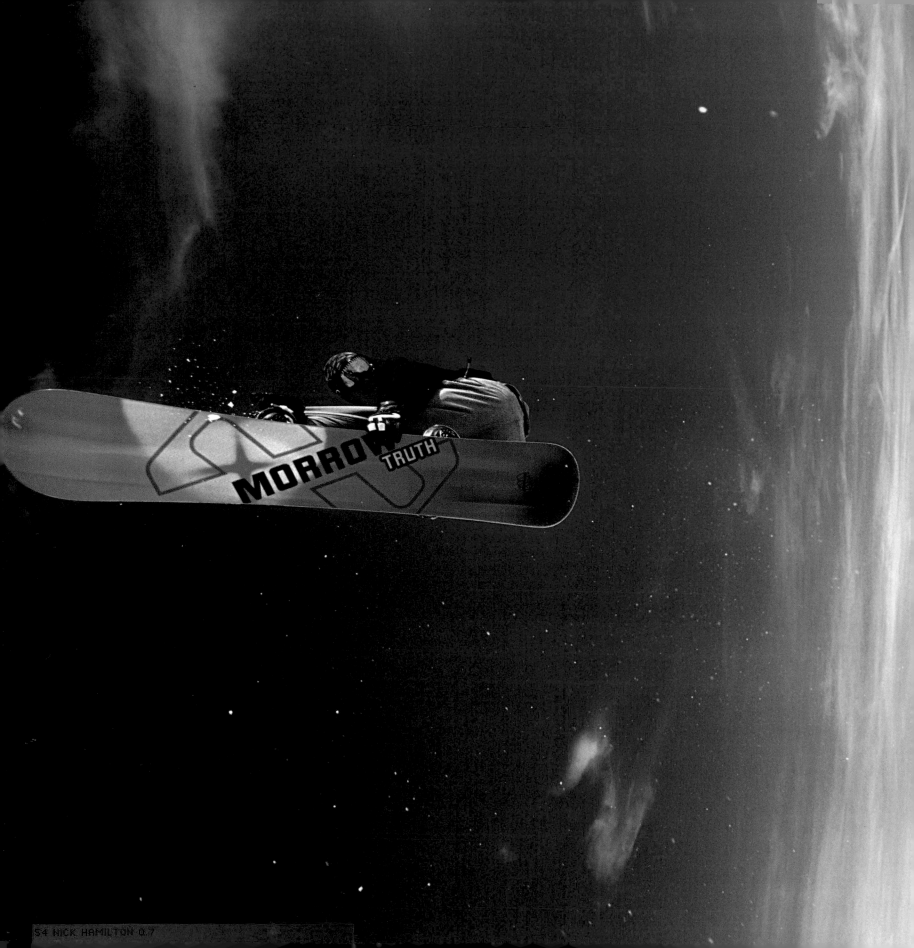

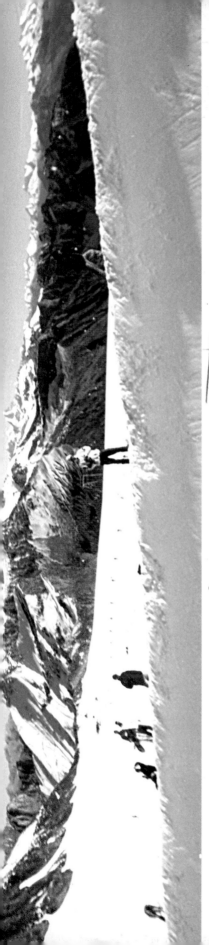

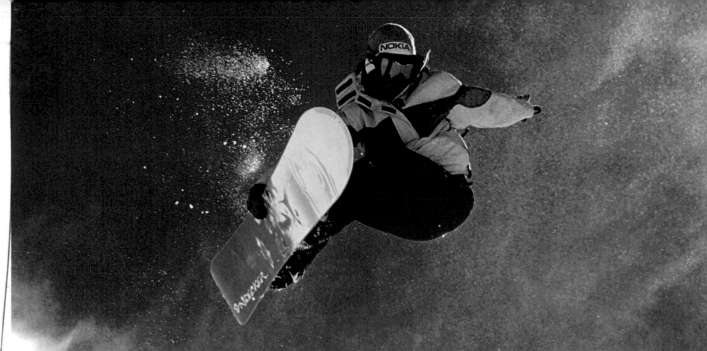

Those who have discovered the joys of snowboarding find the sensation similar to skateboarding and surfing. Some describe snowboarding as having a zen-like quality from the feeling of harmony they experience, especially with fresh, powder snow.

Nick Hamilton is a young British-Finnish photographer, now resident in California, who grew up with the snowboarding boom. He already has ten years' experience in photography and snowboarding, and is photo editor and photographer for the US-based *Transworld Snowboarding Magazine*. "I got interested in photography as a hobby in the early 1990s when I was in high school in the States and really into skateboarding and snowboarding. All my friends were much better than I was at both these sports, so I often found myself too impressed or intimidated to participate. I started filming with a video camera and then I got more into photography as I found it was more technically challenging and satisfying. I started off with a disposable 'point and shoot' camera and got my first film developed, which was really exciting. When I got the film back, every picture was of the subject just landing or finishing his trick. The camera had a delay or lag time of about a second for focusing, so my first lesson in photography was definitely about the timing of the action. Since then, timing has become one of my stronger points."

Many converts to snowboarding insist they will never return to skiing. The stability of modern snowboards means that they are highly controllable, and can outperform skis in some snow conditions. Apart from the snowboard parks, half-pipes, and big-air snowboarding, there is also the challenge of extreme riding on very steep slopes of at least 50 degrees—a dangerous option demanding the highest levels of technical skill. Many snowboarders also explore the backcountry, trekking in with snowshoes in the quest for untouched powder and unspoiled scenery.

Nick loves being out there producing great images of this exciting sport, but is also mindful of the risks and challenges. "With snowboarding photography, technically the greatest problem can be the cold and how the equipment handles it.

Condensation is part of this, and there are a lot of tricks to keeping your equipment in order that are not taught in photography classes. You just have to get out there and learn the hard way. Snowboarding can be very dangerous, especially as people are driven further and further into the elements to get the fresh-looking shots. It is very important to be able to find fresh powder without any sign of the tracks of other snowboarders."

Nick is in no hurry to abandon his preference for film. With snowboard images, there is no real rush to deliver, as most magazines and companies work a year in advance to get the images they need, so the speed of digital imaging isn't so important. "I think that digital images have a pretty limited look of simply documenting the subjects while not really complementing them. I shoot all still-life product shots in a studio with a digital camera so that I know when I've got the shot I'm after. For shooting snow, I've gone in the opposite direction and have started shooting with manual cameras like Hasselblads. I've also been shooting lots of negative film and printing the images myself in a darkroom to get the most 'undigital' look possible."

LEFT
Jamie Phillip in Les Diablerets, Switzerland. "As many of the snowboard brands need their images before the winter kicks off, we shoot a lot in the early season at some glaciers around the Alps. This was a great shoot in October so we had the images in the magazines for the December newsstand."
Details: Canon + 17—35mm wide-angle lens on Fuji Provia 100 panned at 1/500sec at f/8

ABOVE
Lesley McKenna training for the 2002 Salt Lake Olympics. "Lesley was the first British snowboarder to make it to the Olympics. I went on a shoot with Lesley in Chile to get some photos for her sponsors in the summer. The mountains in South America have their own dangers with such high altitudes. The peak we shot on here was over 13,120ft (4,000m) so the air was thin—great for training but not so great for breathing."
Details: Wide-angle lens at 24mm on Fuji Provia 100F panned at 1/750sec at f/6.7

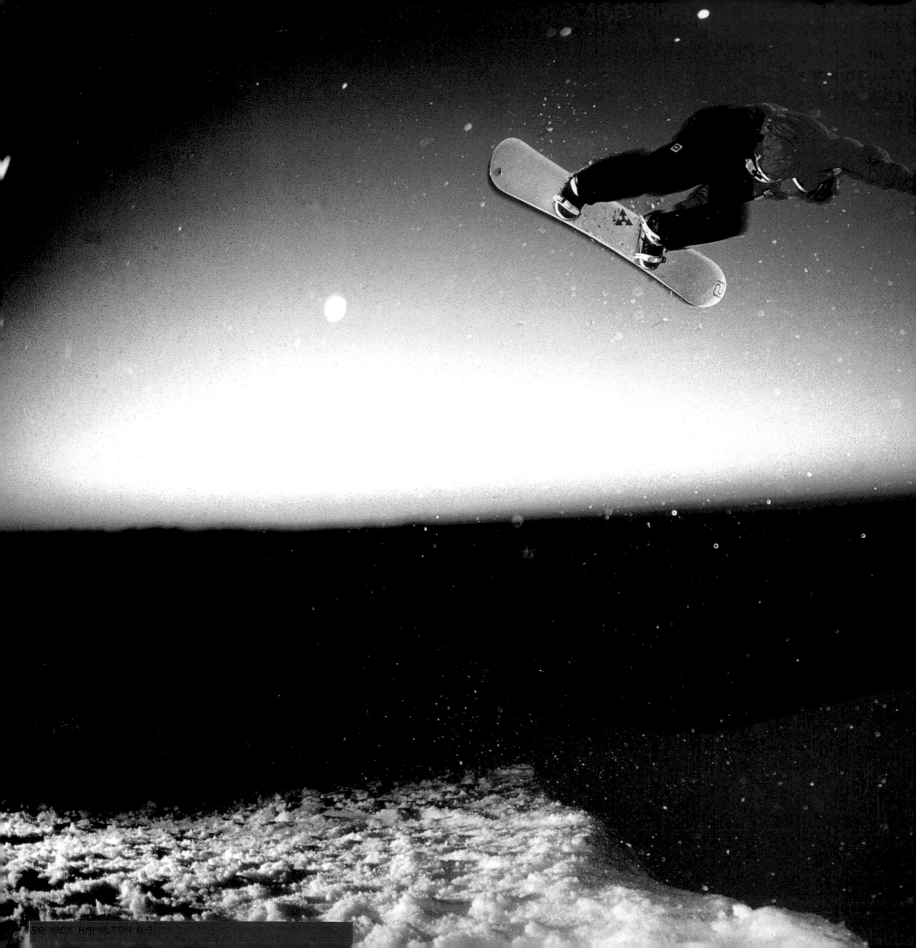

Sami Tourineimi over a midnight sun in the Arctic Circle of Finland. "In the north of Finland at this time of year the light lasts almost 24 hours a day and at night it's called the Lapland Gold. This shot was taken around midnight in late May as the light finally faded."

Details: Film was Fuji Provia pushed a half stop to boost the sunset colors a little and filled in with a Lumedyne flash on a radion slave to the left and a sunpack flash on the camera to fill in on the rider. 1/60sec at f/5.6 with a 15mm lens

Lighting technique has played a large part in the progression of snowboard photography. I work with all kinds of lights, including Lumedyne and Visatec systems. For action, I usually use my Canon EOS 1n, with lenses from 15mm fisheye to 300–500mm telephoto."

Nick travels widely, with regular visits to Europe, enjoying the stimulus of being up in the mountains and well away from city life. "I was in the Arctic Circle in Finland for New Year's Eve shooting in a little resort up there with a snowboard park and a half-pipe. We were shooting in the afternoon with floodlights because it's completely dark at around 4pm. It was -26°C and I had four lights on various stands around the half-pipe. We shot for about an hour until my flash batteries all died in the cold, and got some good shots all on the manual Hasselblad 501 CM cameras, which needs no batteries. When one of the pros turned the floodlights off it went totally dark and we looked up to see a full *aurora borealis*, the northern lights, all over the sky, dancing in green and red shapes. It was unbelievable. It was far too cold to change films in the Hasselblad so I had to shoot with my back-up 35mm on a tripod before the *aurora* disappeared a few minutes later."

As for the future, Nick is keen to explore new ways to create fresh images. "It's mostly the lighting that is being pushed, using more and more strobes and carefully controlled lighting for different effects. Recently, we shot some powder photos at night with flashes strapped to the subject's snowboard. It sounds kooky, but it made the cover of *Transworld Snowboarding Magazine*."

BELOW
Sascha Hamm in great style years before he turned British Champion.
Details: Canon on autofocus with focus point furthest to the left, Fuji Provia 100, 1/1000sec at f/5.6

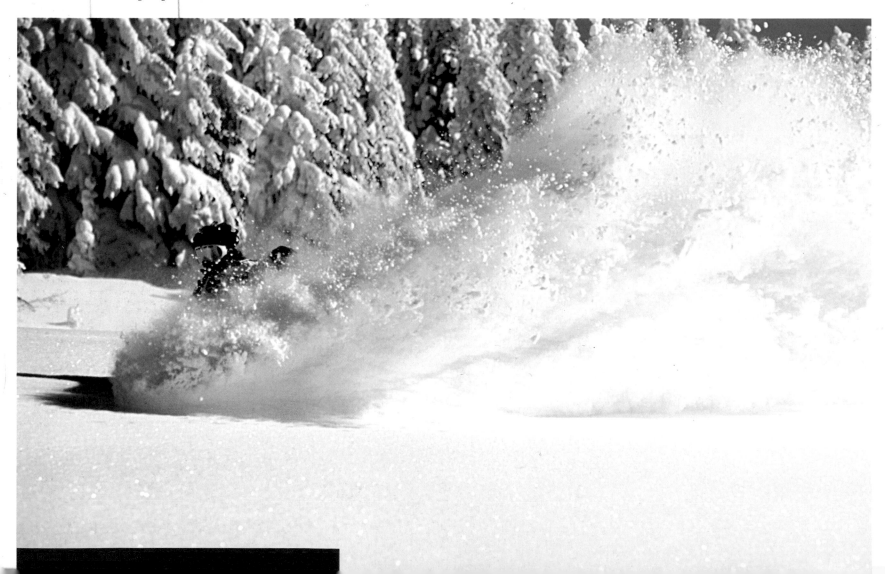

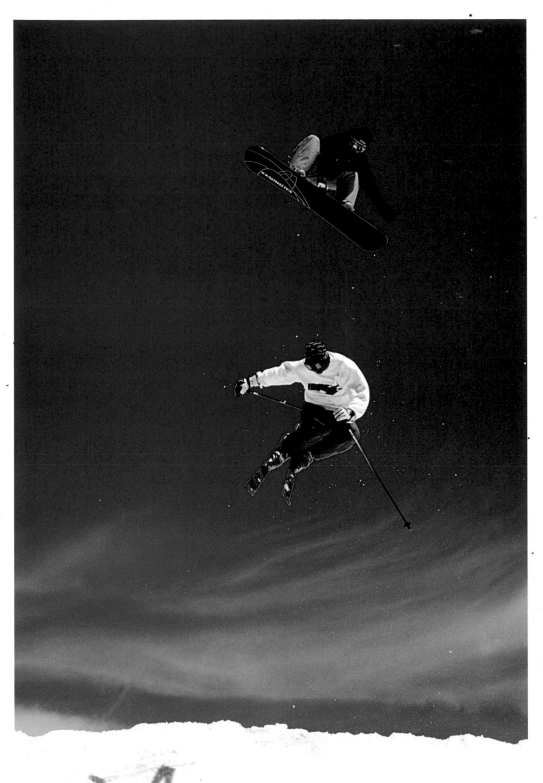

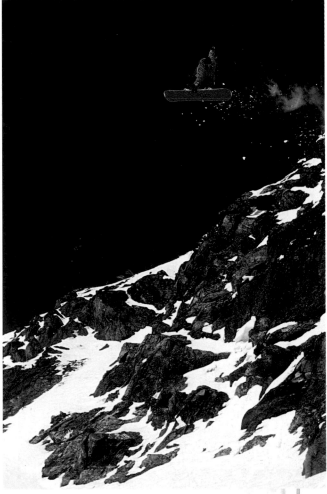

LEFT
A snowboarder flying over a skier. This was not planned and there was almost a huge crash at the bottom, but it was pretty entertaining to see and shoot.
Details: 70—200 f/2.8 lens

ABOVE
Former British Champion Sascha Hamm blasting off a cliff in Lake Louise, Canada. This cliff was pretty big for the conditions, with a lot of exposed rock to clear. Even though it looked brilliant for a photo, I was ready to walk away from this cliff as the landing was so tight and choppy. In our group, the other two riders called it and rode down as Sascha hiked up and launched off into a perfect pocket of fresh snow for a landing. He rode away clean and safe.
Details: Canon + 70—200 f/2.8 lens on Fuji Velvia 50, 1/1000sec at f/4

0.8NEALEHAYNESSPORTSXPERT

VERY FEW PHOTOGRAPHERS HAVE PACKED IN AS MUCH EXPERIENCE IN 12 YEARS AS NEALE HAYNES. FROM ROOKIE PHOTOGRAPHER AT ALLSPORT IN 1990 TO MANAGING DIRECTOR OF HIS OWN PHOTOGRAPHIC AGENCY BY THE AGE OF 28, NEALE HAS SEEN THE WORLD AND ACHIEVED SUCCESS IN SPORTS PHOTOGRAPHY, REPORTAGE, AND CORPORATE WORK FOR A RANGE OF PRESTIGIOUS CLIENTS

0.8 NEALE HAYNES

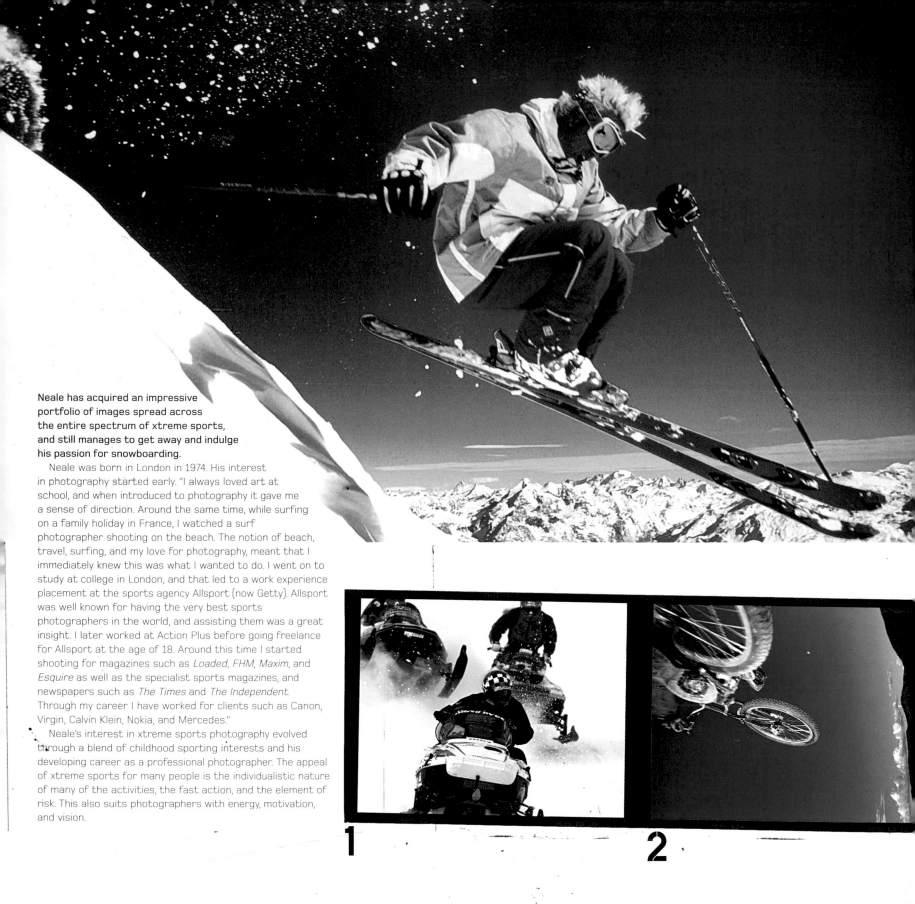

Neale has acquired an impressive portfolio of images spread across the entire spectrum of xtreme sports, and still manages to get away and indulge his passion for snowboarding.

Neale was born in London in 1974. His interest in photography started early. "I always loved art at school, and when introduced to photography it gave me a sense of direction. Around the same time, while surfing on a family holiday in France, I watched a surf photographer shooting on the beach. The notion of beach, travel, surfing, and my love for photography, meant that I immediately knew this was what I wanted to do. I went on to study at college in London, and that led to a work experience placement at the sports agency Allsport (now Getty). Allsport was well known for having the very best sports photographers in the world, and assisting them was a great insight. I later worked at Action Plus before going freelance for Allsport at the age of 18. Around this time I started shooting for magazines such as *Loaded*, *FHM*, *Maxim*, and *Esquire* as well as the specialist sports magazines, and newspapers such as *The Times* and *The Independent*. Through my career I have worked for clients such as Canon, Virgin, Calvin Klein, Nokia, and Mercedes."

Neale's interest in xtreme sports photography evolved through a blend of childhood sporting interests and his developing career as a professional photographer. The appeal of xtreme sports for many people is the individualistic nature of many of the activities, the fast action, and the element of risk. This also suits photographers with energy, motivation, and vision.

1

2

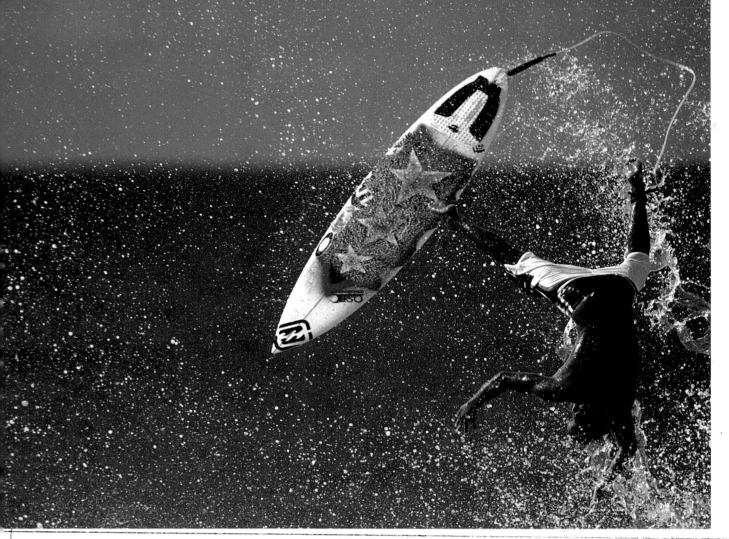

FAR LEFT
Matt Reardon skiing in Tignes, France.
Neale says, "The best advice I think I
was ever given while being an assistant
was to keep it clean and simple and
plan your backgrounds as much as your
subject. This shot is very much all of
those things and I love the way even
Matt's hair matches the color scheme.
I can picture the best days so well,
perfect weather, fresh snow, and a good
gang to mess around the mountain with.
A nice day at the office!"
**Details: Eos 1N RS + 17–35mm f/2.8
lens on Fuji Velvia 50, 1/500sec
at f/5.6**

LEFT
Surfing on the north shore of Oahu,
Rocky Point, Hawaii. "The north shore of
Hawaii in the winter is the mecca for
surfing and for good reason: great
weather and a consistent flow of waves.
As much as I love a great sequence in
the barrel shot of someone doing a
cutback, I do like a good wipeout, and
this one with the board design works
well. Every drop of water is stopped in
motion, as is the surfer and board
before a nice slam back to ground.
The 600mm is my favorite lens, and
wide open it gives dramatic results,
compressing everything to a tight frame."
**Details: Eos 1N V + 600mm f/4 lens
with 1.4x teleconverter on Velvia 50,
1/1000sec at f/4**

1. ESPN X Games in Creste Butte, Colorado. "Snowmobile racing is still
a new sport. I wanted to show the speed head-on, so the long lens
and the compression was an obvious choice. I shot fairly wide open to
give the best film results in these conditions, as it was not the best
light and colors are important for the dramatic subject matter."
**Details: Eos 1n RS + 600mm f/4 lens on Fuji Provia 100,
1/500sec at f/4.5**

2. Mountain biking downhill, Shot Steamboat Springs, Colorado.
"I was lying under a ramp with the rider jumping over me to give
maximum effect. A polarizing filter gave the sky its dramatic color."
**Details: EOS 1V + 14mm lens with polarizer on Velvia 50,
1/500sec at f/4**

3. Downhill mountain biking in Vale, Colorado. "I often try to shoot from
the rider's perspective, which involves some kind of mount or remote
device. Here, the camera was mounted on a Manfroto magic arm and I
triggered the camera using a standard sync lead. I shot this several
times with varied shutter speeds as I could feel the vibrations and I
did not want to distort my hands or handle bars but wanted to keep
the feeling of speed with the blurred ground."
Details: Eos 1n + 17–35mm f/2.8 lens on Velvia, 1/30sec at f/22

3

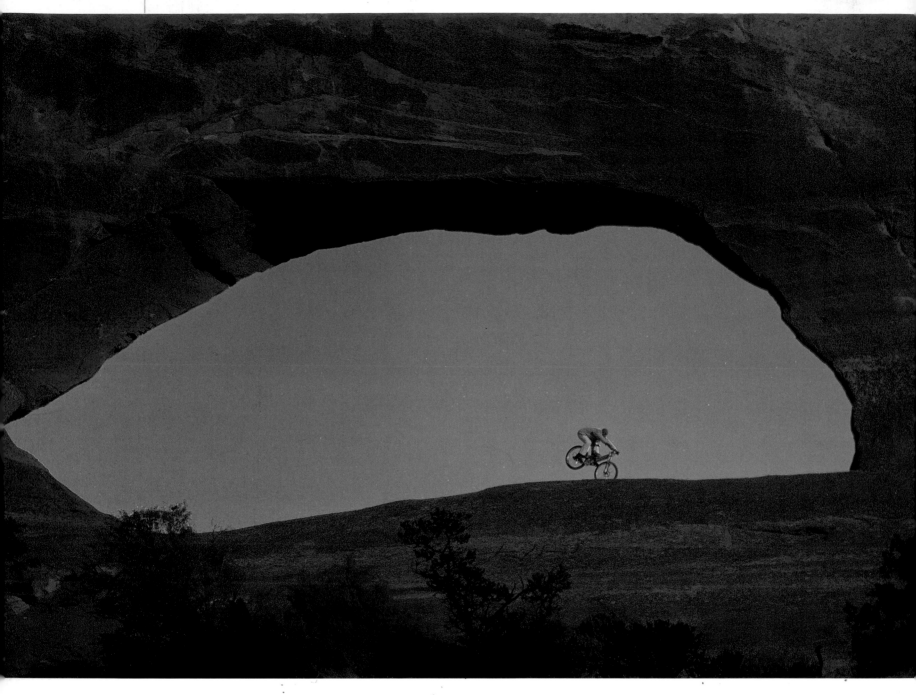

"As a kid, I loved skateboarding, BMX, and surfing. While on holidays in France and Cornwall I experimented, trying to get decent action shots. Work experience at Allsport, shooting mainstream sports such as tennis, football, and boxing only made the colorful shots of my hobbies seem so much more dramatic. In the early 1990s, snowboarding was unseen and some of my shots taken on an early trip got so much attention that I realized my calling was to take xtreme sports photography through to the mainstream. My youth and my fresh approach, along with the experience gained from shooting with the Allsport photographers, seemed to be a perfect match. I had an affinity with the riders of the sports, whereas other photographers were often seen as outsiders."

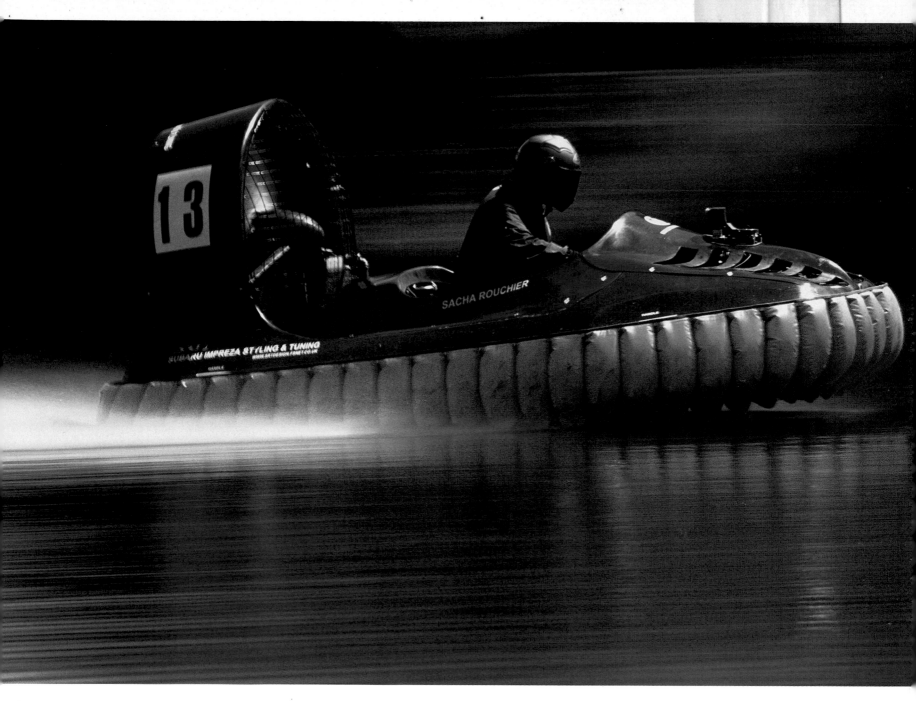

I asked Neale to define the key elements that fire his interest in this field of photography, and the reasons for the explosion of interest in xtreme sports over the last decade. "We live in an era when travel is so easy, and with the Internet, so many barriers have opened. I love the fact that you can go snowboarding for the weekend, or book a ticket on the Internet and surf in Hawaii without needing a travel agent. The diverse sports that I cover allow me to keep a fresh eye, whereas you have to be very strong to keep pushing if you concentrate on only one sport. I love to shoot surfing and work with underwater cameras and housings. The photographers who sit out in the large reef breaks get my full respect, not only for their photography but for their fitness and skill to be in the right place without getting in the way or going over the falls and risking their lives."

ABOVE
This image was taken in Nottingham, UK at a hovercraft race meet.
Details: Canon EOS 1v + 600mm f/4 lens on Fuji Velvia 50, 1/125sec at f/11

Climbing in Utah. "Before going on the shoot, I sketched the sort of image I was after to the climber and we then spent a couple of days driving round chasing the image. This is the one that I felt worked best. The mountainous background and the low cloud together make the shot very simple yet effective, showing great height and danger."
Details: Eos 1n + 70–200mm f/2.8 lens on Fuji Velvia 50, 1/500sec at f/5.6

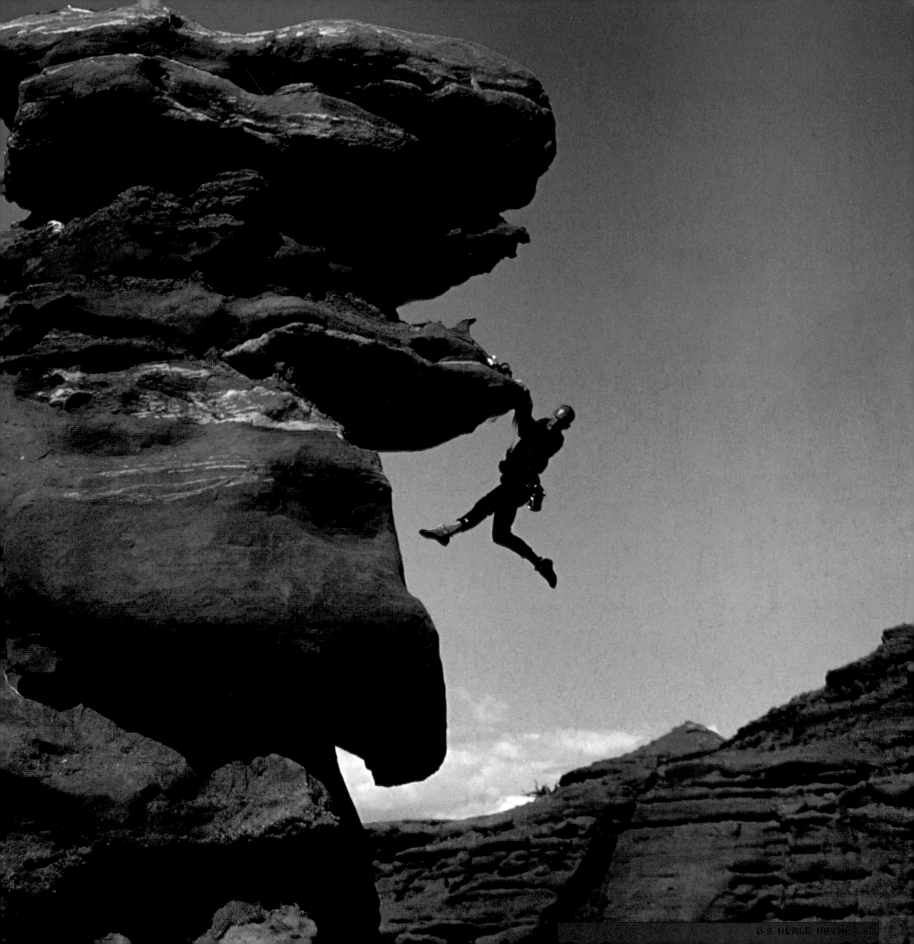

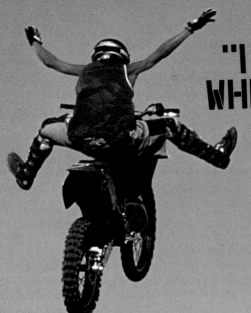

"I ALWAYS LOVED ART AT SCHOOL. AND WHEN INTRODUCED TO PHOTOGRAPHY IT GAVE ME A SENSE OF DIRECTION."

Motocross in Melbourne, Australia. "All day I tried to find a picture that summed up the event and location, but was struggling due to the height of the banners and the sun direction. Then, as the sun swept round, this one guy was really going for it and I managed to get on top of a medic's truck to gain some elevation. The hands and feet free from the bike make the symbol X and it looks as if the biker is flying into the city."
Details: EOS 1N + 70–200mm f/2.8 lens with 1.4x teleconverter on Fuji Velvia 50, 1/500sec at f/5.6

Photographing xtreme sports can involve being in hazardous situations, and Neale is no stranger to the risks that go with the job. "I've had many expensive or even near-fatal moments, such as almost falling out of helicopters when standing on a runner and later finding that I was not tied in properly. I've had cameras thrown from RIBs (rigid inflatable boats) when shooting surfing and a freak set came through, taking the boat, the passengers, and the kit upside down on a reef under a large wave. I was once in Maui on a shoot where I was in the water and noticed a tiger shark fin 50 yards (46m) away. Nearly every shoot seems to involve the danger of being badly hurt due to the proximity of the subject. When shooting snowboarding, for example, I tend to use very wide lenses to give a dramatic effect, which means the rider comes very close. So you end up relying on your subject to fly past at great speed over your head. Usually when the snowboarder or skateboarder takes the lens or flash off the camera you tend to rethink your position!"

The last few years have seen a rapid growth in the use of digital cameras. Like many photographers, Neale uses both film and digital equipment. "For portrait work and feature work, I still tend to shoot on medium format for maximum quality, with a Contax 645 kit. Where longer lenses and high-speed action are concerned, I shoot Canon EOS, both digital and film. The digital aspect is getting greater and greater due to the release of the larger file sizes of the Canon EOS 1Ds and the high speeds of the Canon EOS 1D for editorial work. Clients love the fact that on location you can deliver the work and they need not worry about scanning and reproduction costs. But I think there will always be a market for film, and I still get a real buzz when I get a shoot back and find a really punchy slide on the lightbox."

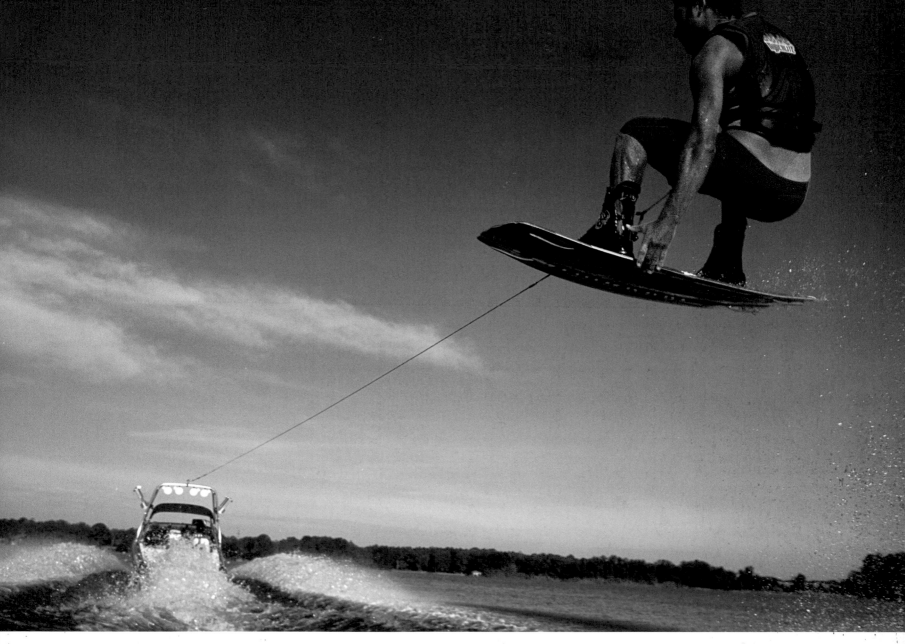

After the intensive early years as a young photographer, Neale recognized the business potential of gathering together the work of a number of photographers under one roof. Many photographic agencies start in this way, when an enthusiastic photographer spots an opportunity for supplying images in a specialist field. "I started Buzz Pictures as I felt that the photographers that I had met over the years, who were often the best in their field, should be represented by one specialist agency. Buzz Pictures is the largest of its type and is growing by the day. Other agencies have small selections of the more popular sports but cannot keep up with the changing fashions or new sports that we can. We have over 40 photographers and an online selection of over 10,000 images that is constantly expanding. Why go anywhere other than a specialist agency that can supply the best images of each sport, that can also be searched online?"

As a major player in the world of xtreme sports photography, both creating images as well as selling them through Buzz Pictures, Neale is in a good position to have an overview of the whole range of activities. "Sports photography has changed greatly since I started in the early 1990s with manual-focus lenses and the need to be able to shoot transparency film without a digital back showing the exposure. The aid of autofocus, digital cameras, and Adobe Photoshop make sports photography very accessible now for everyone, but the need for new angles and styles means that creativity and talent will always stand out, and I can't see that ever changing."

ABOVE
Julz Heaney wakeboarding in Florida. "Wakeboarding is usually shot from the back of the boat like waterskiing, but this shot was taken from a rubber ring being towed at the same time from the same boat, allowing you to see both the rider and pull boat in the shot. This angle is dangerous as the rider jumps over you at close range and if he loses it half-way through you are right in the way. The camera housing has a squeegee on the front so after every pass by the rider you have to clear the water from the front of the lens. It's a great angle, but being bounced around behind a speedboat with a heavy camera while clearing the lens together with the framing makes it a mission." **Details: Nikon F5 + 20mm f/2.8 lens with Ikelite housing on Velvia 50, 1/500sec at f/4.5**

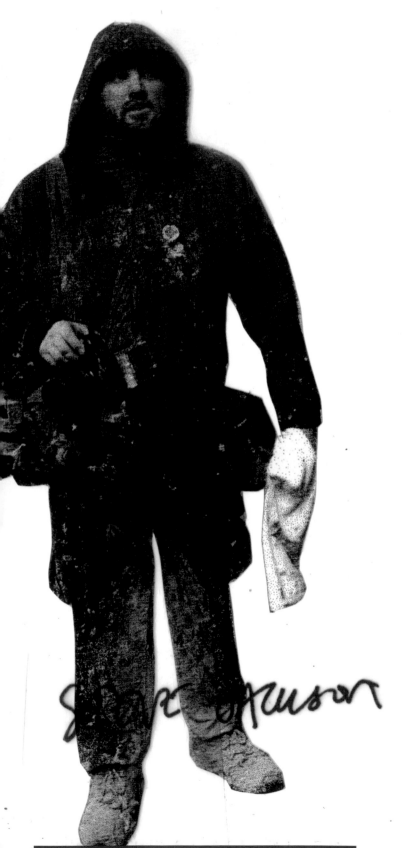

0.9STEVEJACKSONBMX/MOTOCROSS**X**PERT

MOTOCROSS IS A SPORT WHERE THE BOUNDARIES OF WHAT IS PHYSICALLY POSSIBLE ARE STILL BEING PUSHED FORWARD AS RIDING SKILLS IMPROVE AND THE BIKES BECOME LIGHTER AND MORE POWERFUL

0.9 STEVE JACKSON

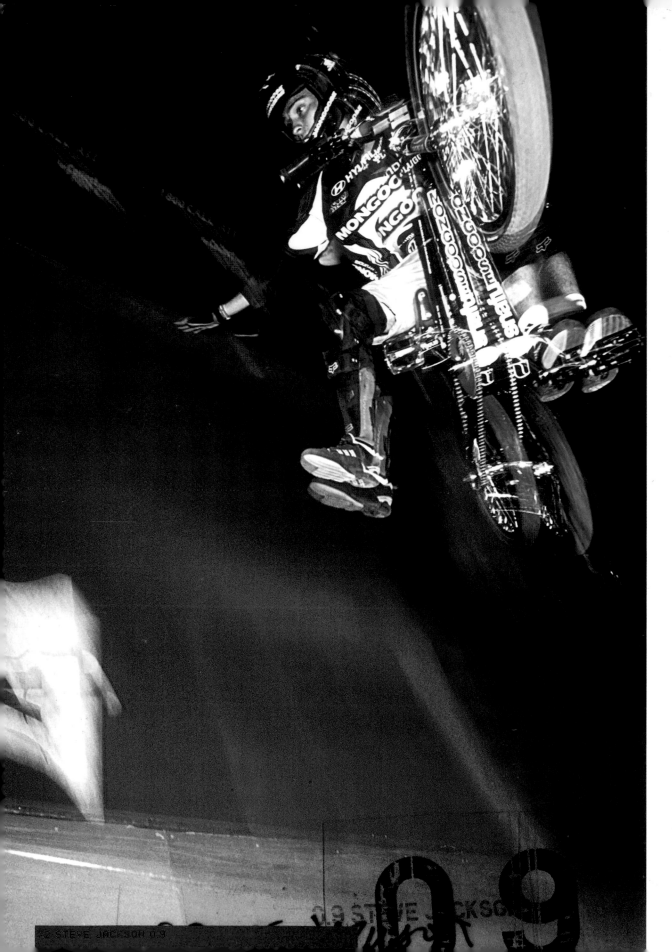

There are new ways in which riders push their machines, and xtreme motocross riders performing in Supercross and freestyle motocross have drawn inspiration from sports such as snowboarding BMX, as well as the more closely related BMX.

Steve Jackson has earned a reputation as one of the world's best motocross photography specialists. He is a senior photographer with the world's leading motocross magazine, *Racer X Illustrated*, in the US, and has won a number of European magazine awards. He also shoots for the motocross apparel company Alloy MX, and other manufacturers and motocross companies.

Steve first started taking pictures as a child, and by the time he was a teenager he was already selling BMX images to magazines. On leaving school, he worked in a photo laboratory, gaining useful darkroom experience, and learning from other photographers' mistakes, but his main interest was to be out there behind the camera. "I discovered photography by accident on a boating trip on the Thames way back when I was about nine. I picked up my mom's friend's camera, an old Canon SLR, and without her knowledge I shot some pictures of passing scenery. I didn't think anything of it until my mom's friend developed the roll of film and wondered how she had several pictures she couldn't remember shooting. By all accounts they were good pictures, so I borrowed her camera whenever I could and it just grew from there."

LEFT
Simon Tabron at the 2001 X Games in Philadelphia, USA.
Details: Canon EOS1 Vhs + ef17.35mm 2.8f lens on Fuji Velvia film, pushed one stop, two Canon 450ez flashes with sync cables, main flash on 2nd curtain sync

RIGHT
Ricky Carmichael at the AMA National, Sacramento, USA
Details: Canon EOS1 Vhs + 300mm f/2.8 lens on Kodak e100vs slide film at 200asa, 1/800 sec at f/4.5

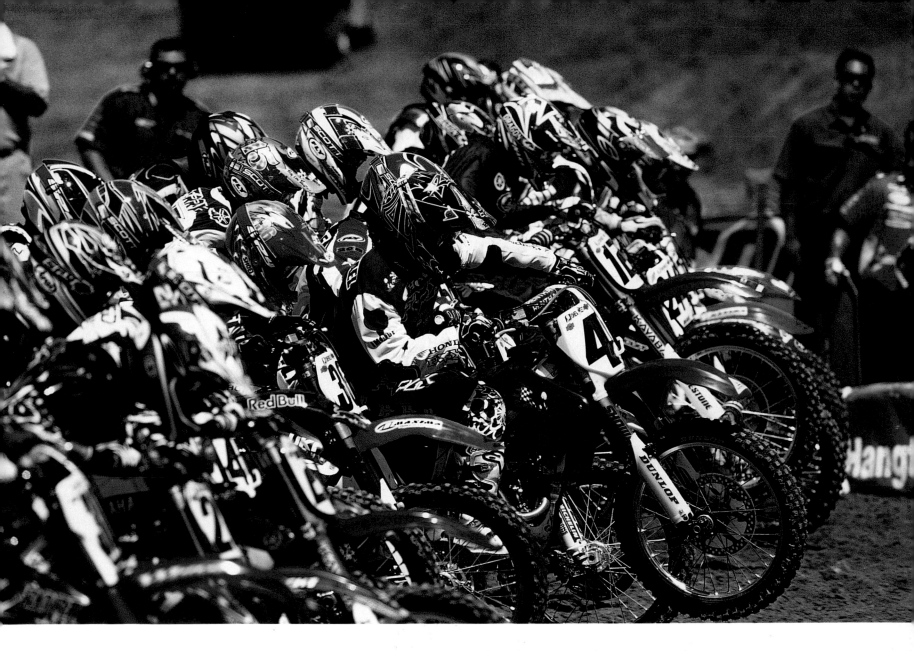

"My photographic interests lie in capturing the whole essence of what I see and hoping that when people see the images, they spark an emotion, whether good or bad. More important though, is that my pictures spark an emotion from me when I look at the slides on the lightbox, reliving those fractions of time."

Two-wheeled sports, including Grand Prix motorcycle racing, are the foundation of Steve's interest in xtreme sports photography such as freestyle motocross, although, like many riders and photographers, he is not a fan of the "extreme" label. "The term 'extreme' can be misinterpreted, so I tend not to use it. I grew up around BMX as a teenager, and this subsequently progressed to my interest in motocross. Although I rode many years ago (and still do now), I often photographed my friends and soon found out that my talent wasn't so much with the bike skills but with the photography. I think this could well be said of many photographers, who are either frustrated 'wannabes,' or fans of the sports they photograph."

"MY PHOTOGRAPHIC INTERESTS LIE IN CAPTURING THE ESSENCE OF WHAT I SEE AND HOPING THAT WHEN PEOPLE SEE THE IMAGES THEY SPARK AN EMOTION."

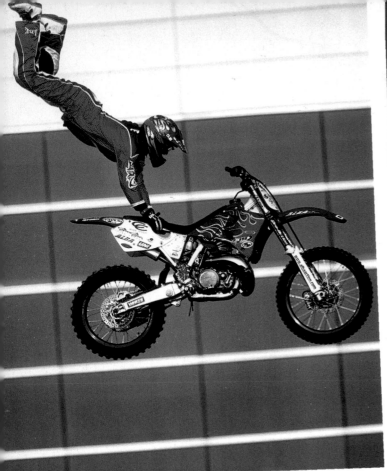

Motocross photography needs split-second timing to capture the best images. In a sport where everything happens very fast, the skill lies in anticipating the peak moment of the trick and being ready to press the shutter at the climax of the sequence.

Steve acknowledges the advantages of autofocus, motor drives, and now digital cameras, but still relishes the discipline of creating great images with simple equipment. "The most important thing is the light. That's what makes the picture for me, and the way I use the light to create the mood. The main challenge of shooting anything is to capture the defining moment. Sometimes manual focus can work in your favor. When Carey Hart performed the world's first-ever back flip in competition several years ago, it was eagerly awaited by both spectators and photographers. I set up my gear, and prefocused on the spot where I expected him to attempt the trick. He made his approach so slowly that I thought he wasn't going to do it, but just test the jump, and then suddenly he was up there doing the stunt and I nearly missed it! I lost the first frames, but then my reactions kicked in and I managed to shoot just in time to get a great image. If I'd been using autofocus, the delay as the lens momentarily searched for the moving figure would have blown it."

"I've recently been shooting with different cameras and different formats, to make me think more about the shot I'm taking and the composition. Old school, no winder, no autofocus, just a fixed focal length lens. Due to the motor drive and the autofocus, unless you make yourself think about what you are doing, it can all become very mediocre and repetitive. For 35mm photography, my choice will always be Canon, and for medium format I use Mamiya and Linhof Technorama rangefinder cameras. I've been experimenting with the

Linhof 6 x 12cm format, and most clients have loved it. With regard to digital photography, some clients have asked me to shoot digitally. I view it just like using a different camera and film stock, nothing more, nothing less."

The appeal of motocross photography lies not only in the speed and drama of the action, but also in the detail. "Motocross riders are among the fittest sportspeople in the world. It takes great agility, flexibility, and overall physical fitness to perform at the highest level. For the photographer, there is all the detailed body language and facial expression that can be brought into the image. Sometimes you are so close to the rider that you feel very involved with the action."

Steve is pragmatic about the business side of photography, and sees a clear divide between producing commercial work and exploring personal work. "Some clients may request a certain style of image that is very mainstream and saleable, and that kind of work helps pay the bills. But the perfect client—and there aren't enough of them—lets me shoot outside of the box, and that's when the fresh, exciting imagery is created. My only ambition in photography is that when I'm gone, my photographs allow my perception of life to live on."

ABOVE LEFT
Clifford Adoptante, X Games silver medallist in 2001.
Details: Canon EOS1 Vhs + 400mm f/2.8 lens on Fuji Velvia slide film at 100asa, 1/1000 sec at f/4.5

ABOVE
Travis Pastrana, X Games gold medallist in 2001.
Details: Canon EOS1 Vhs + 400mm f/2.8 lens on Fuji Velvia slide film at 100asa, 1/1000 sec at f/4.5

RIGHT
Jamie Bestwick showing some old school big "Indian air" at the Gravity Games.
Details: Canon EOS1n + ef17.35mm 2.8f lens on Fuji Velvia film, pushed one stop, 2 Canon 450ez flashes

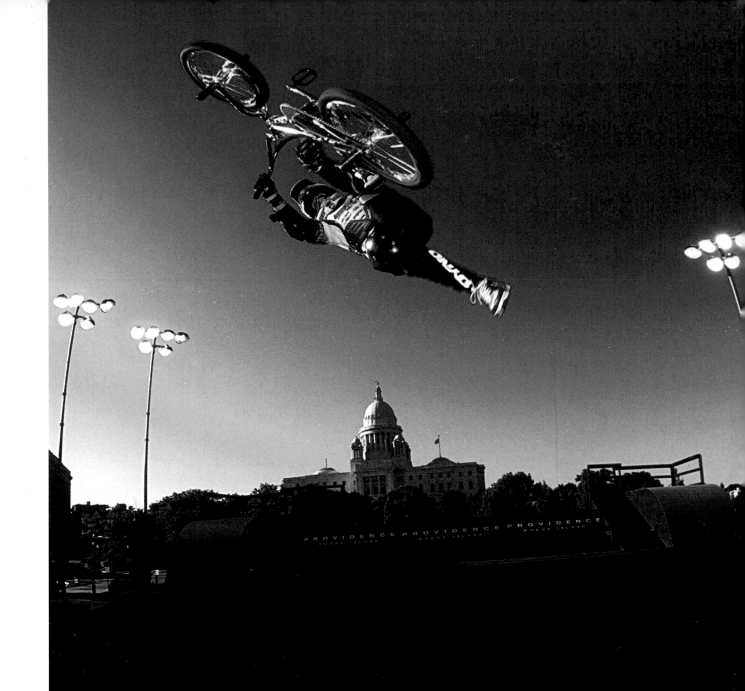

1.0 TIM McKENNA SURFING XPERT

EVER SINCE THE OUTSIDE WORLD HEARD ABOUT THE ISLANDS OF THE SOUTH PACIFIC OCEAN IN THE EIGHTEENTH CENTURY, THE REGION HAS EPITOMIZED THE IDYLLIC TROPICAL PARADISE DREAMED OF BY THOSE LIVING FAR AWAY IN COOL NORTHERN CLIMATES. TIM MCKENNA HAS MADE HIS HOME HERE, ON THE ISLAND OF TAHITI IN FRENCH POLYNESIA

1.0 TIM McKENNA

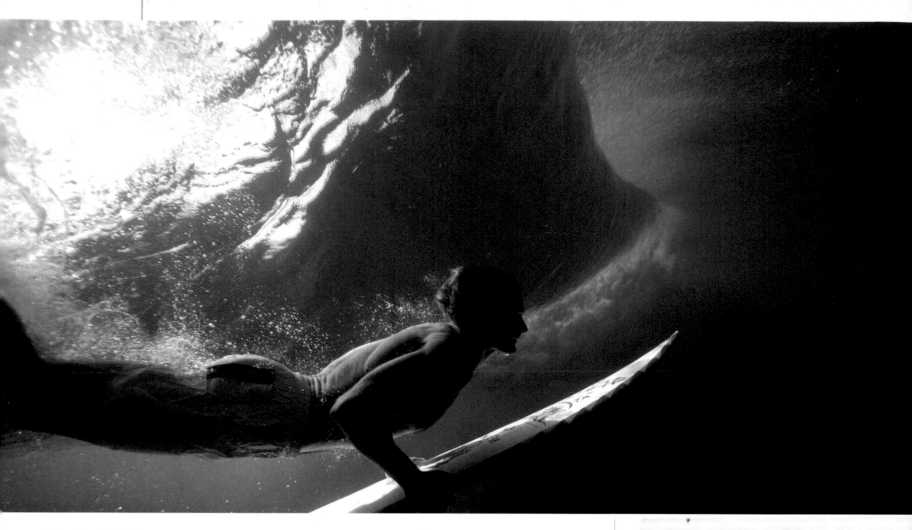

An Australian by birth, Tim spent part of his childhood in France before studying at the University of Queensland. "I choose to live in Tahiti because of the sheer beauty of all these islands, the friendly people and the rich, nature-orientated culture. The lifestyle in French Polynesia is very closely connected to nature. We are in the midst of tropical mountains, and surrounded by the ocean. If necessary, you could just survive off the ocean and your garden. French Polynesia has more than 100 islands that are all different, spanning an area as big as Europe. As an Australian with a French education, Tahiti is the perfect place for me to live in harmony with both cultures. It is also a good base for my usual photographic destinations: Hawaii, Indonesia, and Australia."

Tim started taking skiing and surfing photographs on vacations as a teenager. Although he was unaware of it at the time, these were the foundations for a successful career in photography. "At 18 I stayed in California with my uncle, who was a location scout, and picked up some valuable experience working as an assistant for fashion and advertising photographers, as well as being a production assistant on film commercials. Although I decided to continue my studies, I would still take pictures at weekends and on vacations. I started sending photos to magazines and companies, and as soon as I had enough contacts I decided to take up photography professionally. My main interests are xtreme sports like surfing, snowboarding, windsurfing, and kitesurfing. Whether it's the action photos or the fashion and lifestyle shots that go with them, I also like to do scenic, aerial, and underwater photography in the exotic locations where I regularly travel."

Tim has traveled in more than 30 countries, working with top athletes such as the climber Patrick Edlinger and the surfer Laird Hamilton [pictured above], and gaining a reputation as one of the best outdoor photographers in the world. The locations he has worked in range from the summit of Cotopaxi in the Andes, to the huge ocean waves of Tahiti and the freezing deserts of Mongolia. Tim's action shots have appeared on the covers of surf, snowboard, windsurf, and motocross magazines, while his landscape and fashion work has been used for advertising campaigns, posters, billboards, books, and websites around the world.

ABOVE
Laird Hamilton, Maara, Tahiti.
Details: Nikon F100 with LWS water housing

ABOVE RIGHT
Waimea Bay, Hawaii.

RIGHT
Teahupoo, Tahiti.

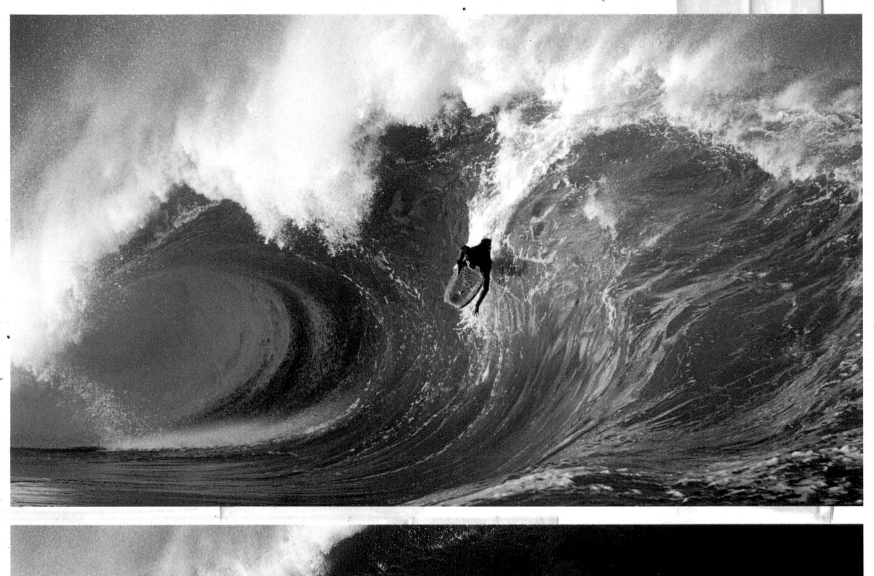

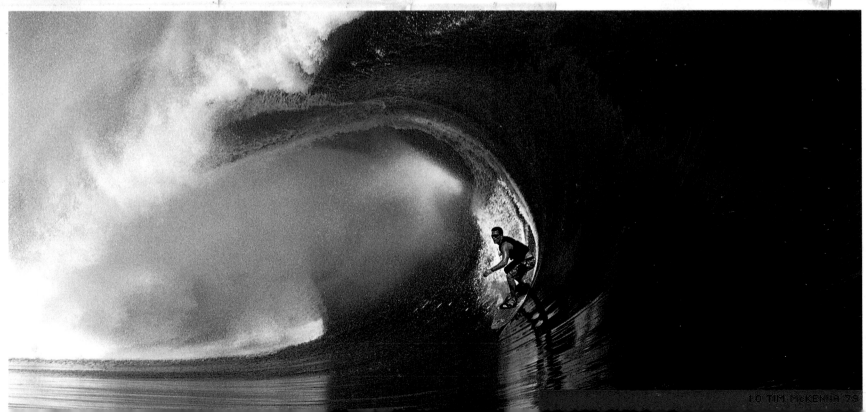

© TIM McKENNA '79

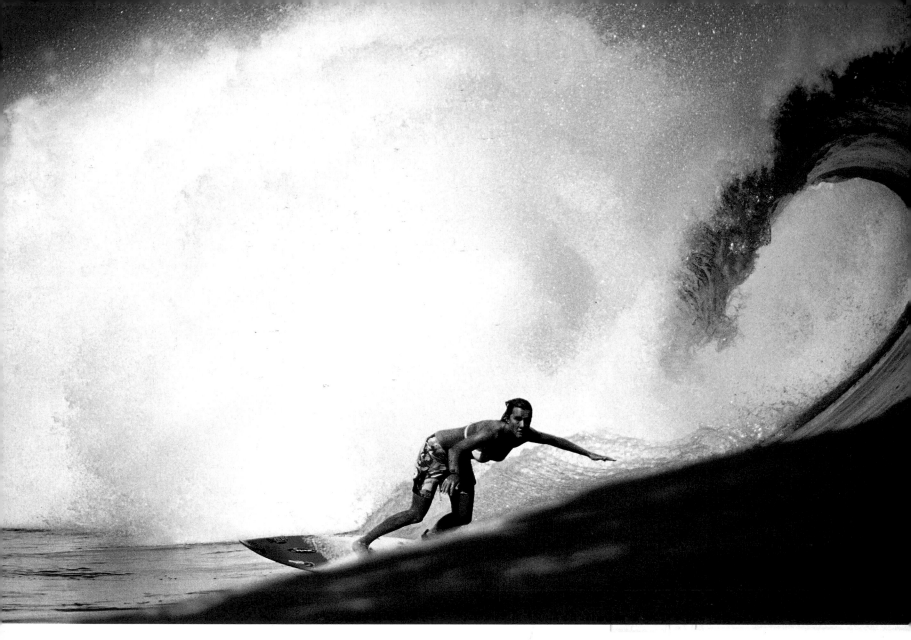

Tim explains how his photography grew from a love of the outdoors. "I started skiing at a very early age, and surfing when I was about 14. The freedom and beauty of the mountains and the ocean are the source of my motivation and photographic interest. The main challenge in my work is to create beautiful images that not only portray the athletes in the best way but also show the beauty of the surroundings. The hardest part is waiting and trying to anticipate the weather, to be ready for the truly great days with perfect waves, masses of fresh powder snow, or strong wind. I work with a lot of equipment to be able to shoot a particular scene or action the right way. I have also done some paragliding, a popular activity in Tahiti as the weather is usually beautiful, the winds are very steady, and the scenery is hard to beat."

Tim's choice of gear reflects the range of his work, from sports to fashion and landscape subjects, using different formats to suit the job. "I use the Nikon F5 and F100 bodies and a wide range of lenses from 16mm fisheye to 400mm. For medium format, I use a Mamiya 7 system, as well as a Fuji 6 x 17cm for panoramic format. Digital photography is still not good enough for outdoor sports, but I will consider digital capture if and when there is a 14 million-pixel camera that can also shoot at nine frames per second."

Serious action sports photography is not without risk. Taking the best images often requires being right there in the environment where the action is taking place, among powerful ocean waves, or in high mountains where there may be dangers such as avalanches. "Being in close contact with oceans and mountains demands a lot of caution and experience. I have hit coral reefs many times and have sometimes been caught in small avalanches. There are many shark encounters in French Polynesia. The sharks are usually more scared of the surfer than the other way round, but you need to be careful about cuts, so the sharks don't get too aggressive. They're mostly medium-sized reef sharks, but we get out of the water if we see certain types like the tiger, lemon, or mako sharks."

The South Pacific is the true home of surfing, dating far back into the mists of time. The ancient heritage of the sport is not lost on Tim, who greatly admires the innate skills of the Polynesian people. "I think the Tahitians are some of the best surfers in the world. Because of their location, they have not been able to get the attention they deserve. One of my objectives is to put the Tahitian athletes in the spotlight of the sports media. Surfing is the ultimate way to be in harmony with nature.

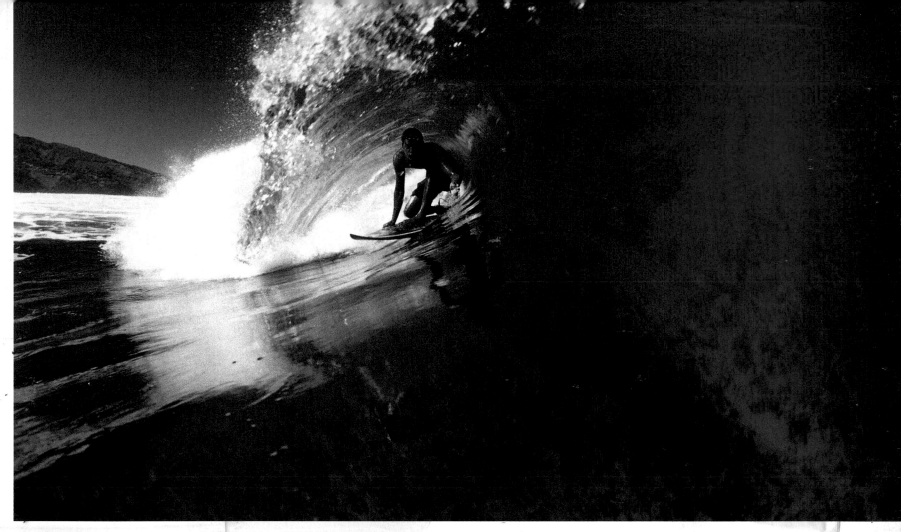

LEFT
Kealla Kennelly, Teahupoo, Tahiti.
Details: Nikon F5 + telephoto lens,
1/300sec at f/2.8

ABOVE
Marama Drollet, Teahupoo, Tahiti.
Details: Nikon F100 + 16 mm fisheye
lens in LWS water housing

RIGHT
Unidentified, Teahupoo, Tahiti.
Details: Nikon F100 + 16 mm fisheye
lens in LWS water housing

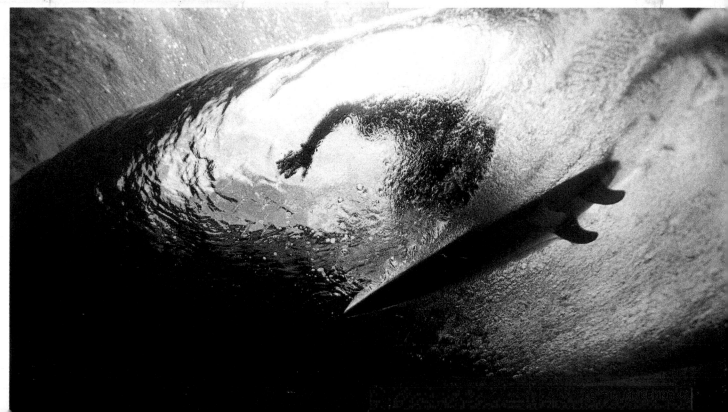

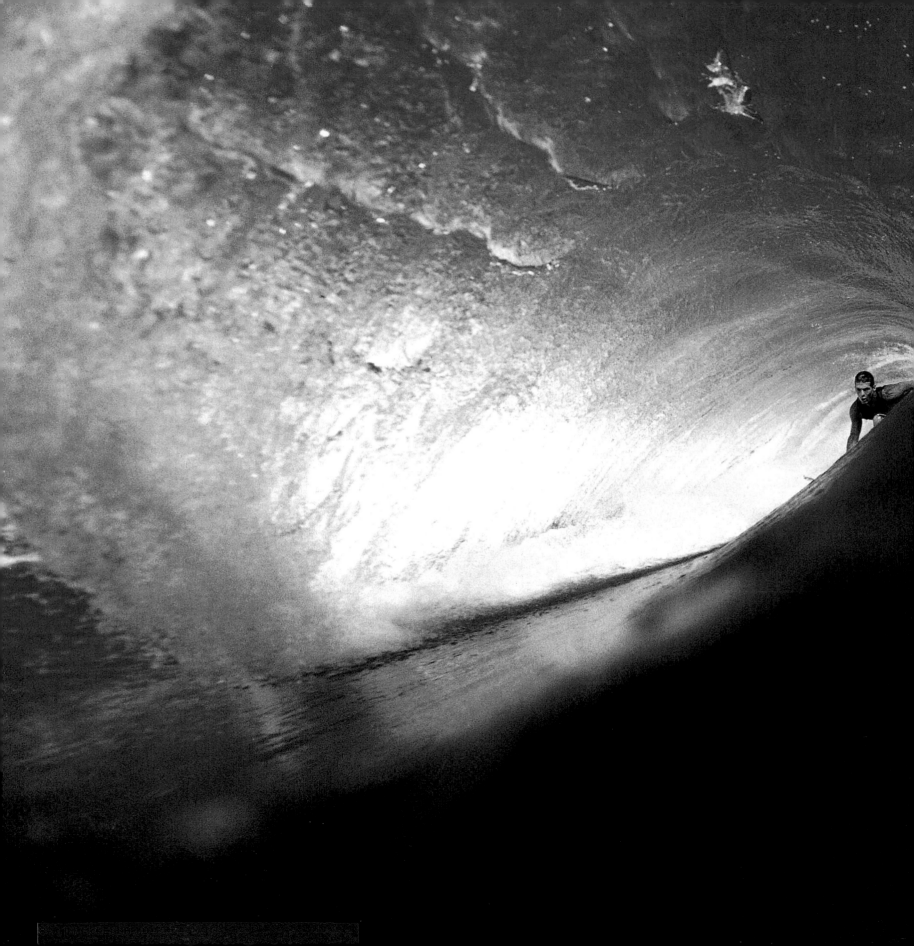

"The feeling of being submerged by the ocean is very relaxing, and the adrenalin rush from getting tubed or just speeding along on a wave is one of life's most enjoyable experiences. The bigger the wave, the bigger the adrenalin rush. Taking pictures of surfing is practically the same for me. Even though the conditions may get too extreme for my level of surfing, they are never too extreme to take pictures.

"Teahupoo is by far the most photogenic wave on the planet. The shape of the reef and its location on the south coast of Tahiti make it a wave magnet for the big swells generated in the Southern Ocean near Antarctica. The coral reef creates a perfect tube that just gets bigger and wider as the swell increases. It forms the most beautiful, but also the most dangerous, waves, and although the ingredients often seem the same, the tube always has a slightly different shape, and the color of the water varies. The sun shines in to the tube for most of the day, providing perfect light conditions."

Surfing photography is a competitive field, and Tim lives in the ideal place to experiment with new techniques and ideas for producing original and innovative imagery. "At the moment, I am working on shooting surfing images from under the water. The clear waters of Tahiti are perfect for creating exciting and different images, but underwater surf photography takes quite a bit of technique refinement. I use regular professional cameras in special customized water housings with a pistol grip underneath that allows me to swim around the impact zone one-handed, using a pair of swim fins. I usually use a fisheye lens to point and shoot within a fraction of a second when the action looks promising. The waves must be very hollow and the water crystal-clear. I anticipate the way the wave is going to break in order to dive under at the right time and position myself close to the surfer. It's better to be inverted to have a clear vision of what is happening. A mistake in the positioning could lead to the wave smashing me on the reef. The surfer or the surfboard fins could also hit me if I'm too close. I am also developing on-board cameras in order to get a more subjective angle on surfing. Another very useful but expensive option for producing different-looking images is to use jet skis, boats, and helicopters to reach hard-to-access areas. Self-publishing is my main ambition in the years to come, as I'd like to be able to showcase the beauty of nature and xtreme sports in the best way possible."

LEFT
Andy Irons, Teahupoo, Tahiti.
**Details: Nikon F100 + 16mm fisheye
lens in LWS water housing**

1.1 JONNASH SAILING XPERT

OCEAN YACHT RACING IS ONE OF THE MOST EXHILARATING AND CHALLENGING OF ALL SPORTS. FROM THE LONELY COMMITMENT OF THE SINGLE–HANDED YACHTSMAN, TO THE FULLY CREWED TEAMS OF THE CORPORATE YACHTS, RACING FOR TENS OF THOUSANDS OF MILES ACROSS SOME OF THE WORLD'S STORMIEST SEAS AND RETURNING HOME SAFELY IS A SUPREME TEST OF SKILL AND DETERMINATION.

1.1
JON NASH

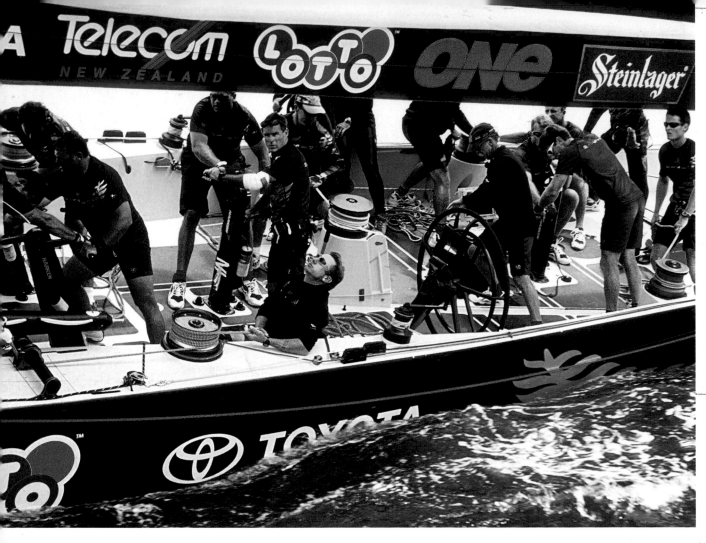

When everything is going well, nothing can beat the sensation of sailing fast in a big sea. On the other hand, there are few environments more unforgiving than the Southern Ocean, with its relentless storms and mountainous waves, where any boat can be at the mercy of the elements.

Jon Nash has sailed all over the world with his cameras, and his quest for adventure has led to a spectacular evolution from a job printing wedding pictures to photographing the world's greatest yacht races. "From a very young age, I was always intrigued by adventure documentaries about river rafting or mountain climbing or skydiving. I longed to go on exotic expeditions to far-away places. At the age of 17, I spent a year with a wedding and portrait photographer and then decided to go to South Africa to photograph the apartheid system. I naively thought that my pictures could make a difference, but the reality was that I got into trouble with the police and ended up making a hasty retreat from the country. My next position was with a still-life furniture room set photographer. A year later, I was working on cruise ships in the Caribbean—hardly a great career move, but one of the best years of my life. The photography was simple but hard work, the money was poor, and seeking something more adventurous, I decided to leave the ship on Antigua. The captain told me that this would be a good spot to join one of the many yachts heading back to the Mediterranean. I had $175 and no sailing experience."

With the optimism of youth, Jon set foot on the adventurous path he craved, and soon found that fortune favors the bold. "The first night, I slept in a bush and spent the second day walking the docks asking for work. By sheer chance, I met an elderly Englishman from my hometown, on a solo round-the-world voyage. He agreed to help me out, and offered me a bunk while he was in port, in return for some help with running repairs to his boat. He taught me some basic sailing, and a week later luck came knocking at my door again, when a Danish boat was looking for another crew member. I embarked on a steep learning curve and six weeks later arrived in England after achieving my lifetime's ambition of sailing the Atlantic. We had weathered huge storms in what I later realized was a very old boat and an inexperienced crew. I had taken a few pictures that were published in a sailing magazine, and from that moment on, I have never looked back."

This experience gave Jon the confidence to try to become a professional freelance sailing photographer. "I went on to sail at a higher level, flying out to the world's prestigious sailing events to shoot action images, and spending a few years working for one of the world's largest sailing and marine sports photo libraries. While covering a round-the-world yacht race, I found myself one night in a bar in Rio de Janeiro talking to Sir Chay Blyth, organizer of the world's toughest yacht race. Apparently it was too tough for some of the crew and they had dropped out.

LEFT
The prestigious Americas Cup regatta. "This shot was taken just before the start of the race while the team were warming up near to my chase boat. It's unusual to get this close during a race. Whilst other photographers were snoozing and not expecting any action for another 15 minutes, I was able to get this shot. The boat went on to win the regatta, which was an added bonus."
Details: Eos 1N + 80–210mm f/2.8 lens on Fuji Velvia, 1/500sec at f/5.6

RIGHT
A crew member onboard the Pelagic, a 67ft sailing expedition yacht on a photo assignment on the Antarctic peninsula. "The ice cave was formed on a massive iceberg that was taller than our mast. I took the image from a small inflatable boat. Keeping the batteries and camera warm in such cold conditions was a concern. Condensation would often form on the lens if the camera came from the warmth of the boat to sub-zero conditions. Batteries run out much faster in cold climates, so I took hundreds with me for back-up."
Details: Canon Eos 1N + 80–210mm f/2.8 lens on Fuji Velvia, 1/400sec at f/5

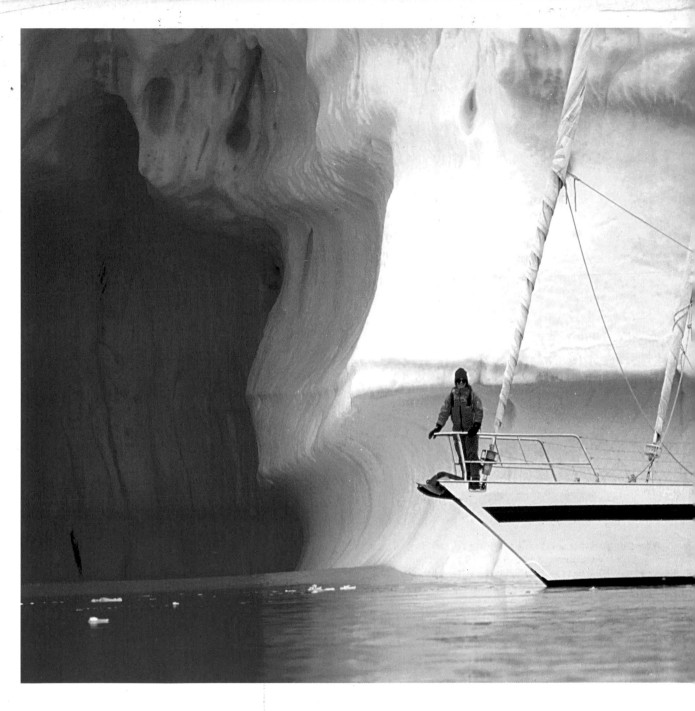

"I agreed to join the next stage of the race aboard a 67ft yacht, subsequently spending 42 days with 15 strangers, crossing the world's most inhospitable ocean. We sailed down the coast of Brazil and Argentina to Cape Horn, then turned right into the prevailing westerly winds of the Southern Ocean, sailing past icebergs and enduring freezing winds, sometimes in excess of 60 knots. I ruined two Canon EOS 1 bodies and although the photographic challenge was immense, I derived a huge amount of satisfaction from the voyage."

As with any sports photography, innovation, creativity, and technical skill are the qualities needed to produce outstanding work. Jon describes what it takes to produce good sailing images. "Searching for a new angle in yachting photography is a constant challenge. Just when I think I've shot a boat from all angles, whether it's from the top of a mast or hanging off the spinnaker pole, dangling from a chopper or getting a fish's perspective from the water, a new angle is discovered. Working on water, it's vital to protect camera gear from the elements. I have tried housings in the past, but find them too restrictive. It's easier to keep the bulk of the equipment in a large cool box, with a hinged lid allowing quick, easy access to change lenses. Knowing the sea conditions and reading the water helps me to anticipate any waves that are making a beeline for my equipment."

Ocean racing is not always about surviving epic storms and fighting the elements. There can be lot of time spent waiting for the right conditions, and carefully liaising with the yacht crews in order to be in the best position to shoot. "Waiting for the wind is something I have got used to over the years."

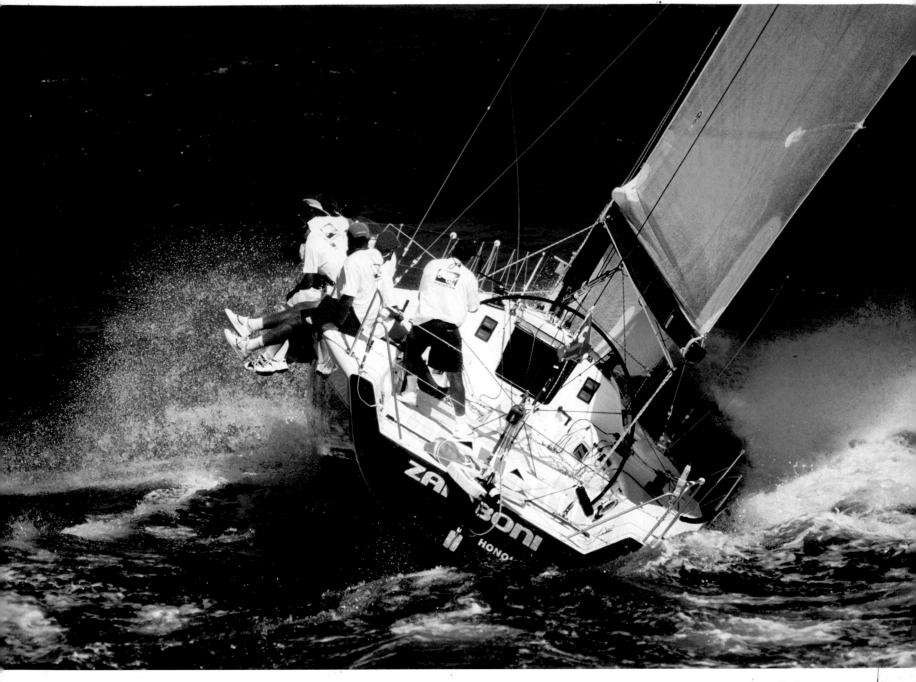

ABOVE
"This shot was taken from a helicopter during a sailing regatta in Hawaii. I got the pilot to position me at a constant pace behind the yacht at a very low angle off the water whilst we flew sideways. I shot out of the side whilst trying to time the shot with the perfect wave pattern."
Details: Canon Eos 1HS + 500mm lens on Fuji Velvia rated at ISO 64, 640sec at f/4.5

"WAITING FOR THE WIND IS SOMETHING I HAVE GOT USED TO OVER THE YEARS."

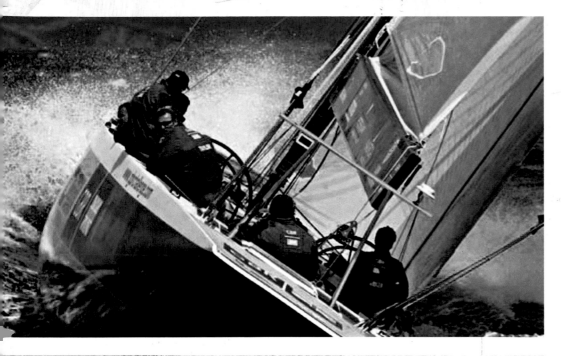

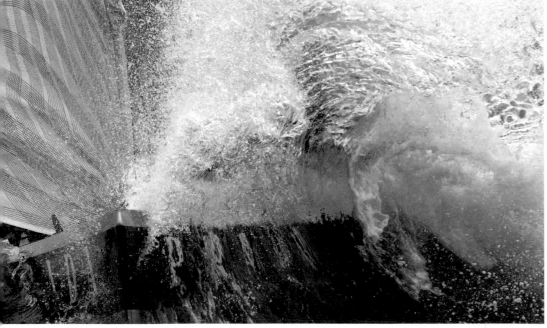

"The past two Americas Cup events in Auckland, New Zealand, have been held in particularly fickle conditions. The wind can blow from any direction with no reliable advance warning, and that's if it blows at all. There are few positions from which to photograph yachts under racing conditions without interfering too much with the race. I really enjoy being able to control a shoot and direct the team to get the shots I want, but I can only do this from within the team while working on training days. Knowing the sport and being competent on board a boat means I am able to gain the respect and confidence of the crew."

Jon has explored digital photography, but feels there is some way to go before film is discarded in favor of digital capture. "My first major digital camera purchase was a Canon D200. I found it frustrating during some events, knowing that the client and news services demanded a fast turnaround of images, but I was shooting relatively small files of around 6MB, which was all the camera was capable of. This was fine for newspapers and the Internet, but it posed a problem when magazines and advertising clients wanted to reproduce the shots at larger sizes. Although I was a pioneer of digital photography in the yachting industry, it was with some reluctance that I accepted the medium. However, I accept that there are many advantages in digital capture, and I'm sure it will become an accepted industry standard."

Sailing photography continues to enthrall Jon, and his motivation and enthusiasm are undiminished. "I'm still hungry for the breathtaking images that show sailing at its best. It's a sport that brings together so many elements: color, action, danger, and risk in sometimes unpredictable conditions. When I combine all the unique elements of a shot with split-second precision, it can result in a hugely rewarding image, and make all those days bobbing around waiting for the wind seem worth it."

TOP
Team GBR training for the Americas cup race in Auckland, New Zealand. "The beauty of working as an official team photographer is that I can get shots that other photographers don't have access to. I managed to orchestrate this shot and instructed the skipper to sail on a course that suited me for light and wind. I would never have been able to achieve this angle during a race, as I would be kept too far away by the race officials."
Details: Canon Eos 1N + 500mm f.4.5 lens on Fuji Velvia, 1/800sec at f/4.5

ABOVE
"Everyone who sees this shot is amazed at how close I must have been to take it. In fact I was a considerable distance from the boat, using the equivalent of a lens with a 900mm focal length. The drama and detail of the shot speaks for itself. It was taken on a fairly flat sea with one rogue wave that created this large bow wave."
Details: Canon Eos 2000 digital body + 300mm lens with 2x teleconverter. The digital camera adds a further 1.4 magnification to the frame

DEAN O'FLAHERTY

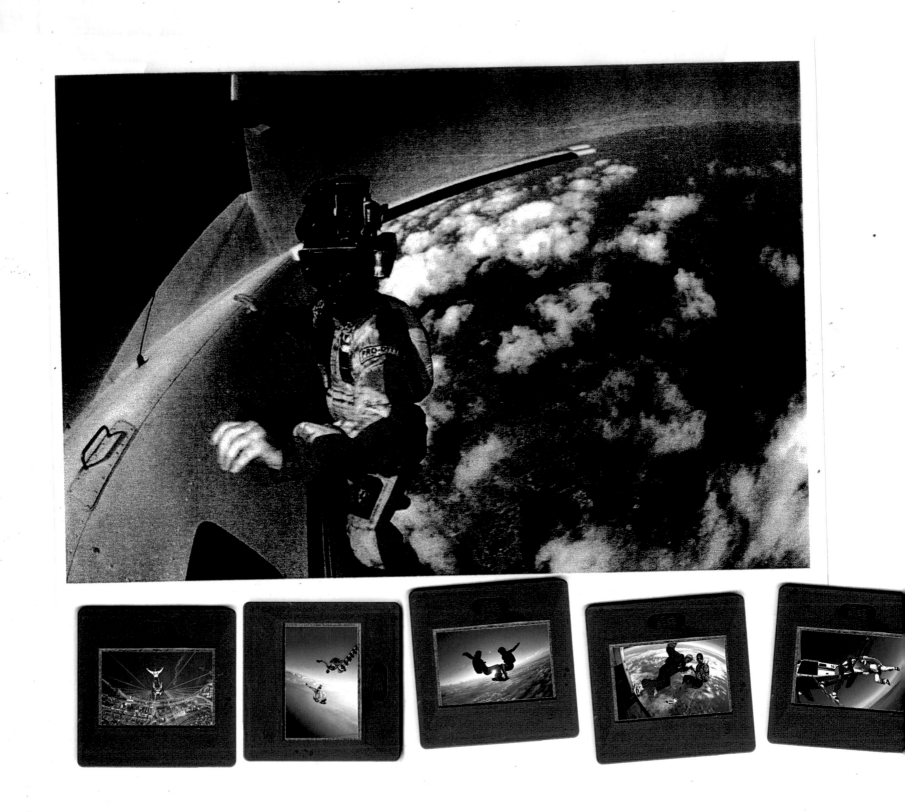

1.1 DEAN O'FLAHERTY SKYDIVING XPERT

SKYDIVING IS A SPECTACULAR SPORT THAT INVOLVES PLUMMETING EARTHWARD AT 120 MILES PER HOUR BEFORE DEPLOYING A PARACHUTE AND GENTLY LANDING ON THE GROUND. IT IS AN EXTREMELY POPULAR AND RELATIVELY SAFE SPORT—SOME WOULD SAY SAFER THAN DRIVING A CAR—AND IT HAS BEEN THE INSPIRATION FOR SPORTS LIKE SKYSURFING AND BASE JUMPING

1.2 DEAN O'FLAHERTY

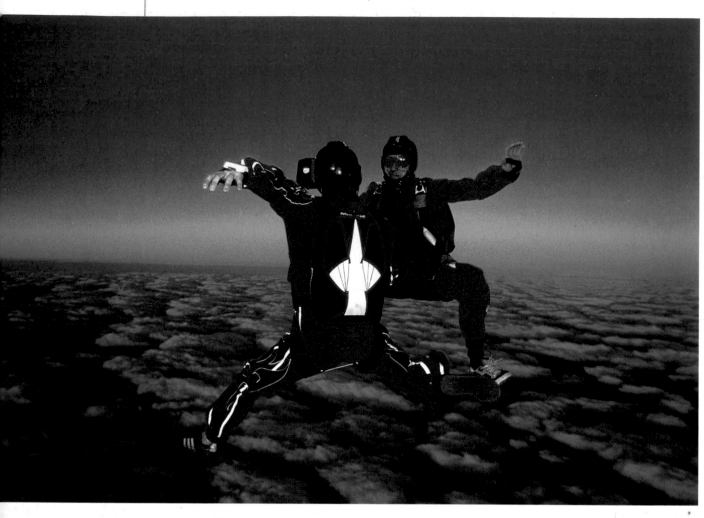

It was in only 1948 that the Frenchman Leo Valentin developed the technique for stabilized freefall, paving the way for skydiving as a sport.

Dean O'Flaherty is a professional skydiver with more than 10,500 skydives to his credit. He works as a skydiving photographer and videographer, tandem master, and accelerated freefall instructor. He also coaches freeflying and skysurfing. His photographs have appeared in magazines and books all over the world and his video work has been used for many television shows and news reports.

"In 1989 I made my first parachute jump. At 2,000ft (600m) on a static line and a round parachute, it was not exactly skydiving, but I was hooked. After a few trips to the USA, I decided I needed to live there if I ever wanted to get anywhere in skydiving. The weather is better, skydiving is more active and it's also cheaper."

Dean moved to the USA in 1993, and focused on becoming a professional skydiver. "I worked packing parachutes and spent all my earnings on skydiving. Then I purchased a video camera and started filming competition formation teams.

This is where I learned the basics of flying a camera. The camera is mounted on my head and I frame the shots via a Newton ring sight, which is lined up with the lens of the camera. You need to fly smooth and precise, flying your whole body and maintaining the correct distance. The next logical step was to add a stills camera, and this is where I fell in love with the photograph. I realized I could look at a photo for longer and feel more rewarded than with a 60-second video of a skydive. Even though the videos are cool, a photo has much more to say."

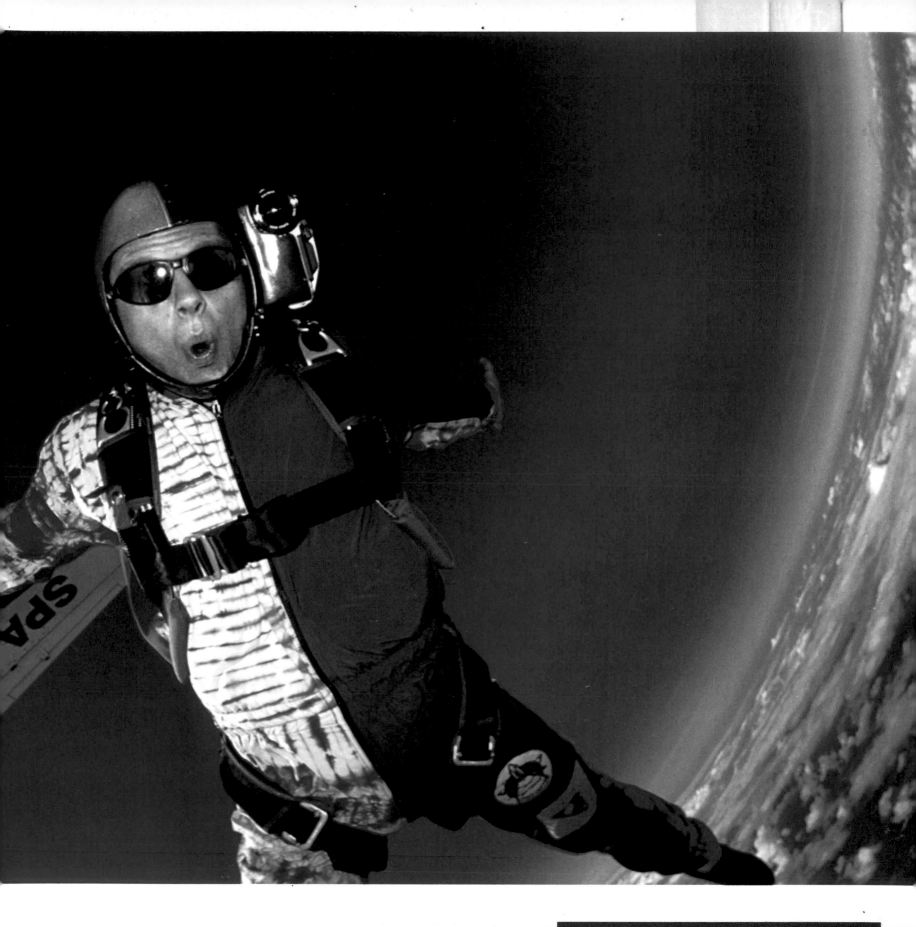

Before long, Dean had thousands of jumps under his belt and had experience of filming teams, students, tandem skydives, large formations, freestyle, skysurf, and freefly. He decided it was time to upgrade and customize his equipment to maximize his productivity on any skydive.

"I decided to make my own camera helmet. After much trial and error, I finally had a design that worked for me, a custom-moulded carbon-fiber helmet that ensured a perfect fit. The platform on the helmet supports many different types of cameras, and now I'm able to mount multiple cameras. It means I can shoot video at the same time as using two Nikon cameras (one vertical and one horizontal) and a flash. Both Nikons can be fired simultaneously with one switch. A button that sits against my lower lip is pressed by lightly pushing my tongue against my lip."

Dean explains the methods and techniques for successful skydiving photography. "You have no control over the light, and on some skydives it feels as if you have no control over your subjects. It could be overcast all of a sudden, or the beautiful sunset you were hoping to get is now blocked by a big cloud on the horizon. At midday in summer, the light can be very harsh, especially at 15,000ft [4,500m]. Low cloud can be a benefit, acting as a fill light when filming up at your subject. Descending at 120–180mph [193–290kmph], the light can change dramatically in 60 seconds, especially at sunset. That's the duration of the average skydive, and that's how much time you have to shoot film. You have to make a plan before the jump, as different times of day require a slightly different approach. I

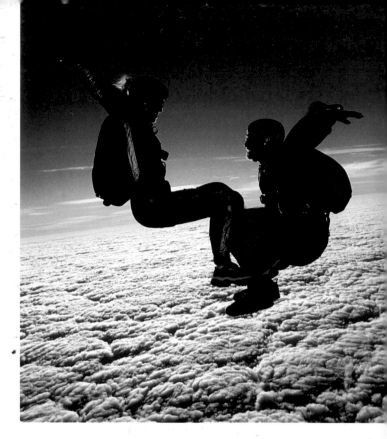

have to decide on the type of film and which lenses to use, whether to use fill-flash, to take one camera or two, decide the distance, and whether I will be shooting into the sun or have the sun behind me. The level of experience of the people I am filming also plays a big part in the equation. And then there's jumpsuit selection, with different jumpsuits for different skydiving disciplines, as well as different types of wings, for flying on my belly or for sit-flying or using maybe no wings at all. The wings allow for rapid changes in fall rate from fast to slow or slow to fast. Everything has to be right before I exit the aircraft, as once I step out I cannot change anything. The rest is up to the elements, my subjects, and my flying skills, which have to be as good as, or better than, those of the people I'm filming."

Dean reads the light in the sky rather like a landscape photographer reads the light on the land. It's constantly changing, and the beginning and end of the day often provide the most interesting conditions. "I really like to shoot sunrises and sunsets as the colors can be so beautiful, and photographing moving subjects in low light can be challenging. Florida has some of the best sunsets and sunrises I have seen, and every one is unique. A little luck and good timing is needed to be in the air at the right time of day and to have good conditions."

Skydiving is Dean's true vocation, and after thousands of jumps, his love for the sport is expressed in his beautiful images and his enjoyment of sharing it with others. "Skydiving allows you to be completely out of your natural

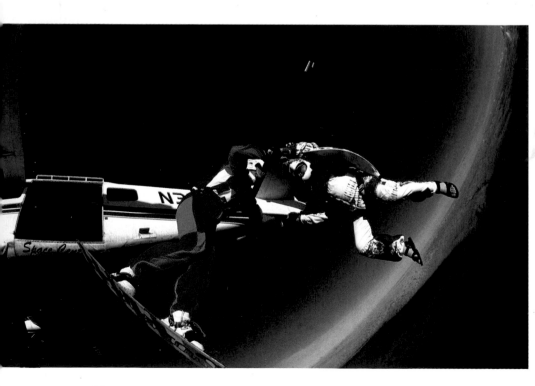

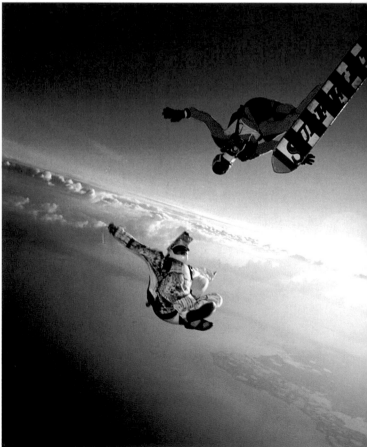

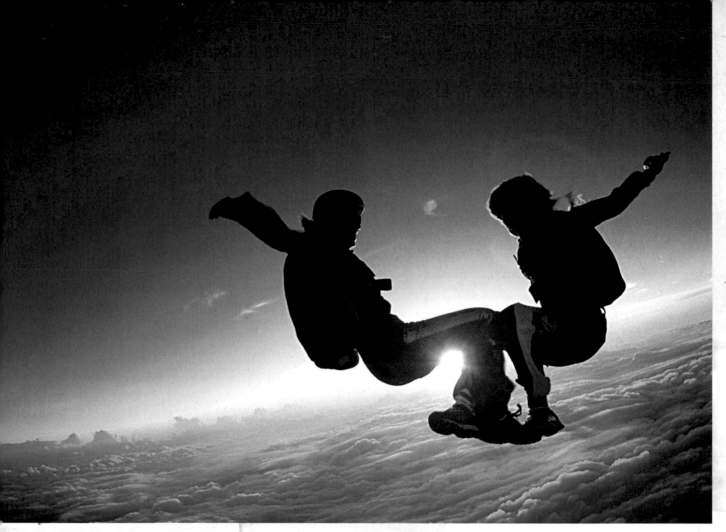

FURTHEST LEFT
Valery Rozov /skysurfer/ and Clif Burch /cameraman/ exit a Cessna caravan over Skydive Space Center in Titusville, Florida. This was taken during a training jump at sunrise for the ESPN extreme games, where they won a gold medal.
Details: Nikon N90s + 16mm fisheye lens and SB26 fill flash on Fuji Provia 250

FAR LEFT TOP
Shanda Sheppard and Allen Rice skydive together in a sit-flying position. The image was taken over Skydive Space Center, Florida with a level cloud-filled sky for the dramatic backdrop. It was close to sunset so I could hide the sun behind the subjects and just slightly fill them in with a flash.
Details: Nikon N90s + 24mm lens and SB-26 fill flash on Fuji Provia 100, 1/250sec at f/11

FAR LEFT BOTTOM
Valery Rosov and Clif Burch training at the ESPN extreme games.
Details: Nikon N90s + vertical mounted 16mm Nikon lens and SB26 fill flash on Fuji Provia 100asa

LEFT
Shanda Sheppard and April Ballard fly together during a beautiful sunset over Skydive Space Center in Titusville, Florida.
Details: Nikon N90s + 16mm Nikon lens and no flash on Fuji Provia 100

element and I love it. You're not just falling, you're flying your body in every conceivable position. The ground is no longer a restriction and the sky is no longer the limit. To fly smoothly through the air, to see others play in the sky, the smiles on their faces and the beautiful light in the sky is fantastic. Capturing it on film is priceless. I love to be able to share these moments with the many people who don't experience the thrill, excitement, and personal rewards that skydiving provides. Skydiving is similar to any sport in the sense that people will always come up with new ideas and push the envelope so that what was once a boundary becomes the norm. There will always be new and exciting things to photograph. On the technical side, I would like to see a camera that shoots 25-megapixel video, so that each frame of video would be a high-resolution image in its own right. You could then film the whole skydive, fire the flash at will, pick out the frame you want and be sure of never missing a shot again or running out of film and memory. I'll be waiting."

Dean's equipment choice is similar to that used by ground-based photographers, but with a preference for wide-angle lenses, and obviously no requirement for a tripod or camera bag. "I shoot a Sony VX1000 digital video camera, which to my amazement still works after over 5,000 jumps. It's been through rain, freezing cold, humidity, and drastic temperature changes; it gets knocked around jump after jump, and still works even though it's mostly held together now with

gaffer tape. I use two Nikon N90S cameras, [known as F90X outside the USA], SB26 flash, and a Quantum turbo Z. For skydiving, I usually shoot Nikon 16mm and 24mm lenses. Wide lenses allow me to be very close to my subjects and minimize the effect of camera shake caused by freefall wind. My films of choice are Fuji Provia 100F and Fuji Velvia 50. I still prefer the look of film compared to digital, but I definitely like digital as it's so convenient. I would like to see more cameras available with the full-size CCDs (i.e. the same size as the film frame) so that my lenses will capture the same image size as film. Of course, higher resolution would be welcome as well as a drop in price, but it's only a matter of time before I switch from film to digital. Currently I scan my slides with the Nikon LS-2000 slide scanner, edit in Adobe Photoshop, and for general printing I use the Epson 2200, which is a great leap forward in print quality."

BEN OSBOURNE

1.3BENOSBORNESAILING**X**PERT
SAILING IN THE ANTARCTIC INVOLVES CROSSING
THE WORLD'S STORMIEST SEAS TO REACH THE
REMOTEST, COLDEST, AND WINDIEST CONTINENT
ON THE PLANET. THE REWARD IS AN ADVENTURE
IN ONE OF THE WORLD'S MOST PRISTINE AND
SPECTACULAR ENVIRONMENTS

1.3

BEN OSBORNE

Ben Osborne has come to know the Antarctic well after repeated visits, initially as a scientist with the British Antarctic Survey (BAS), and later as a professional wildlife photographer.

Ben's interests in sailing and photography both started at school. "I have always enjoyed sailing. You simply have to accept the wind and weather and react accordingly, and it generates a very close link with the natural world."

The opportunity to sail in the Antarctic came by chance, while Ben was in transition from wildlife biologist to photographer. He had been contracted by BAS to take part in an elephant seal survey, working from a specially chartered yacht on the rugged coast of South Georgia, a remote and mountainous island on the edge of the Southern Ocean. "The skipper was the French yachtsman Jerome Poncet, probably the most experienced polar sailor of modern times, with his yacht the Damien II. At the end of the work on South Georgia, Jerome invited me to stay on board and sail with him across the Southern Ocean to Antarctica."

This opportunity led to commissions with *National Geographic* magazine and the British Broadcasting Corporation. "Photography from a yacht in the Antarctic is challenging but extremely rewarding. I also always carry a back-up mechanical Nikon FM2 camera that can be used if my Nikon F5 fails. By modern standards, the FM2 is an archaic piece of technology, but it has never failed me in over 20 years of being thrown around in remote parts of the world. I haven't made the leap into digital cameras yet but will probably do so soon. I am assured that they function well in very cold conditions, although they don't do cliffs so well. I use zoom lenses for convenience and they are especially useful when working 50ft (15m) up a yacht mast, where changing lenses and film is not easy.

RIGHT
"Most images of sailing are taken at deck level. With its tall mast, a yacht provides another perspective: the view from aloft. The Damien 11 has two masts, which provides even more options. This shot was taken as the yacht was driven through pack ice. A skimpy crowsnest provided a platform on which to stand. This position was often used as we navigated the pack because it gave a much better view of the ice ahead than could be achieved from the deck."
Details: Nikon FM2 + 20mm f/2.8 lens on Kodachrome 64, 1/250sec at f/11

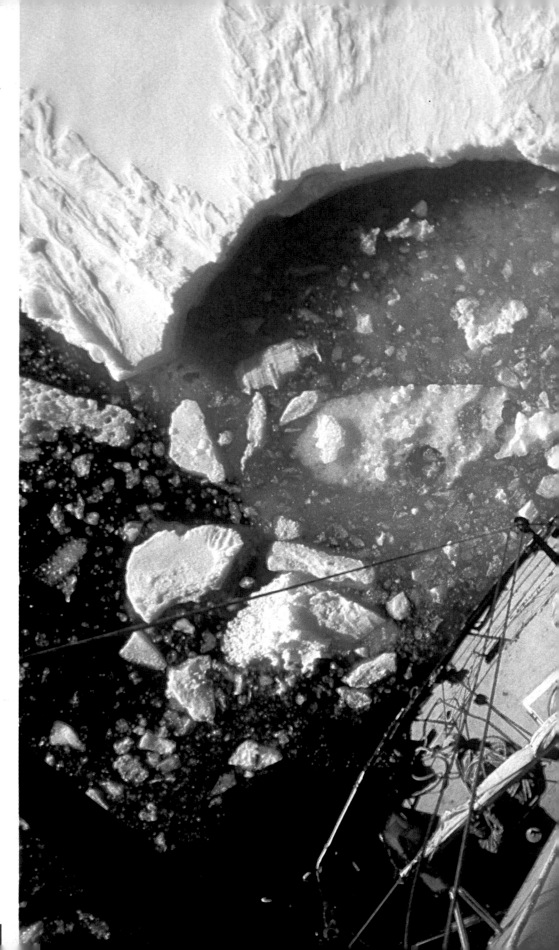

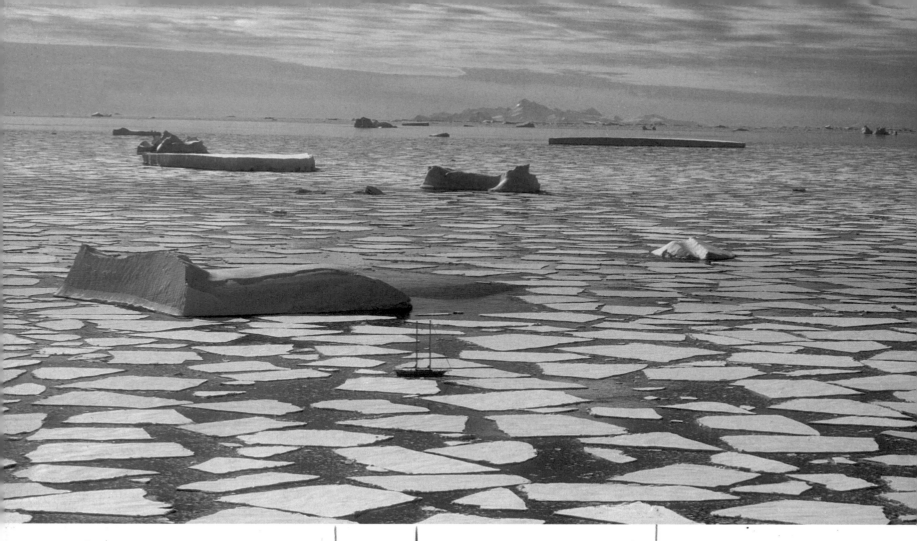

Ben's sailing expeditions in the Antarctic have produced a unique collection of stunning images. Working with an adventurous yachtsman like Jerome led to voyages in remote and spectacular areas that had rarely, if ever, been reached by yacht. "Sailing in ice gets you to the most extraordinary places and there is something special about being in a small boat surrounded by pack ice and icebergs. There is a marvelous quality of light, and in midsummer it never gets really dark. The soft twilight during the night-time hours can be particularly beautiful. An obvious subject is the boat itself, although on a yacht, the rigging, decks, and mast may dominate the picture so you need to create some distance, either by leaving the boat or by climbing the mast. With a wide-angle lens a yacht looks frighteningly small when viewed from the masthead. Leaving the boat gives many more options and I love taking the inflatable out into the ice and creating all kinds of images where the yacht itself is placed in a larger landscape view. A boat provides a dramatic sense of scale and adds an almost contradictory human presence in an otherwise totally wild and natural scene."

Ben has been on expeditions to Antarctica three times with Damien II and twice on larger research vessels, but familiarity with the far south has not diminished its appeal. "It's always a sublime moment to catch the first glimpse of snowcapped mountains on the horizon. Most landfalls imply safety and relaxation after what may have been a long and hard journey. In Antarctica, the excitement of arriving is tempered with the knowledge that every anchorage is only as safe as the ever-changing weather and ice conditions allow. The constant movement of ice, driven by wind or tide, presents many hazards. Both sailing and being at anchor require constant vigilance. Later in the season, as the nights get rapidly darker and the weather worsens, you are woken by a heavy clunking on the yacht's hull and a grinding sound from the bows. That awful sound tells you the ice has blown into the anchorage and is dragging the yacht, probably toward rocks. There are few things less welcome than emerging from a warm sleeping bag into cold, clammy oilskins and crawling out onto the deck in a freezing wind to haul an anchor and shift the boat, before concentrating on moving the boat to a safer place."

ABOVE
"This is one of my favorite Antarctic images (and not just because it featured as a three-page spread in *National Geographic*). After months of traveling, we arrived in the southern reaches of Marguerite Bay and spent a couple of days weaving our way between the ice floes, surveying small, remote islands for signs of life. From one of the islands, we looked back to the yacht, seemingly stranded in a landscape of ice. This is a truly wild and remote place, an atmosphere that is enhanced by the tiny human presence in the middle of the picture."
Details: Nikon FM2 + 85mm lens on Kodachrome 64, 1/250sec at f/8

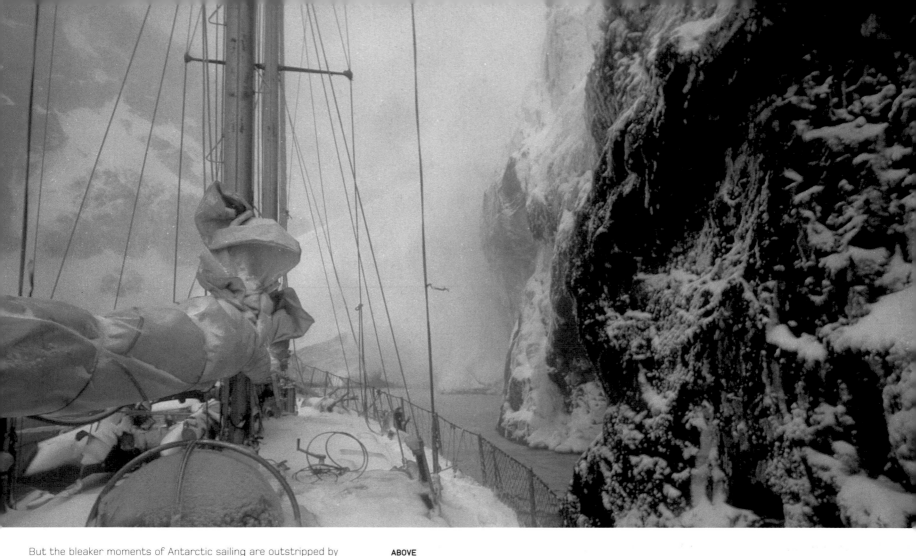

But the bleaker moments of Antarctic sailing are outstripped by the joy of seeing fantastic sunrises in places of overwhelming beauty and grandeur. "In midsummer the best time for photography is late evening, night-time, and early morning. You get into a weird timescale when you travel, eat, and sleep, in any order, at any time of day or night. You spend weeks living in the moment. So there you are, surrounded by huge icebergs, sitting on deck, wrapped up against the cold, a hot chocolate spiked with malt whisky in your hand, musing on the last few hours of traveling through some of the most spectacular ice scenery that you have ever seen. It is 2 am, a good time for calm. But it doesn't last. Almost immediately, the sky starts to change color and soon the sun bursts out from the side of a mountain, cascading golden light. In an instant, the cold twilight is replaced by the burning energy of the sun and the icebergs are glowing in the sunrise. Light, cameras, action! The drink is set aside, the dinghy loaded with camera gear and I'm off, cruising around these floating castles of ice, getting distant glimpses of the yacht as we play hide and seek in the ever-brightening dawn. The isolation is tangible, maneuvering the fragile hulled inflatable through the frozen surface of the cold sea, hoping that the sharp ice doesn't rip the thing to pieces. And losing sight of the yacht for a while as I sit and wait, engine off, contemplating the silence and loneliness."

ABOVE
"Our yacht moored in Larsen Harbor, South Georgia. The island of South Georgia is a superb cruising ground with stunning scenery, a rich and varied wildlife, and good moorings. Larsen Harbor is a breeding site for Weddell seals, which makes a visit to this remote fjord very rewarding. Deep water allows mooring next to a cliff, but overnight snowfall created mini-avalanches onto the deck from the slopes above."
Details: Nikon FM2 + 35–70mm f/2.8 lens on Kodachrome 64, 1/125sec at f/8

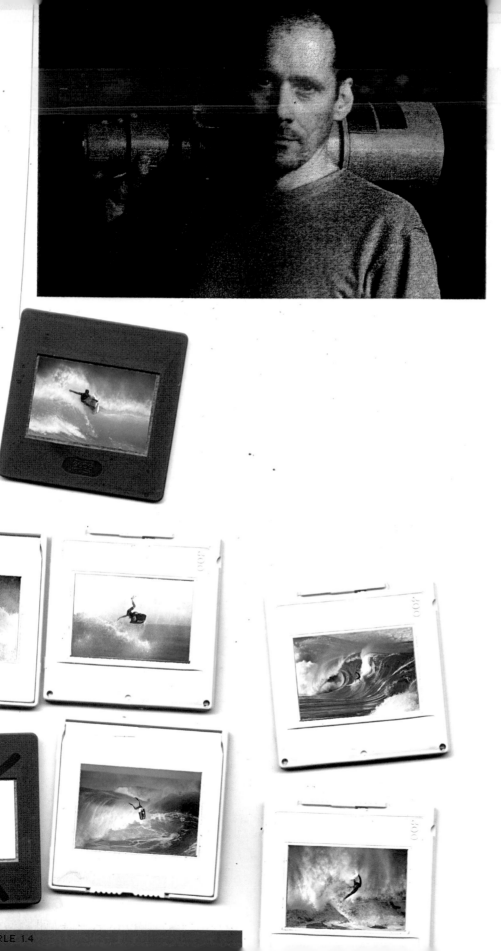

1.4MIKESEARLEBODYBOARDING**X**PERT

AT FIRST GLANCE, THE ANCIENT ART OF BODYBOARDING CAN GIVE THE IMPRESSION OF BEING THE POOR RELATION OF SURFING. THE TRUTH IS THAT BODYBOARDING IS TO SURFING WHAT NORDIC CROSS–COUNTRY SKIING IS TO DOWNHILL SKIING. BOTH BODYBOARDING AND NORDIC SKIING HAVE VERY LONG HISTORIES, AND ARE THE FORERUNNERS OF TODAY'S SPECIALIZED AND VARIED SURFING AND SKIING DISCIPLINES

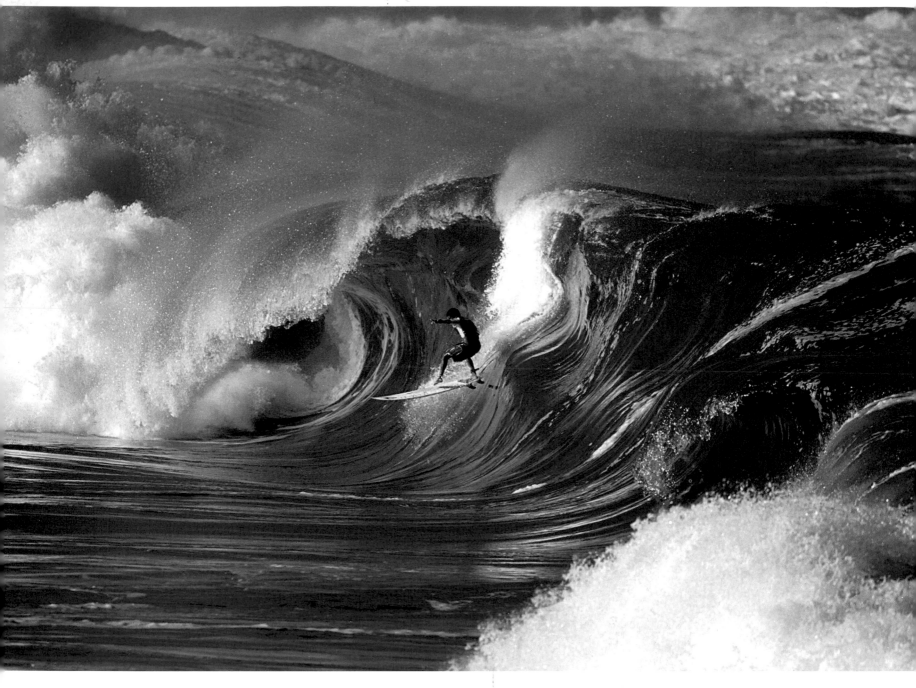

ABOVE
Waimea Shorebreak, North Shore, Oahu, Hawaii. Normally a bodyboarding spot, the occasional suicidal surfer decides to have a go.
Details: Canon EOS 1N + 600mm f/4 lens on Fuji Velvia, 1/1000sec at f/4

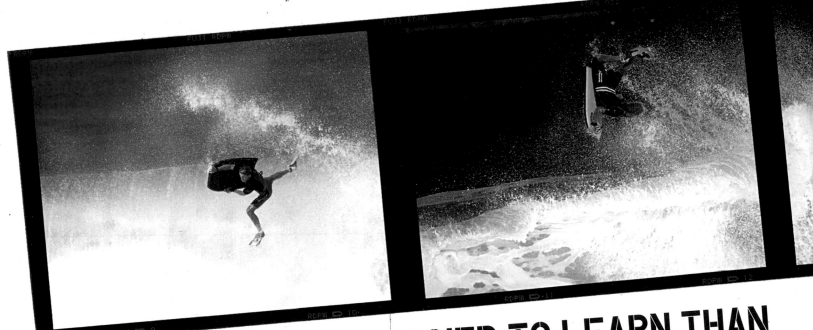

"IT'S EASIER TO LEARN THAN SURFING BUT JUST AS HARD TO MASTER."

For thousands of years, Polynesians rode the waves on pieces of wood, bundles of reeds, palm fronds, or any other object that could plane across the water. Stand-up surfing became popular much later in Hawaii, and spread across the world during the twentieth century.

Bodyboarding photographer Mike Searle explains: "It's easier to learn than surfing, but just as hard to master. Bodyboarders use a shorter, softer board compared with surfers, and lie or kneel on it. Because you are lying down, you can take off on much steeper, gnarlier waves than the average surfer. This means that you can get in the tube quicker and deeper, and bust bigger, more acrobatic airs." Bodyboarding bypasses the technical difficulties of standing up on a surfboard, and so the bodyboarder can immediately focus on learning to ride the waves.

Mike originally worked in marketing in London, whilst escaping most weekends to go bodyboarding in Cornwall. "In 1991 I moved to Cornwall, and my partner and I set up *ThreeSixty*, the UK's first bodyboarding magazine. We didn't have much money, so we did everything ourselves: writing, editing, layouts, and even delivering the magazines to shops. I'd been interested in photography at school so I shot most of the pictures, and I'm basically self-taught. I wasted hundreds of shots in the early days, but I learned from my mistakes. Spending the winter in Hawaii helped; it's a great place to meet other photographers and learn from them. In 1994 we launched *Carve* surfing magazine, and haven't looked back since."

A professional interest in xtreme sports photography evolved from Mike's experience as a bodyboarder. "The photography has to grow out of participation in the sport. You then have a much better feel as a photographer for what's going to happen, as a lot of the skill is anticipating and squeezing the shutter release in that split-second before the action takes place. The main challenge is from nature. I'm totally reliant on swell and weather.

You could go to the most consistent spot on earth, and get a two-week flat spell. Or you can get good surf, but there can be cloud or rain, or the wind's in the wrong direction."

Modern bodyboarding was born in 1971, when Tom Morey, a Californian surfboard-builder was on vacation on Hawaii. Looking out at the surf one day, but with no board to ride, Morey made a small board out of polyethylene foam and found it was surprisingly easy to navigate. He began to produce them for sale. Before long, the demand was huge and by 1977 he was producing 80,000 boards per year as the sport caught on worldwide. In 1979 came the first professional bodyboarding contest. Soon the top bodyboarders were performing spectacular aerials and barrel rolls in Pipeline, the world's premier big-wave barrel in Hawaii. Bodyboarding as a competitive sport has surged forward as riders push the frontiers of what is rideable.

Mike's preference is for a 35mm camera system, using the film beloved of landscape photographers, Fuji Velvia. "I use the Canon EOS 1n and EOS 3 bodies and a range of lenses. The Canon 600L is the main lens for action, with a 135mm for line-ups."

ABOVE LEFT
Jay Reale, Off the Wall, North Shore, Oahu, Hawaii.
Details: Canon EOS 1N + 600mm f/4 lens on Fuji Velvia, 1/1000sec at f/4

ABOVE RIGHT
Off the Wall, North Shore, Oahu, Hawaii.
Details: Canon EOS 1N + 600mm f/4 lens on Fuji Velvia, 1/1000sec at f/4

"I also have a Canon EOS 10D for digital, but only for studio work. I'm not very on keen on digital surf photography. My best results have been achieved with Fuji Velvia, a superb film that seems to enhance the blues in the waves, especially if it's pushed by up to one stop. If it's properly scanned, it reproduces beautifully in print and I just love it. I've tried tweaking digital images in Photoshop, but you just can't replicate the richness, saturation, and contrast that you get with Velvia."

All surfers and bodyboarders are vulnerable to the enormous power of the ocean, but Mike plays down his own experiences. "I'm generally standing on a beach shooting, so short of tripping over a sunbather there's not much danger to me. However, I've seen plenty of blood spilt. The worst incident was on my first trip to Hawaii in 1995. I went to the North Shore of Oahu with the first crew of British bodyboarders to really take on surfing's mecca. I was shooting 6–8ft (1–1.5m) waves at Pipeline one morning. One of the Brits paddled for a meaty one, but he left it too late, the wave jacked up, and the air dropped about 12ft (2m) straight onto the reef, landing head first. The lifeguards helped him out of the water, but he'd basically been scalped and he almost died. They had to use the defibrillator on the way to hospital."

As a magazine publisher, editor, and photographer, Mike is in a good position to assess the direction of surfing photography today, and the way it may evolve in the years ahead. "I think all the angles have pretty much been covered, and with the Internet, hundreds of TV channels, and dozens of magazines, it's become much harder to create something that really catches the imagination. Innovation comes from finding new and more remote places to surf. Surfers and bodyboarders are always searching for the ultimate wave. So if someone finds a new spot, photographers will eventually follow. I don't travel much now, so my main aim is to get the best surfing and bodyboarding images in Britain. The ocean is an ever-changing, dynamic entity, so it will always be possible to create a fresh image."

RIGHT
Danny Wall, Constantine Reef, Cornwall, UK.
Details: Canon EOS 1N + 600mm f/4 lens with 1.4x teleconverter on Fuji Provia 100, 1/1000sec at f/5.6

BELOW
Thomas Richard in an early morning heat of the World Championships. Pipeline, North Shore, Oahu, Hawaii.
Details: Canon EOS 1N + 600mm f/4 lens on Fuji Velvia, 1/800sec at f/4

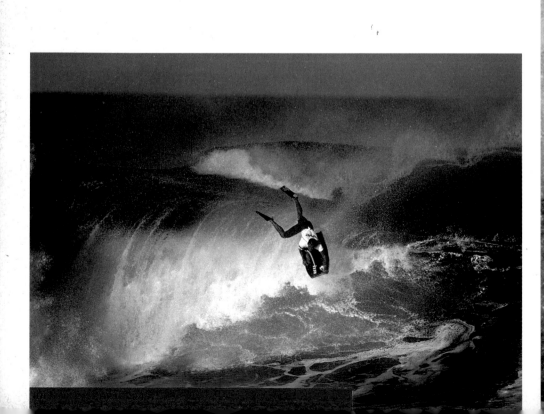

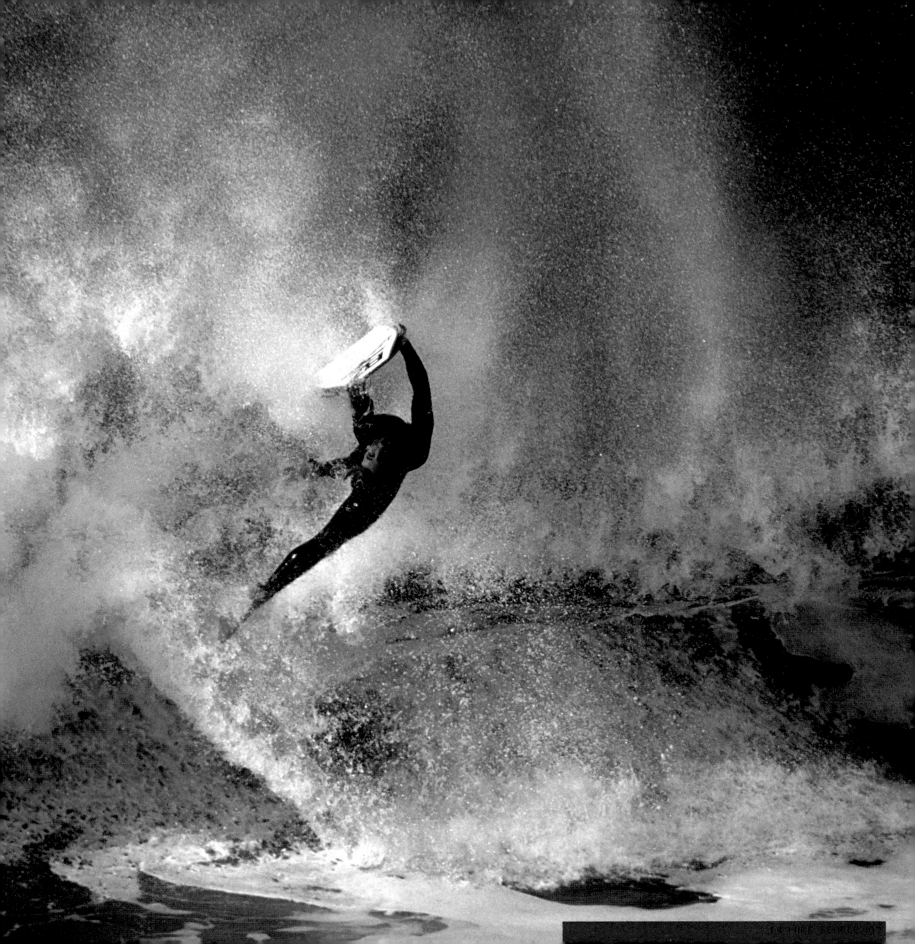

LEO SHARP

1.5LEOSHARPSKATEBOARDING**X**PERT
SKATEBOARDING IS SECOND NATURE TO LEO SHARP. LIKE MANY
EXPONENTS OF THE SO-CALLED XTREME SPORTS, LEO REGARDS
HIS SPORT AS A COMPLETELY NORMAL ACTIVITY, BUT AS ANYONE
WHO HAS EVER VENTURED ON TO A SKATEBOARD FOR THE
FIRST TIME KNOWS, IT IS INFINITELY MORE DIFFICULT THAN IT
LOOKS.

1.5 LEO SHARP

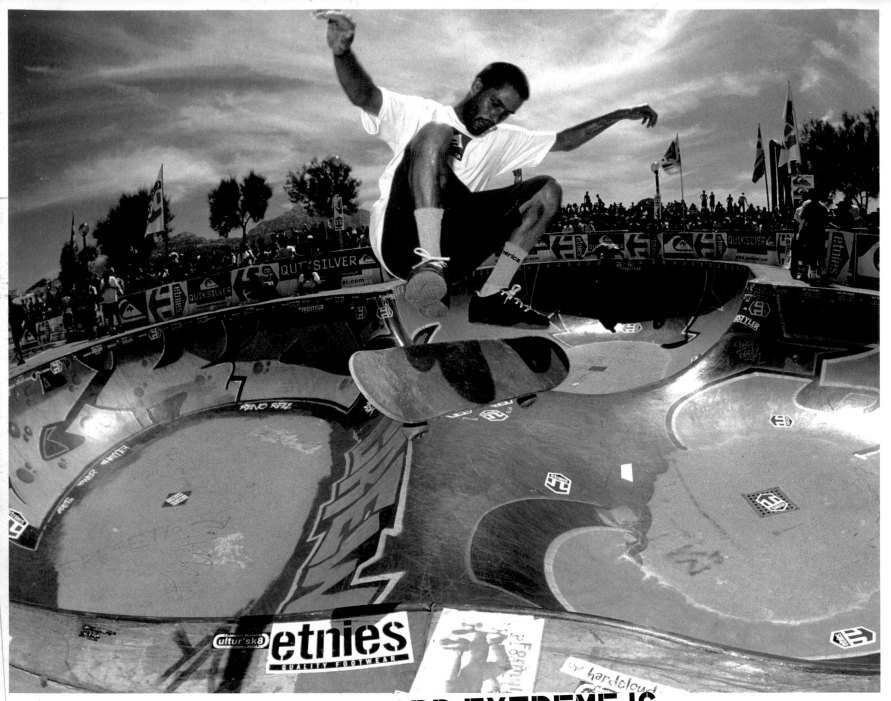

etnies
QUALITY FOOTWEAR

"IF THE USE OF THE WORD EXTREME IS MEANT TO IMPLY SOME SORT OF DANGER, THEN RUGBY IS PROBABLY MORE EXTREME THAN SKATEBOARDING AS PLAYERS GET INJURED IN PRACTICALLY EVERY GAME."

ABOVE
Chris Senn at the bowlriders competition in Marseille, France. "I used a fisheye lens to exaggerate the height of the trick and encapsulate the vibrant color on the concrete."
Details: Kodak E100VS transparency film at f11, one flash

RIGHT
Garry Woodward in Marseille, France. "Framing and height of camera are crucial here. To achieve maximum impact the subject must be set against the blue sky causing the stark outline of board and rider."
Details: 15mm lens, f11, one flash

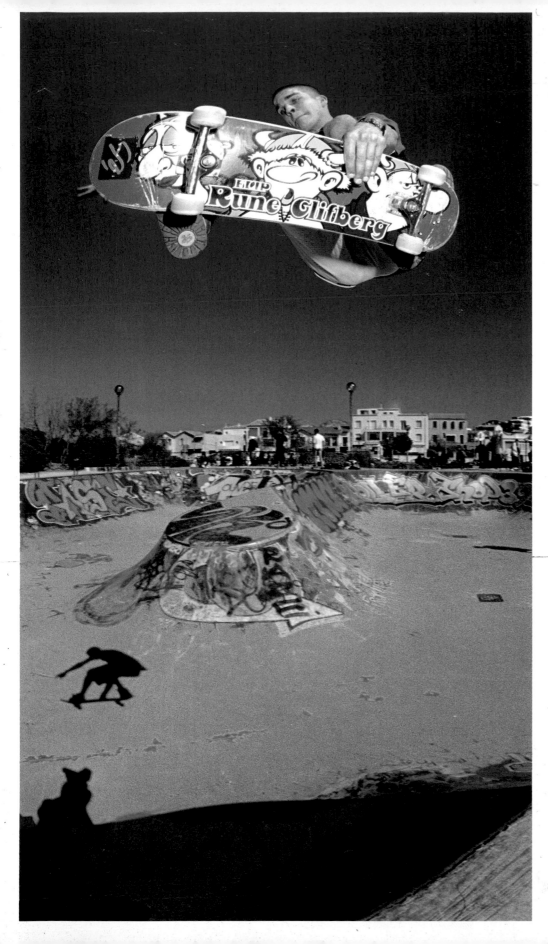

Leo says: "If the use of the word 'extreme' is meant to imply some sort of danger, then rugby is probably more extreme than skateboarding, as players get injured in practically every game. I can't see why nipping down to the shops on your skateboard is in the least bit extreme. That's how skateboarding became my first love: a way of getting around an urban environment. A mode of transport far quicker than walking and a thousand times more fun. To this day, cruising down the street on a skateboard is still one of my favorite things to do."

Skateboarding had a long gestation period for such a quintessentially modern sport. In 1958, the owner of a California surf shop, who saw some kids riding surfboards with wheels attached, developed the idea and started selling "sidewalk surfboards." A new name was coined in 1959, when the Roller Derby Skateboard was introduced. In the USA, the first national skateboard championship took place in 1965, by which time more than 50 million skateboards had been produced.

The initial boom was short-lived since it had attracted bad publicity due to a number of serious accidents. In the early 1970s, the development of an upward curve or "kicktail" at the back and the introduction of polyurethane wheels gave greater control and traction. Then, in 1978 Allan "Ollie" Gelfand discovered that by stamping down on the tail of his skateboard, he could go airborne in a technique now known as an "ollie." This apparently simple maneuver meant that skateboarders could use curbs, rails, benches, and other features of the urban environment. There are now more than 50 million skateboarders worldwide, and the sport is growing faster than ever, moving out of the underground and into the mainstream. It has also directly influenced snowboarding and surfing styles and techniques.

Leo explained how his interests in photography and skateboarding merged. "I grew up in an area with a lot of modern architecture, where my friends and I skated all the time. Each week more steps were ollied, bigger handrails were conquered, and new tricks were invented. But still the emphasis was always on being with friends and having fun. When I wasn't skating, I took photos of people who were. Although most of the work I do these days involves the use of color, black-and-white has always been the medium that most ignites my imagination. I took photography as part of my university degree and assisted various photographers along the way. This provided some valuable technical skills, but I was always keen to go it alone. I try to frequent exhibitions of photographers and artists involving portraiture and urban landscapes. My favorites include Bill Brandt, Lucian Freud, and Eve Arnold. My inspiration is derived daily from the urban world that I work in. Cities always contain the most interesting backgrounds and you never have to search too far."

Leo explained his approach to skateboard photography, and the factors that have to be taken into consideration in creating great images of this spectacular sport. "The biggest challenge in shooting skateboarding in the UK is the weather. This foiled many a shoot and the cold, damp winter evenings are hardly conducive to outdoor pursuits that require at least a dryish surface."

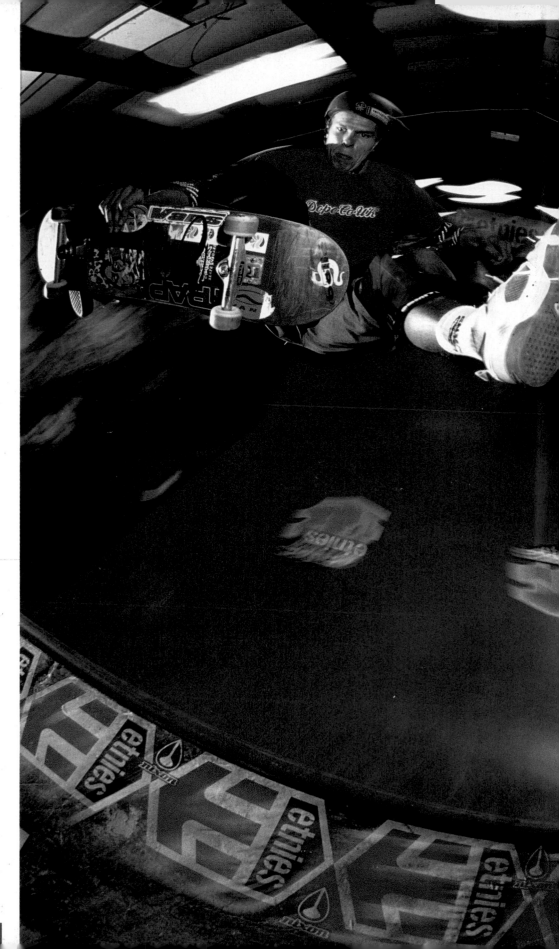

"There is a growing number of indoor skate parks dotted around the UK, but the best shots require some nice-looking architecture. Once you have this, you're half-way there. Next comes composition and choice of angle. Fish-eyes exaggerate the size of an obstacle and create an illusion of enormous height on a trick. But the fish-eye's wide angle can cause some larger steps and rails to appear small, as the low angle required makes the top steps almost disappear. Luckily, there's more than one way to capture an image. It's often difficult to know when to leave the fish-eye in the bag and go long to achieve the most striking image."

Digital capture seems to be a subject on which most photographers are still weighing up the exciting opportunities offered by the new technology, while pondering the limitations that have not yet been fully resolved. Skateboarding is a sport where the pros and cons seem to be more distinctly drawn than in many other fields. "My kit bag has definitely got bigger over the years! As the quality of skate photography has improved, from technical, artistic, and trick viewpoints, the standard kit has increased quite drastically. It used to be just a 35mm body, fish-eye, long lens, and a couple of flashes. These days a lot of people rock medium format, maybe an XPan, and a half frame. Then there's the radio slaves to trigger flash, the Polaroid, extra flashes, power packs, high-power batteries, light stands, and so on—even a generator for those long night missions. Digital stills photography is just beginning to make an impact on skateboarding. Shooting a sequence of images has always been a tough call for skate photographers. If the skater can't make the trick quickly, then wasted film quickly becomes an issue: most high-end 35mm cameras with motor drives can expose film at up to eight frames per second. This is where the newest generation of digital cameras comes in. They have the same motor drive speed without the film wastage issue. But there are a few 'ethical' problems thrown up by this. Before digital, if you saw a stills sequence in a magazine, you knew that whoever was performing the trick landed it within a finite number of attempts."

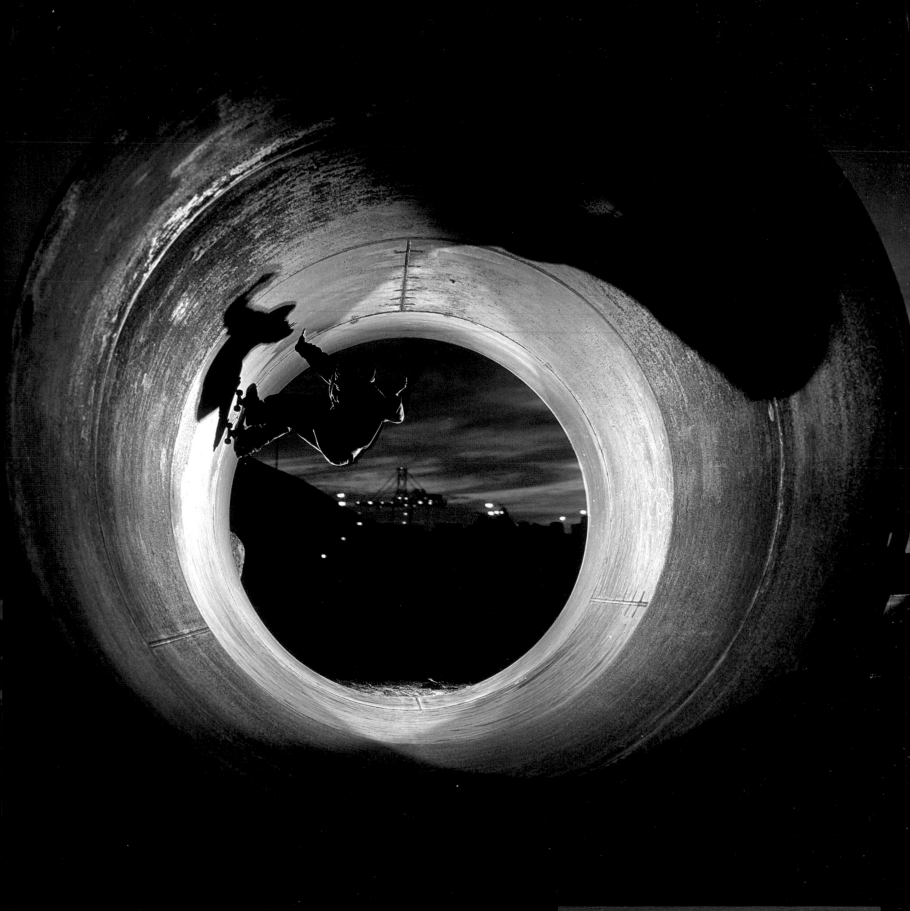

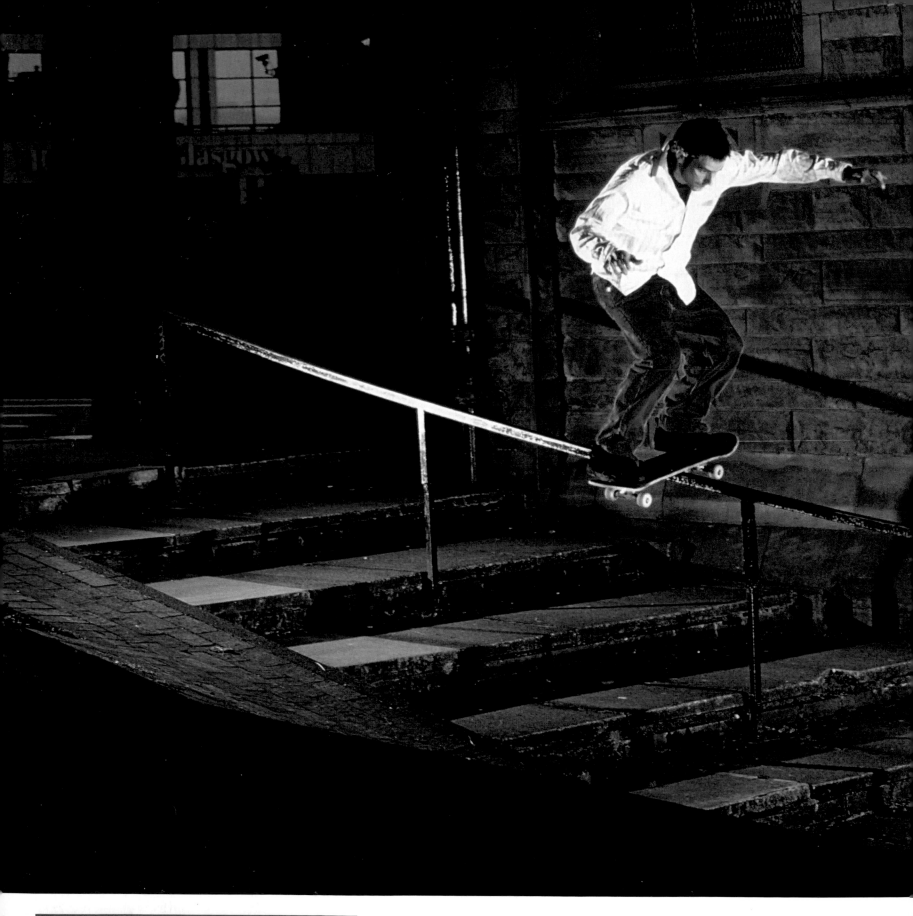

"SKATE PHOTOGRAPHY IS REWARDING ON SO MANY DIFFERENT LEVELS. THE RUSH OF SOMEONE MAKING A TRICK IN FRONT OF YOUR LENS ISN'T A MILLION MILES AWAY FROM LANDING IT YOURSELF."

"The trouble now, however, is that it's just like filming a trick with a video camera. The rider could have tried the same trick for days before landing it. This is okay from my point of view as I used to burn so much film shooting sequences, yet I can see where the purists are coming from. I don't want to shoot the same trick for a week! As far as shooting stills is concerned, I don't think the color saturation, tonal range, and contrast of decent transparency films will be topped by digital cameras for a while. Digital also doesn't seem to handle flash quite as well as film."

Most photographers who shoot xtreme sports are passionate about their creative work, and keen activists in their sport. Leo still loves skateboarding and is constantly on the lookout for new ways of honing his skills and coming up with new ideas. "Skate photography is rewarding on so many different levels. The rush of someone making a trick in front of your lens isn't a million miles away from landing it yourself. As my joints can't take the heavy landings any more, this is a pretty good substitute! Getting to go on so many trips around Europe and further afield is always a bonus. I love to travel anyway—so to combine work and travel is amazing. Although you don't always get to see the sights of a particular town or city because you are there to get photos, an insight is usually gained into that particular place at 'street level.' Skateboarding is always changing, though maybe in more subtle ways these days. As long as there are new and different things to shoot, you can find original ways to shoot them. It's so easy to become stagnant and shoot the same angle and lighting over and over again. Finding a good-looking virgin spot is always a treat. I think there are processes and techniques that may have been tried in other areas of photography, but not yet fully tested and realized in skate photography. I would like to carry on shooting skateboarding as long as I can. Most of my friends skate, so even if I wasn't taking photos I'd be skateboarding anyway."

LEFT
John Rattray. "I lit this shot with three lights—one precariously positioned in the roll out from the rail, another just down the slope in front of the rail, and the third to the left of the frame acting as a key light to emphasise the subject's shape."
Details: Canon 70–200mm f2.8L lens, 1/250 sec at f5.6

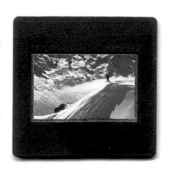
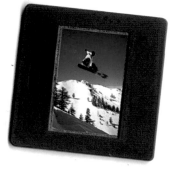

SANG TAN

1.6 SANGTANSNOWBOARDINGXPERT

SNOWBOARDING DATES BACK TO 1965
WHEN SHERMAN POPPEN, AN
ENGINEER FROM MICHIGAN, USA,
WATCHED HIS DAUGHTER WENDY
TRYING TO SLIDE DOWNHILL ON
HER SLED. HE WENT TO HIS GARAGE
AND SCREWED A PAIR OF CHILDREN'S
SKIS TOGETHER.

1.6 SANG TAN

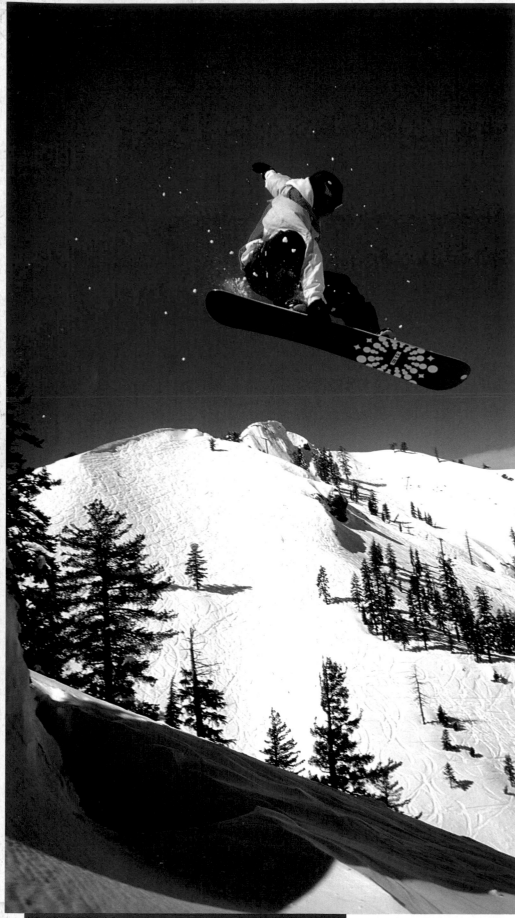

As soon as the other children saw Wendy on her "snowboard," they all wanted one: a new and exciting sport had just been born. Poppen saw an opportunity and began to produce the boards on a commercial scale, selling millions during the next decade.

Sang Tan is a photographer who specializes in photojournalism, street, and documentary photography. He is also a keen and experienced snowboarder. "My work these days is mostly features, news and sport events for news agencies and newspapers. It all started off with an interest in sports photography. I have been involved in snowboarding photography for over ten years, after I began to snowboard, and I turned professional in 1996. In 1998, I was awarded British Snowboard Photographer of the Year award, and have contributed regularly to a variety of snowboard magazines and British national newspapers."

It was a video on snowboarding in a ski shop that initially caught Sang's attention and he immediately decided that this was a sport he wanted to learn. He became a competent snowboarder himself, as well as a superb photographer of this spectacular sport. "Snowboarding was then very new, so I went to France to learn the skills from some French instructors who ran a snowboard school. The next season, I went to a British-run snowboard camp in France, where I met up with many British snowboarders. When I got back to the UK, I went to shoot a dry-slope snowboard

LEFT
James Kemp indies off a drop at Alpine Meadows, Lake Tahoe, USA. "I had to keep the rider in the top third of the frame in order to include the landing in the picture."
Details: Canon EOS 1n + 24mm f/2.8 lens on Fuji Velvia film, 1/1000sec at f/4

BELOW
Mark Rothwell drops off a cornice at Timberline on Mt. Hood, USA. "For this big drop, I chose to shoot from the other side of the huge semicircular cornice formation directly opposite the take-off point in order to include the flat slope at the top of the cornice to add contrast to the scene."
Details: Canon EOS 1n + 70—200mm f/2.8 lens on Fuji Velvia, 1/1000sec at f/4

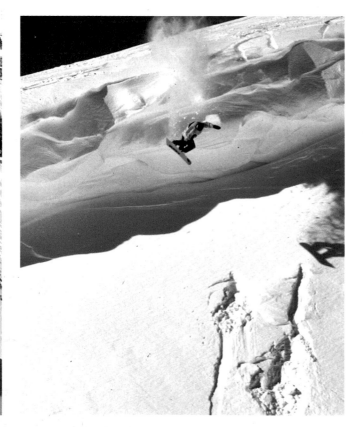

competition and most of the snowboarders I had met in the camp were there. One of these snowboarders, Eddie Spearing, was editing a snowboard supplement in a skateboard magazine, and I was asked to contribute to it. Later on, Spearing and another snowboarder, Mark Sturgeon, launched the first British snowboard magazine, *Snowboard UK*. From then on I was very much involved in supplying snowboarding images to the magazine."

Snowboarding photography is physically demanding, involving hard exercise in snowy terrain, inevitably carrying a heavy load of equipment. "The main challenge for me is a physical one. I have to be very fit to move around the mountain, hiking and snowboarding the whole day, while carrying a load on my back. I have to be strong enough and technically competent enough to snowboard with very good riders, in different terrain and weather conditions. Photographically, I am quite confident about the technical aspects and the more I shoot, the more I get a thorough grip of technique. Artistically, I tend to shoot instinctively, to express how I see and feel about the subject. Perhaps the main artistic challenge is to push some of the techniques in order to create more unusual images, but I don't believe a photograph should just be about creating superficially artistic images if it fails to convey the photographer's true feelings for the subject at the time the image is made."

Like many photographers who operate in environments where weight is a crucial factor, Sang has had to compromise on equipment choice. "I use mainly Canon SLR cameras now, although I started snowboarding photography with a medium-format system, the Pentax 6 x 7cm, which produced nice, large transparencies. The weight issue becomes a problem if you have to carry the equipment on your back all day. To save weight I switched to a Canon EOS 1, then later the EOS 1n. I now carry the minimum of equipment when I am on the mountain; usually a camera body with a wide-angle zoom lens, and a longer 70–200mm f/2.8 zoom, and plenty of film—almost always Fuji Velvia. A couple of years ago, I used a Canon D60 digital camera to shoot snowboarding and the results were pretty good. With the next generation of digital cameras becoming available, with bigger file sizes and fast-winding speeds, there will no reason for me not to use digital exclusively."

RIGHT
Jonno Verity backflipping off a kicker at Kaprun in Austria. "Instead of shooting from the usual position on the down slope, I shot from the same side that the rider was going down in order to catch his face as he did the backflip."
Details: Canon EOS 1n + 70–200mm f/2.8 L lens on Fuji Velvia film, 1/1000sec at f/4

31

Chp

1.6 SANG TAN

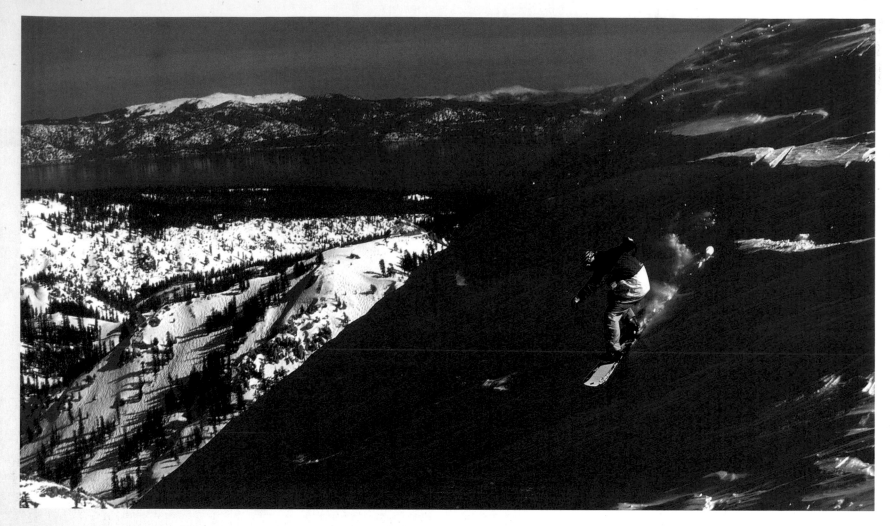

"There will be no more wastage of film if the snowboarder fails to execute a sequence correctly. A roll of 36-exposure film is normally enough for three sequences, but sometimes only one sequence from three rolls of film is good enough to be used in a magazine."

As with many xtreme sports, photographing snowboarding is not without its dangers. Sang recalls a painful incident on one snowboarding shoot. "I was traveling with Mark Webster and Stuart Brass, snowboarding on Mt Hood on America's west coast. I was shooting by a half-pipe and talking to Webster when a snowboarder came flying out of the half-pipe in our direction. He didn't crash into us, but kind of brushed past me. A moment later, I felt my leg getting wet inside. I did not feel any pain, but when I looked down I saw that my knee had been sliced open and there was blood pouring out. It needed ten stitches before I limped out of the hospital."

Sang has also had some close calls with avalanches. "I was once shooting on a steep off-piste slope in Austria, with a group of snowboarders. I was worried about the stability

of the slope, but I started shooting the snowboarders riding down fast. One of the snowboarders began to traverse across the slope above me and instinctively I called out to him to stop. Straight away I felt the ground underneath me sliding away. I realized what was happening and my next instinct was to tuck my camera inside my jacket as I was being carried down the slope by an avalanche. Luckily, it wasn't a huge avalanche and the slope flattened off very quickly at the bottom before it got any bigger. I was not seriously hurt, but everything, including the camera equipment, was soaked by the snow. Later that day, I was asked to accompany a snowboarder to do a shoot on the other side of the mountain. Reluctantly I accepted, thinking it was the best way to forget about the morning incident. I had to exert tremendous self-control when we had to traverse a narrow ridge, but eventually we got to the top of the powder field. All I wanted to do was to ride down quickly and get back to the hotel, but we stopped to shoot some pictures. The results were terrible."

Sang enjoys the variety of his work and finds that applying his skills in different situations helps him return to snowboarding with a fresh creative vision. "It can be a very good discipline to shoot entirely new subjects. Working in a different discipline helps me when I return to shoot my usual subjects."

ABOVE
Martin Robinson powers down a crusty slope at Alpine Meadows, Lake Tahoe, USA. "I had to shoot this from a distance across from the slope to get the lake in the background. With the framing in mind, I followed the rider down the slope, always keeping him toward the right third of the frame. I adjusted focusing manually and released the shutter when I reached the framed scene that I wanted."
Details: Canon EOS 1n + 70—200mm f/2.8 lens on Fuji Velvia, 1/500sec at f/4

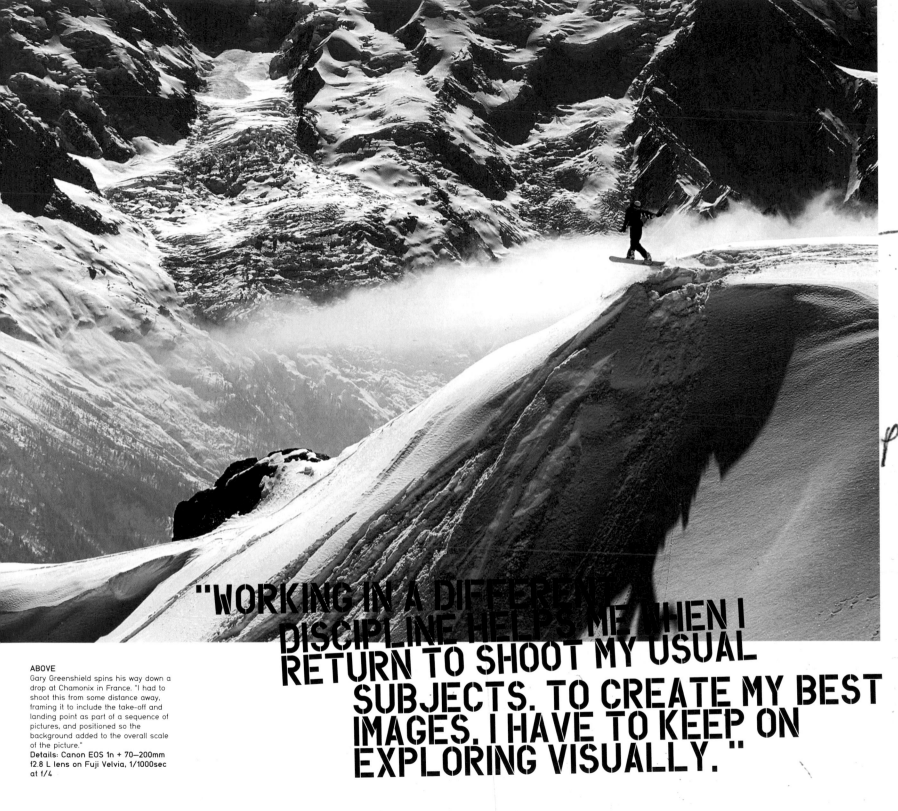

ABOVE
Gary Greenshield spins his way down a drop at Chamonix in France. "I had to shoot this from some distance away, framing it to include the take-off and landing point as part of a sequence of pictures, and positioned so the background added to the overall scale of the picture."
Details: Canon EOS 1n + 70—200mm f2.8 L lens on Fuji Velvia, 1/1000sec at f/4

"WORKING IN A DIFFERENT DISCIPLINE HELPS ME WHEN I RETURN TO SHOOT MY USUAL SUBJECTS. TO CREATE MY BEST IMAGES, I HAVE TO KEEP ON EXPLORING VISUALLY."

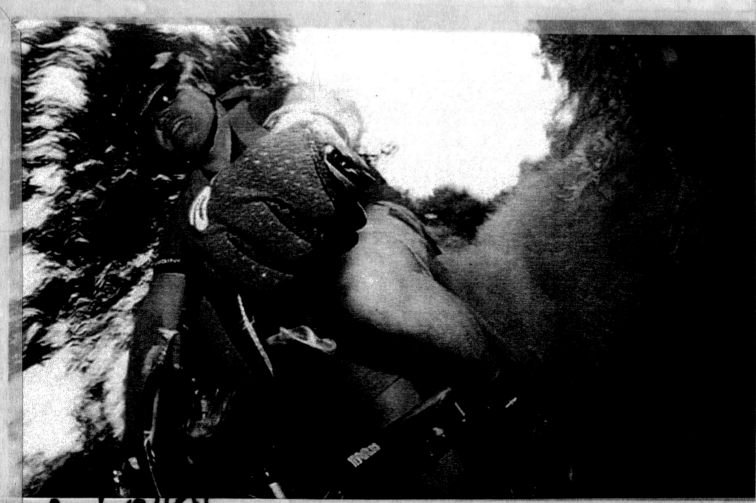

GEOFF WAUGH

1.7GEOFFWAUGHTWOWHEELED**X**PERT
AS AN EXPERIENCED ACTION PHOTOGRAPHER, GEOFF
WAUGH MOSTLY SHOOTS TWO-WHEELED SPORTS,
PARTICULARLY MOUNTAIN BIKING AND MOTORCYCLING,
THOUGH OCCASIONALLY HE MIGHT TAKE ON A
CORPORATE PORTRAIT OR A COMMERCIAL COMMISSION

1.7 GEOFF WAUGH

Geoff has photographed sports and action subjects for over ten years for a wide range of newspaper and magazine clients. He has won and three times been highly commended in the Sports Photographer of the Year competition, which draws entries from some of the world's best action photographers.

The first mountain bikes were designed and used for riding down mountain trails in California in the early 1970s. The first official mountain bike race was in 1976, and this event heralded a biking revolution. By 1983, the first mass-produced mountain bike became available and sales took off dramatically. Within three years mountain bike sales overtook road bike sales.

Geoff's entry into professional photography came when he was sent out on a job to take pictures for his employer, despite having very little photographic experience. "I was handed an SLR on my first job as a cub reporter for an angling magazine! I had never used such a camera before and had to learn the ropes by trial and error." Geoff learned fast, but soon recognized that he was totally unsuited to a career in angling photography and reporting. "It didn't take me long to realize that angling is a sedentary sport and was never going to satisfy my love of all things exciting! I bought a mountain bike as soon as they appeared in Britain and this led me to shooting xtreme sports today. I still ride, both in my work and for pleasure and fitness."

Geoff has a broad interest in photography and art that informs his work. "I enjoy looking at great composition and new, challenging ideas. Although I shoot sports, I visit portrait exhibitions and art galleries for inspiration whenever I can. Technically I always strive for a composition and a look that appeals to the biker. If I have done my job properly, they will know from my images that I am a mountain biker with an affinity with dirt riding. Artistically, getting the best possible shot is always the aim, whether it's a peak of the action race image, a high mountain ridge image or a screaming descent. They have to portray what mountain biking means to us."

Choosing the camera equipment to take on a shoot is often dictated by weight factors. As with any activity where the gear may have to be carried for long distances, compromise is inevitable, and there is a constant appraisal of what is essential for the job, balanced against the practicalities of transporting it. "I have been a Nikon man since I sold my first camera—a Pentax K1000. Besides the 35mm outfit, I also use Fuji and Mamiya medium-format equipment. I have a Nikon D1X digital body that has been a useful addition when clients demand that the images be delivered in that form."

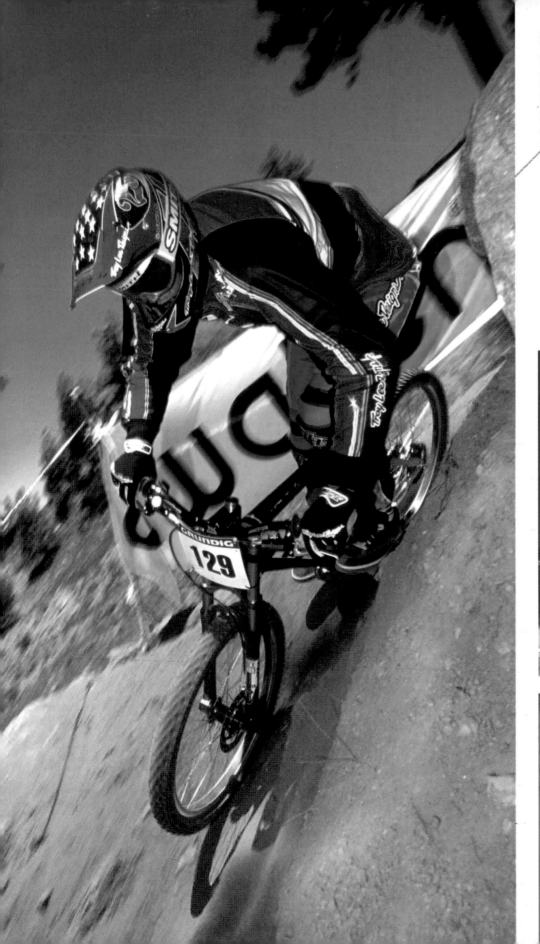

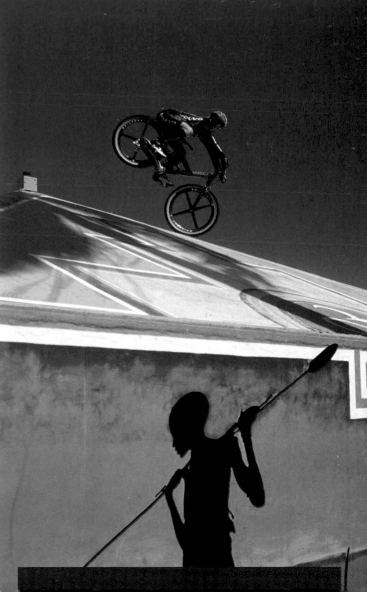

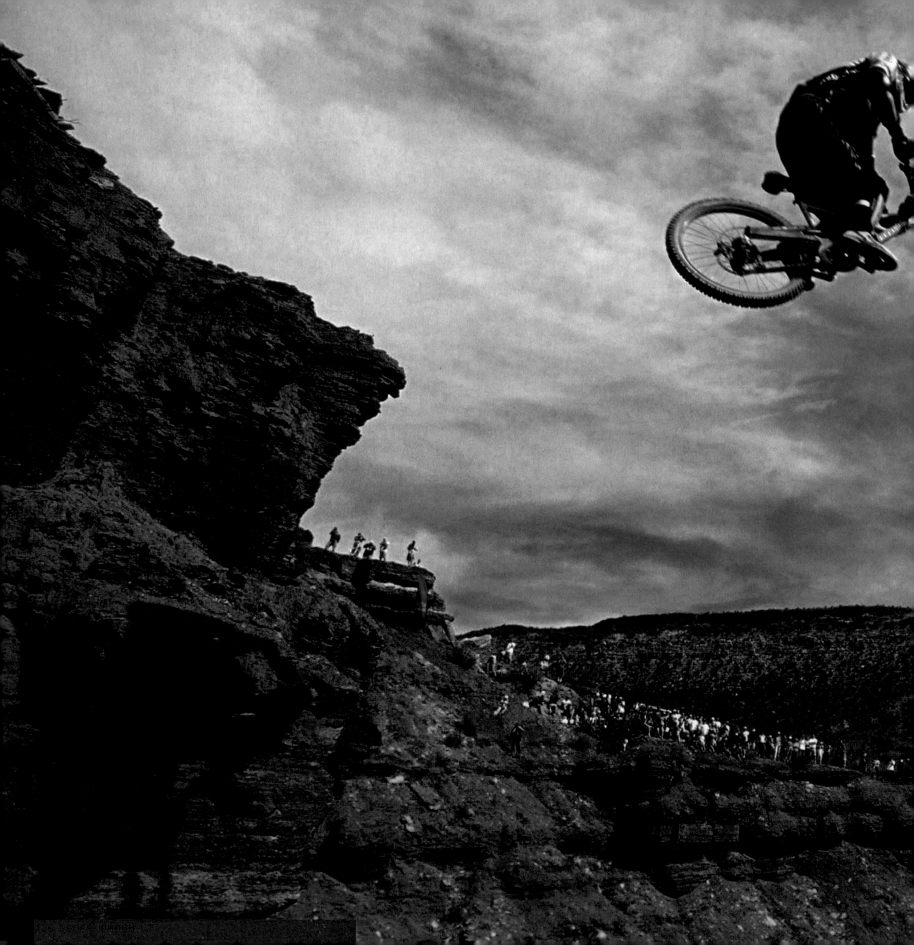

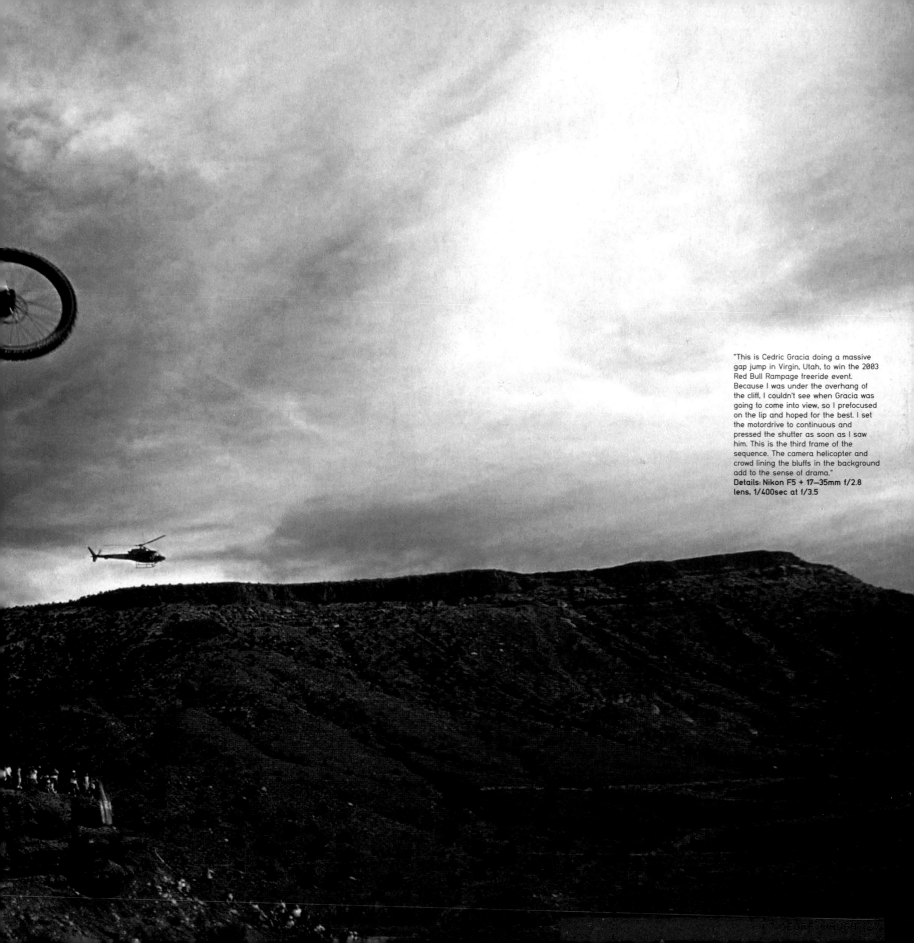

"This is Cedric Gracia doing a massive gap jump in Virgin, Utah, to win the 2003 Red Bull Rampage freeride event. Because I was under the overhang of the cliff, I couldn't see when Gracia was going to come into view, so I prefocused on the lip and hoped for the best. I set the motordrive to continuous and pressed the shutter as soon as I saw him. This is the third frame of the sequence. The camera helicopter and crowd lining the bluffs in the background add to the sense of drama."
Details: Nikon F5 + 17—35mm f/2.8 lens, 1/400sec at f/3.5

"My minimum selection for a bike shoot, when I ride with the riders on long days in the hills, would probably be one Nikon F5 body with a 24–120mm lens and a 16mm fisheye lens, along with an SB-28 flashgun. That is the lightest combination and I use it on long days when I also need to carry a lot of water and food. On shorter days I carry an 80–200mm f/2.8 zoom and a 17–35mm f/2.8 zoom. Sometimes I put a Nikon 801 body in the bag, too, just in case my main body fails. For bike test shoots and almost everything else I take two Nikon F5 bodies or an F5 and a D1X digital body. The lenses would be a 16mm fisheye, 17–35mm zoom, 80–200mm zoom, and a 300mm f/2.8 plus 1.4x teleconvertor. The SB-28 flashgun is supplemented with the SB-80DX, which covers both digital and film shooting. For bike tests I sometimes take a 60mm macro lens for close-ups of the various components on the bikes. When the light is good and for offbeat images I use a Fuji GA645Z1, which is a fairly small medium-format camera. This is mostly used for portraits and candid shots. I often shoot transparency film, which is then cross-processed. I have a Mamiya RB67 that is a beast compared to my other kit and is used purely for portraits in set-up situations because it needs a tripod. I used to use a Bronica ETRSi complete with a Metz flash to photograph road bike racing. Since this was from the back of a motorbike in or near the front of the pack, this was a good set-up and the art editors loved the bigger format. But now it's 99% dirt, that had to go!"

Geoff has perfected a range of techniques to cope with varying light levels, mainly making use of modern electronic flashguns to capture the shot in any conditions. It is this kind of technical skill, developed over time, which enables top photographers to deliver even when conditions are far from perfect. As with many different photographic subjects, the ability to previsualize an image and then to create it with consistent and reliable results is an essential skill. "In the UK in winter, the light level is often so low that I am forced to use slow flash sync techniques to give the rider some motion and use what ambient light I can. I use rear curtain sync on the flashguns for this method. In the sunny months this is not so crucial, but I put some fill-in light into the riders' faces when called for. Mountain bikers tend to wear visors on their helmets and I need to illuminate their faces and light the shadows cast by the peaks. For both racing and landscape images, using a telephoto lens can be beneficial. I use mine to add dynamics to corners that cannot be accessed because they are deemed dodgy by the race organizers or marshals. In a landscape context they are great for foreshortening perspective, which can put the rider into a more precipitous position then he or she really is, thereby adding drama."

In mountain biking, hard knocks are inevitable for riders and photographers alike. Geoff is no stranger to painful wipeouts and other hardships on the job. "Only recently I put my front wheel through an iced puddle on a fast downhill and the weight of my pack dragged me over the handlebars. I ended up with a fractured and dislocated shoulder. I am still mending from that one, both physically and mentally. I can think of numerous occasions when we have been lost in the Lake District, the Yorkshire Dales, or the Peak District, in the dark with no lights, looking for a way down and some food! Or breaking the back wheel at the furthest point from civilization in the middle of the Utah desert and getting back with a tongue swollen from dehydration, sore legs, and a screaming headache. I have been nearly wiped out by stray motocross bikes many a time, but I've been lucky. There is never a day out in the hills when something either funny or scary doesn't happen. It could be flat tyres,

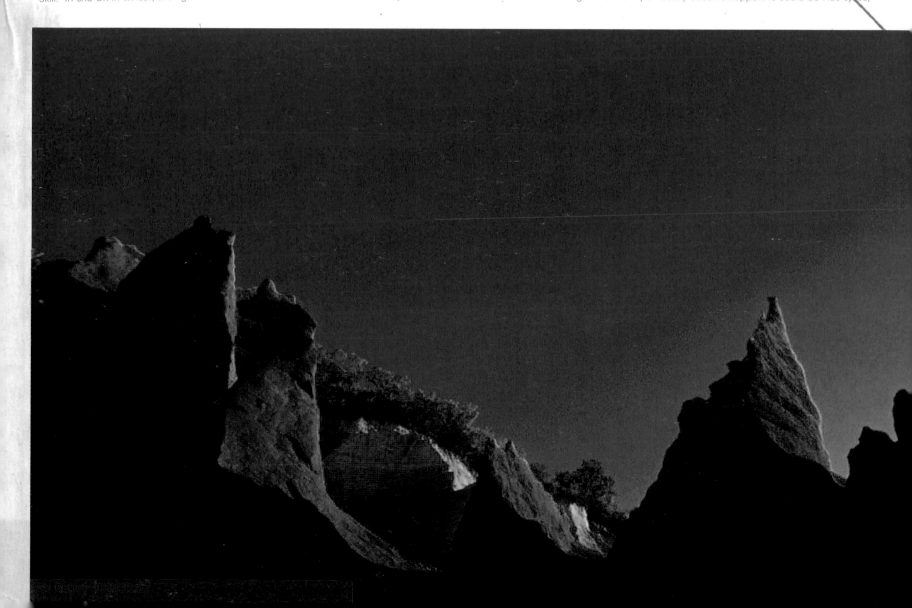

getting abused by horse riders, a sudden rain or snowstorm on a supposedly good day, or people crash and I end up donating my camera straps to fashion a makeshift sling."

Geoff's enthusiasm for his sport and his work continues unabated, and he has plenty of creative ideas to explore. "My main ambition is simply to become as proficient as I can at image-making. I would also love to do more portraits of the athletes. There are always challenges in this job: keeping the editors happy is the biggest one. We are all influenced to some extent by other photographers and artists, but there are always opportunities for fresh, original, and exciting new imagery. My sport is relatively young, and new image-makers and riders are coming in all the time. We should welcome them and their ideas."

BELOW
"This image, entitled 'We Three Kings,' won me the UK Sports Photographer of the Year David Worthy Trophy in 2001 and is a personal favorite. I shot it in Provence, France, at a secret-ish location. As I was climbing along the base of the sandstone spires I noticed my three riders playing around at the top against the lovely azure sky.
Details: Nikon F5 + 35–70mm f/2.8 lens at 35mm, 1/350sec at f/8

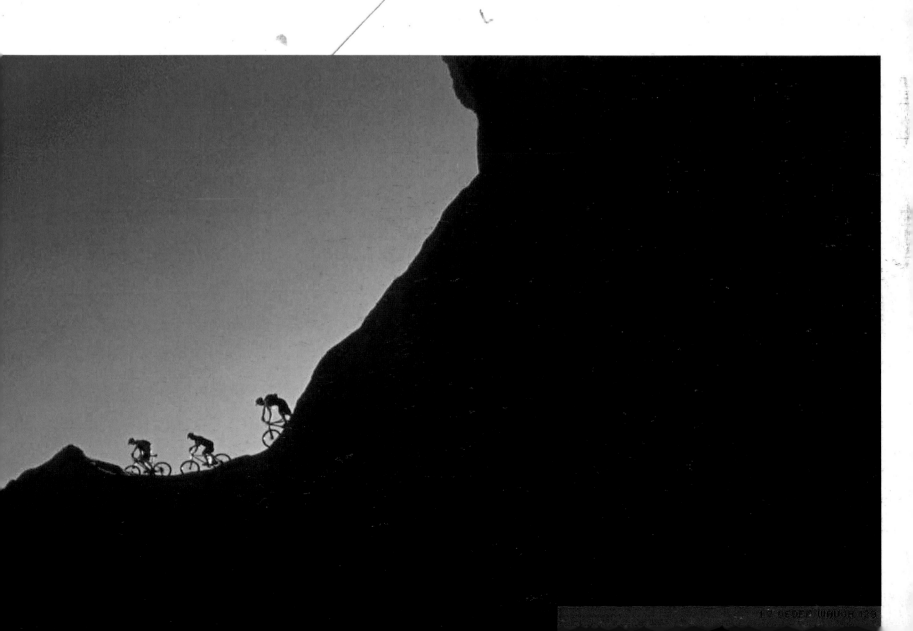

1.8ALEXWILLIAMSSURFING/WINDSURFING**X**PERT

THE NATURAL WORLD INSPIRED ALEX WILLIAMS FROM AN EARLY
AGE. HE GREW UP ON A FARM IN THE SOUTHWEST OF ENGLAND
WHERE HIS INTEREST IN PHOTOGRAPHY WAS STRONGLY
INFLUENCED BY LIVING CLOSE TO THE SEA AMIDST BEAUTIFUL
COUNTRYSIDE AND ABUNDANT WILDLIFE

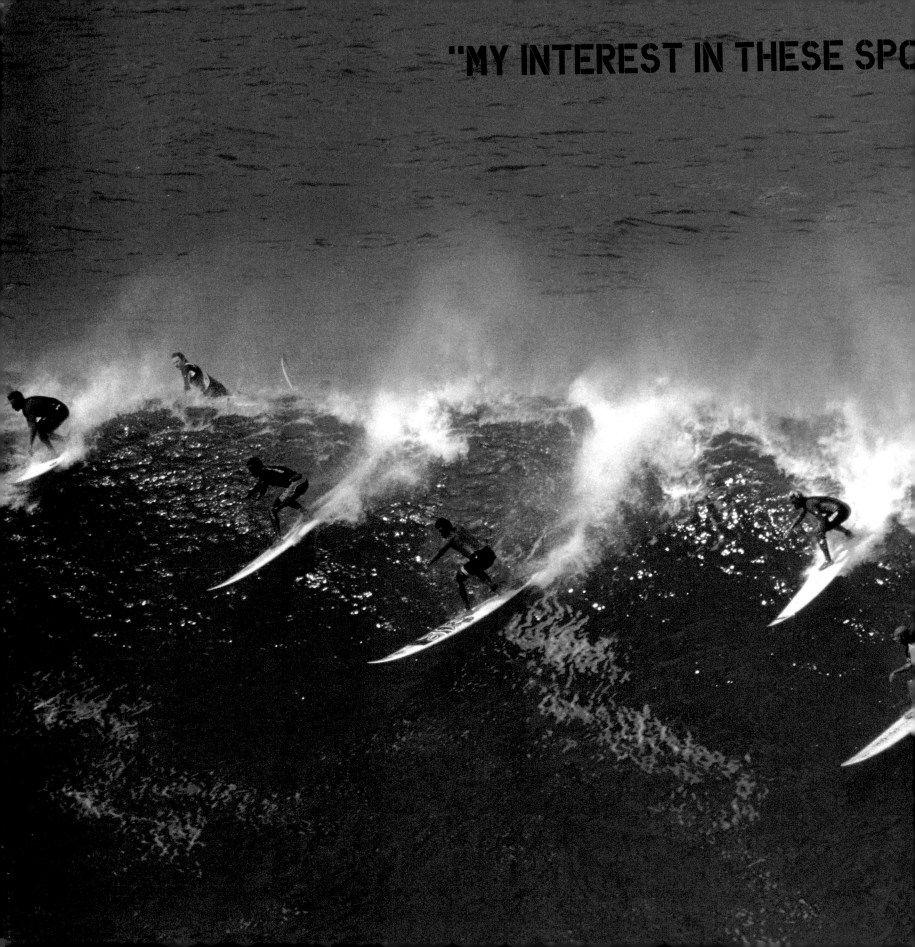

S WAS DUE TO MY LOVE OF THE OCEAN."

Alex says: "I wanted to record the wildlife around me, so my
parents bought me a camera in the 1970s. Being by the beach,
looking at it every day and seeing its ever-changing moods and
the wonders of the surf, it was a natural step to take up surfing.
It wasn't long before I started taking pictures of the surf and my
surfing friends. In 1976 I went to Plymouth College of Art and
Design, where I started off with the idea of being a wildlife
photographer. During the course, I found that I was taking more
surfing shots than wildlife, so it became clear that this was the
area I really wanted to work in. Back then, there wasn't much of a
market for xtreme sports images, but I began to shoot
skateboarding, and took some of the first images of wave sailing
with windsurfing boards in the southwest of England. By the
1980s, there was one surfing magazine and three more on
windsurfing, from which I was able to make a living, along with
some work on the farm where I was brought up."

For many who grow up by the coast, the sea is in their blood. In
surfing areas such as Cornwall, many people are drawn to the
surfing lifestyle. For some, surfing can become a vocation, and
once they have tasted the thrill of riding the waves, it can become
an all-consuming passion. Alex applied his photographic skills to a
number of xtreme sports, but always found that the sea called
him back. "My interest in these sports was due to my love of the
ocean. That is where I want to be and I don't like to move too far
away from it. I shot some mountain biking and snowboarding, but
fortunately there was always plenty of work in the surfing and
windsurfing world, which kept me close to the sea."

In any photography, success lies in capturing the moment, and in
surfing photography this is of paramount importance. The great
surfing image captures the defining moment when there is an
equilibrium between the movement of the surfer and the sea. The
great photojournalist Henri Cartier-Bresson, one of the founders
of the Magnum agency, was famed for his "decisive moment" style
of photography. He defined this as "the simultaneous recognition,
in a fraction of a second, of the significance of an event as well as
the precise organization of forms which gives that event its
proper expression." This approach epitomizes successful surfing
photography and, indeed, all action sports subjects.

RIGHT
Klaus Simmer at Hookipa on the island
of Maui in Hawaii. "I shot this late in the
afternoon; there was nobody out in the
morning as it was looking ripped apart
by the current and no wind, but by 3pm
a few sailors braved going out."
Details: Canon EOS 1v + 600mm AF IS
lens with 1.4x teleconverter making it
a 840mm lens

Alex has always been fascinated by the technical and artistic
challenge of revealing the dynamic beauty of surfing in a still
image. "The technical challenge is to capture the action or mood,
showing either the anticipation, or the result, or both. If you get it
right, then in that 1/1000sec you can see the detail that would not
have been visible to the human eye in the continuation of the
move. Artistically, I am simply recording what is there in front of
the lens, so the creative control all comes down to the choice of
lens, the angle, the use of light, and my interpretation of the
subject. Shooting from the water gives a different perspective of
surfing, compared to what most people only see from the land."

Alex uses a comprehensive 35mm system with specialist
accessories for working in water. "I have used Canon equipment
since I was at college. The 15mm fisheye is my widest-angle lens
and 600mm is my longest telephoto. I also have converters for
that lens to double its focal length. I used to make my own water
housings, but I was so busy that a friend now makes them. I have a
number of housings for different cameras, with one dedicated to
the fisheye lens, which takes an EOS 5, then a standard housing
for an EOS 3, and a number of ports to take different zooms,
16–35mm, 35–135mm, and 28–80mm. I also have a remote housing
for using on windsurfers, and a pole cam, which is a pole with a
fisheye on the end. Digital imagery is becoming a very important
part of my work now. News media and weekly magazines need the
shots fast and if you have to supply lots of magazines around the
world, you can send out 40 CDs quite easily with all the images."

Alex has lost none of his respect for the ocean, accepting the
risks while being careful to avoid being in the wrong place at the
wrong time. All surfers and surfing photographers will sooner or
later have a close call, and inevitably there are some who are
injured or even killed. The power of the ocean is a force to be
reckoned with. "Sometimes it can be dangerous, and if you are out
in big waves or dangerously hollow reefs then it can get a bit
intense. Like many other water photographers, I have been
bounced off the bottom at Pipeline in Hawaii and had a caning at
Sunset when it was in the 12ft (3.5m)-plus range. In Hawaiian size,
that is big—very big. I remember the first time I shot Sunset in
1984. It was 8–10ft (2.5–3m) in the morning and I was shooting
windsurfing up the long reef at a spot called Backyards."

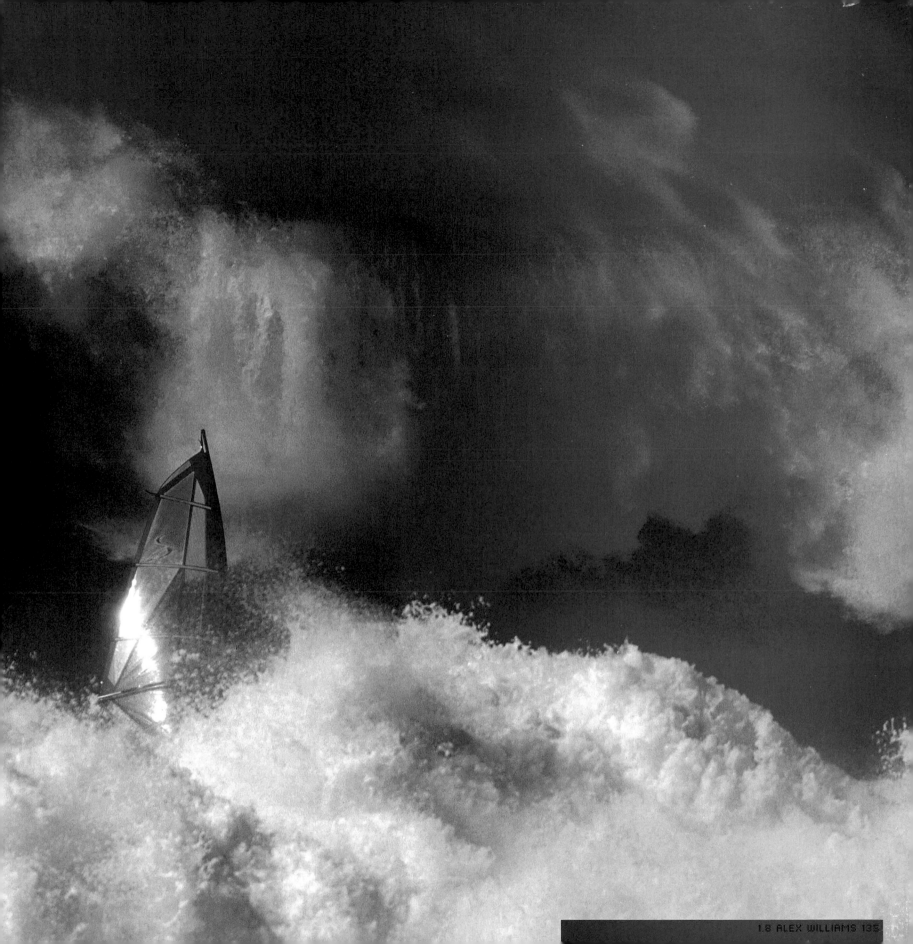

"It was a solid 10–12ft (3–3.5m) when I had finished there, so we moved down to Sunset where it was 10ft (3m), but with bigger sets. Just before I paddled out, I took some shots from the beach and there were guys dropping in on waves four times head height. At the end part of the wave, there is a hollow section that is shallower than the rest, so I sat on the end of that. I had shot most of the roll after about an hour and the sea was getting bigger all the time. The swell does not always come in at the same angle, so you occasionally get a sneaker set from a different angle that can catch you out. I had managed to swim wide on most of these through the hour, but then this set stood up coming in from the west. I had been pulled in to the bowl area and was now swimming as fast as my legs would flip. I got under the first two waves, but the third was twice the size and landed squarely in front of me. As I headed to the bottom for safety, I saw the clouds of bubbles hit the reef, rebound and hit me. I tumbled around for some time and was pulled up and down several times. Whenever I came to the surface I tried to grab a breath of air, but there was about a foot of foam on the surface, so all I got was a mouthful of foam before the next wave hit. I was very glad to get back to the beach that day!"

BELOW
This is a water shot taken at Hookipa in Maui, Hawaii. The sailor on the wave is Matt Pritchard, who has been a world champion freestyle sailor. The sailor jumping is Vincent Lartesian, a French big-wave rider.
Details: Canon EOS 1v + 35–135mm IS lens in a water housing made by Alex out of Plexiglas and fiberglass

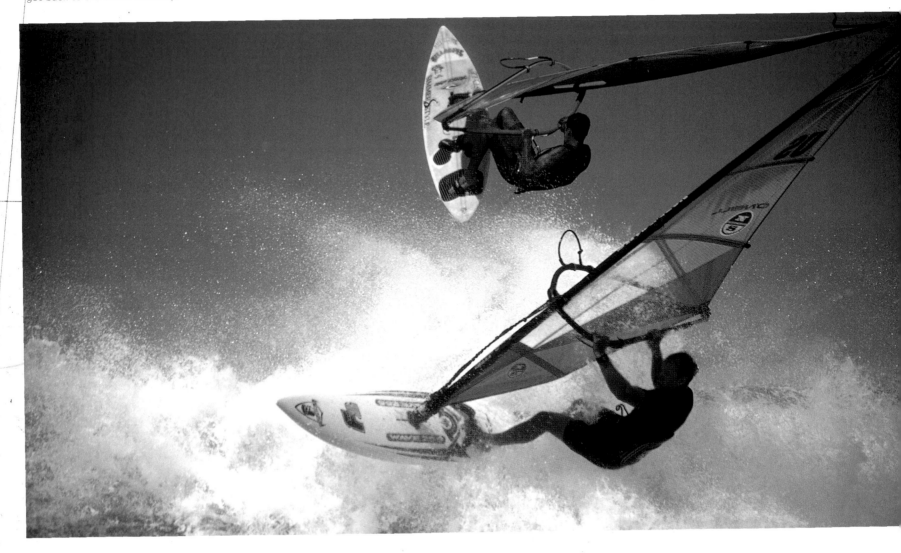

Alex still gets tremendous enjoyment from his work and loves to be out shooting the action. "Getting in the water and shooting is always rewarding. I feel that I'm part of the action and not just observing on the sidelines. There are a lot of things that have been done before in surfing photography, but there is always the opportunity to make your own interpretation of a particular theme. Nothing is the same twice. The waves change, the people change, and the locations change, so it is always new and exciting."

BELOW
World surfing champion Barton Lynch at Mundaka in the Basque country of northern Spain. This is a world-renowned wave at the mouth of a large tidal river.
Details: Canon EOS 1v + 600mm AF IS lens with 1.4x teleconverter

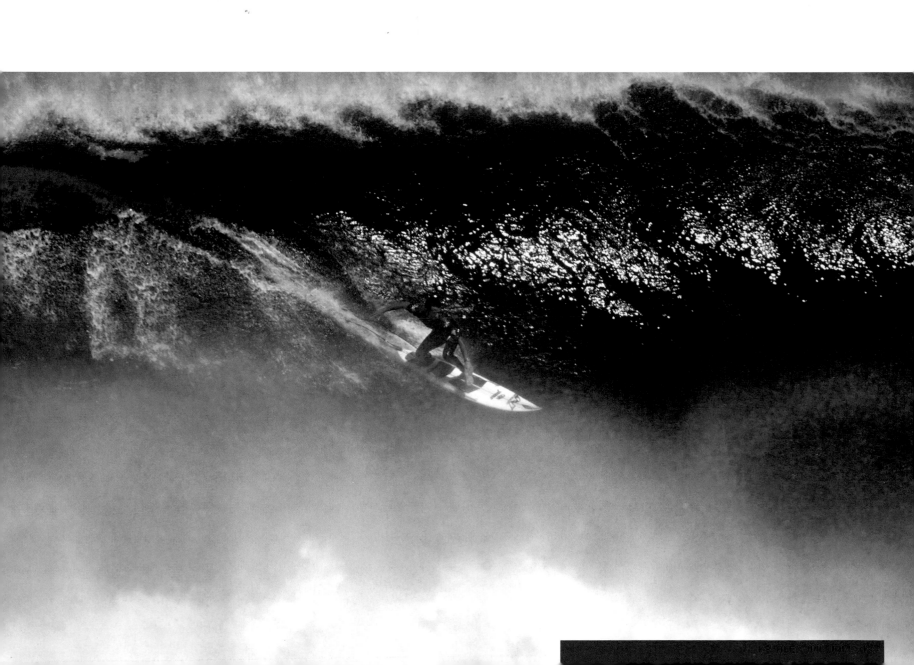

1.9RAYWOODCLIMBINGXPERT

CLIMBING AS A SPORT DATES BACK TO THE NINETEENTH CENTURY WHEN IT WAS THE PRESERVE OF THE AFFLUENT CLASSES, AND MOST OFTEN ENJOYED BY ENGLISH GENTLEMEN WHO HAD THE MEANS AND THE LEISURE TIME TO SEEK ADVENTURE: THEY MADE MANY FIRST ASCENTS IN THE ALPS, IN THE COMPANY OF LOCAL GUIDES

1.9 RAY WOOD

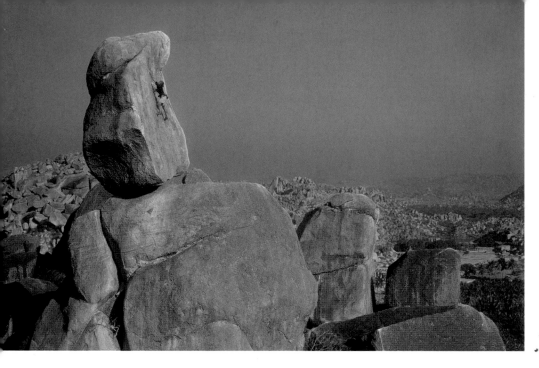

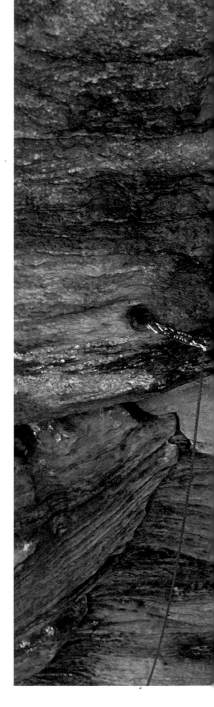

Climbing is now a worldwide activity, covering many disciplines from pure rock and ice climbing, to mountaineering on the highest peaks of the world's greatest mountain ranges. The pursuit of climbing takes its activists to some beautiful and spectacular settings, and for many it is not just the climbing, but also the high adventure in wild and remote parts of the world that is the lure. For photographers, climbing is a rich and multifaceted subject, whether as a participant on the climb, or as an observer from a specially chosen vantage point. British photographer Ray Wood is a keen climber for whom photography provides the perfect way of blending his skills and being involved in his sport professionally.

Like many climbers, Ray started recording his early adventures on local crags as a teenager, before venturing further afield. "My first camera, a Rollei 35, didn't last long before it was dropped from the top of a climb on the sea cliffs at Swanage. Soon after, a camera I'd borrowed met a similar fate in Cornwall—not the most auspicious start to a photographic career. It was to be quite a while before I could afford another camera, but I've not dropped any since. I worked as an outdoor activities instructor after university, then went climbing in Australia for a few months and started to think about pursuing photography more seriously. I bought my first SLR camera with the intention of seeing if I could make it pay. I concentrated on the sports that I knew, such as rock climbing, mountaineering, and paragliding. My interest in mountains and the outdoor world made landscape photography another obvious subject. After a couple of years of editorial work for magazines, I took a postgraduate course in photojournalism. I like to explore subjects and issues important to me. If I see something interesting, I immediately evaluate it in terms of how it would make a good photograph. It isn't a nine-to-five job, so I have to be proactive in coming up with ideas and making them pay."

Ray started climbing with school camping trips on the South Downs in the UK. This led to hill walking and rock climbing, and later to winter and alpine mountaineering and skiing. It was the love of the outdoors that propelled Ray into xtreme sports photography. As well as climbing, Ray spent some years paragliding, but it was difficult to find time to combine flying and climbing; in recent years he has concentrated on creating dramatic rock-climbing images. Ray explains the technical aspects of his work. "To take climbing photographs, it is best to be independent of the climbing team, and to be able to move around quickly between the best vantage points. This often involves abseiling into position and using jumars [mechanical ascenders] to go up the rope. Deciding which part of a climb is going to make the best picture in relation to the light conditions, where to record it from, and getting into a position to do so, are vital considerations in the process. The purest style of climbing photography is where the climber simply climbs the route as if the photographer wasn't even there, and the action is recorded as it happens. The photographer doesn't direct the shoot, although he or she will probably have researched the best angles to shoot from. The photographer has to anticipate what is going to happen next, so being a climber oneself is obviously very useful. It is unlikely that there will be a second chance to make that 'best shot.' If the route is an important first ascent then this also lends the picture a historical gravity. I find that good photos obtained using this approach are among the most pleasing, as they look totally natural, and there is the satisfaction of knowing that the shots are for real and that the expression of fear or effort is genuine.

"At the other end of the spectrum is the staged or recreated image, where the climber is working very closely with the photographer to try to get a good shot. This may involve re-climbing a route or repeating moves several times until the photographer thinks the shot is in the can, or the climber runs out of strength or patience.

"As far back as the late nineteenth century, the famous Lake District photographers, the Abraham brothers, would sometimes direct their subjects to create good photographs. I consider it important when possible to convey the psychological as well as the physical challenges of the route. In general, the choice is between the relatively close-in shots that show action and emotion, and then the shots that show the climbers in the context of the setting or landscape."

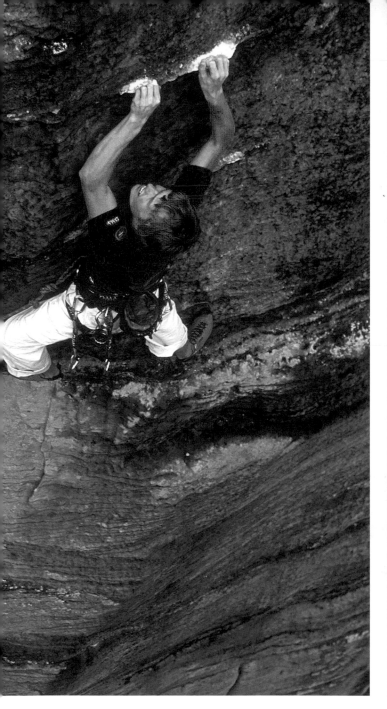

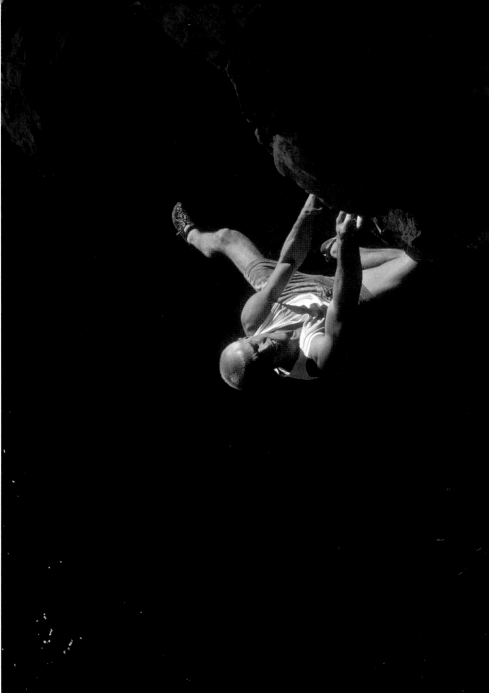

Photographing climbing action requires a range of equipment to suit the photographer's situation, whether suspended in midair on a rope, or standing on solid ground. "I mostly use autofocus 35mm Nikon gear when I'm hanging on a rope, or maneuvering on steep ground. If it's possible to set up a tripod, then I'll use my Mamiya medium-format gear, especially for landscapes or where the figures are effectively small against a large 'canvas' of rock. Digital gear hasn't become an important part of my work yet. There were initially problems such as dust on the CCD, the time-lag before a picture is taken after pressing the shutter, and heavy battery use. Magazines still mostly prefer slides, and it is difficult to better the impact of a perfectly exposed, beautifully saturated, and sharp transparency on a lightbox. That moment when you realize you've got a winner makes all the effort seem worthwhile. However, a scanner is useful for archiving and to send pictures to potential clients without having to send valuable transparencies."

ABOVE
"This shot illustrates the importance of timing, awareness, and having a bit of luck. Nearing the end of the day, I abseiled over the top of the cliff for one last shot, to photograph Neil Gresham deep-water soloing Animal Magnetism at Lulworth Cove in Dorset, England. Noticing that the cliff was in shade apart from a small patch of rapidly diminishing sunshine, I didn't think I'd get a picture, but as Neil climbed up there was a point where his whole body was momentarily in the theatrical light as he moved through it. There was one chance to get the shot. The sea behind was dark because the sun was low in the sky."
Details: Nikon F-100 + 85mm lens on Fuji Velvia, 1/250sec at f/4

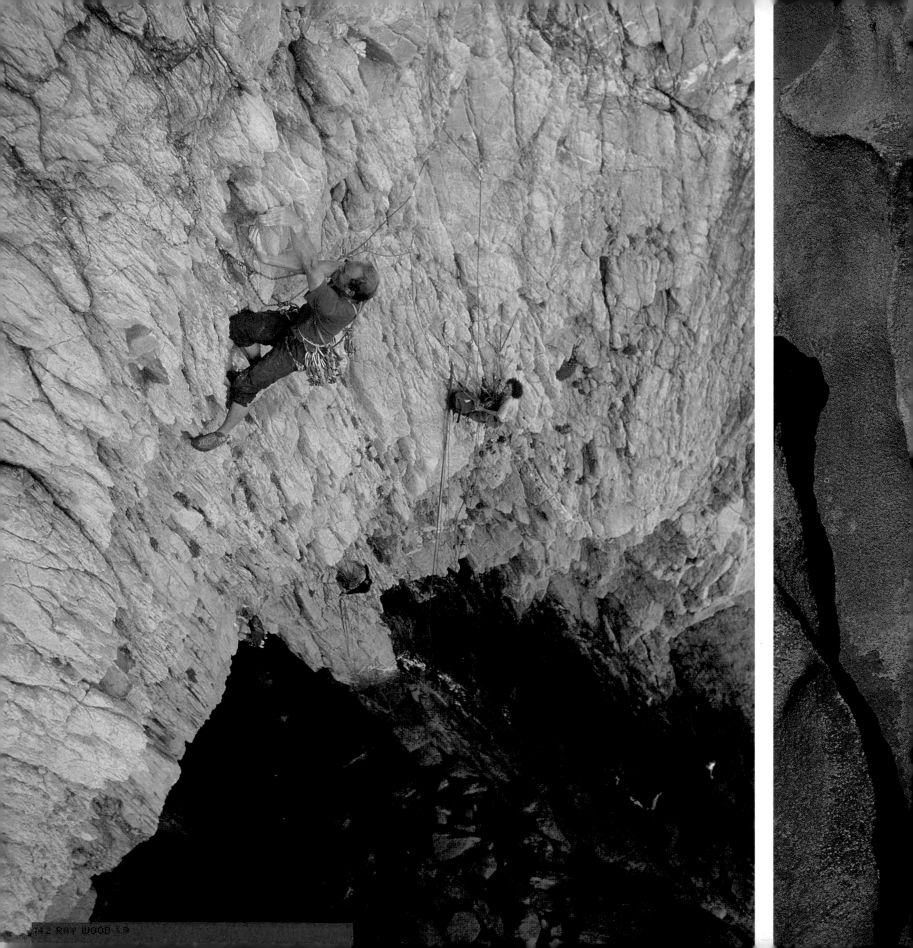

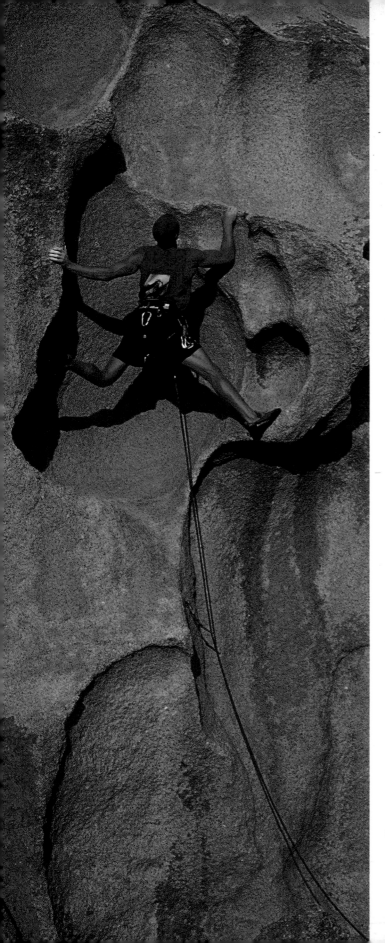

"IN MALI (WEST AFRICA) AT THE BASE OF A CLIFF A LONG WAY FROM THE NEAREST VILLAGE WE WERE CONFRONTED BY A MAN BRANDISHING A SHOTGUN AND WANTING A GIFT TO LET US CLIMB"

One of the great attractions of climbing is the opportunity to explore extraordinary locations around the world. Ray has traveled widely, and has been in some interesting situations, from edgy encounters with armed tribesmen to the more typical hazards to be expected in mountain areas. "In Mali (West Africa) at the base of a cliff, a long way from the nearest village, we were confronted by a man brandishing a shotgun and wanting a gift to let us climb, despite the fact that we had already obtained permission from the tribal chief. Arguing didn't seem prudent, so we gave him the few coins in our pockets.

"On the same trip, one of the team discovered that his rucksack was disintegrating, and holes appeared in his clothes. He'd traveled on a bus with a moped on the roof, and battery acid had leaked all over the luggage. Needless to say, we didn't use any of his ropes. In contrast, snow-covered mountains and frozen cascades bring a new set of hazards to evaluate and minimize. I was once below a large ice fall in northern Italy when a section of ice broke off, exploding on impact into television-sized blocks that tumbled down the slope toward me, requiring some nimble dance steps to reach safety. What was so scary was that we couldn't have predicted the collapse, or understand why it occurred."

As climbing continues to gain in popularity, there is an increasing demand for good climbing photography, and Ray foresees a healthy future for this field of work. "Climbing has a much greater commercial side now and there are a small number of climbers who make a living from sponsorship deals. For them, getting high-quality photographs published is important to keep their sponsors happy. If this interest continues to grow, it can only be good news as far as increasing the sophistication of climbing imagery. A big plus of photographing outdoor adventure is getting to know some of the characters in the climbing world. Those at the top of their game are often individualistic, bold, and incredibly talented and it can make for a very entertaining day out."

FAR LEFT
"George Smith making the first ascent of the top pitch of a route named The Mad Brown. Graded E7, this climb up the back of Wen Zawn at Gogarth on the Anglesey coast in North Wales is notable for its 'out there' position and loose rock that needs handling with care to make progress. Taken from an abseil rope, my only involvement with this picture was being there to record it."
Details: Nikon F–100 + 35–70mm on Fuji Provia 100, 1/250sec at f/6.3

LEFT
"The golden granite of Roccapina in Corsica has a wonderful sculptural quality about it best appreciated in the early morning or evening light. This bolt-protected climb threaded its way through fins of rock and it was only necessary to get Tim Emmett to bridge out at one point to make the picture."
Details: Nikon F–801s + 35–70mm lens on Fuji film, 1/125sec at f/5.6

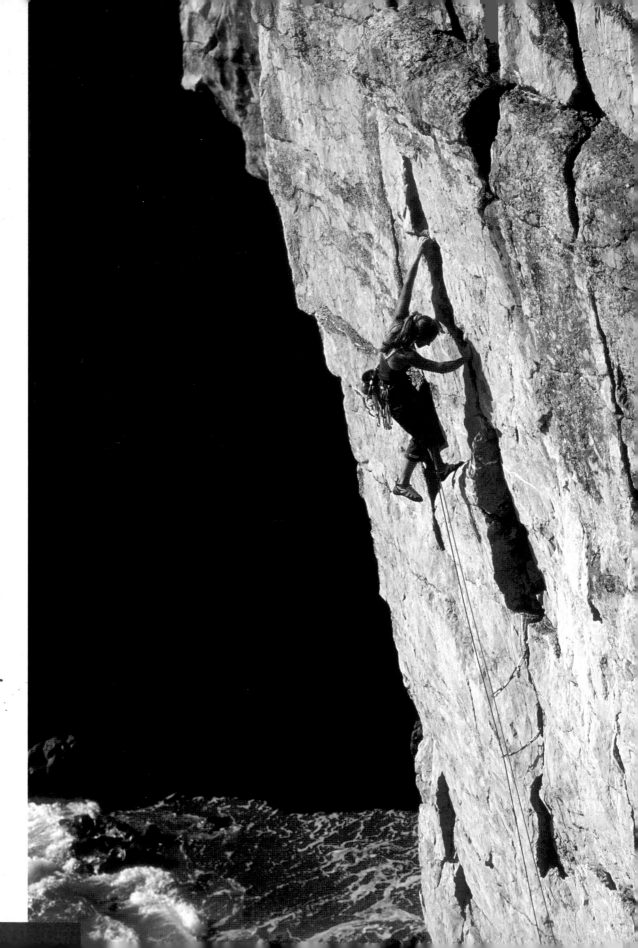

As a sport, climbing is flourishing, with climbers pushing standards and continuing to explore new techniques and new places, wherever there is steep rock and ice waiting to be climbed. "Climbing is more diverse than ever. Deep-water soloing, bouldering, mixed winter climbing, dry tooling, and applying technical free-climbing skills on to big walls are all developments providing new opportunities for photographers. Climbers love seeing pictures of new and exciting destinations that they can perhaps visit one day. The old adage that you are only as good as your last picture always acts as a spur to deliver high-quality work. I like to think that my best pictures are the ones I've yet to take. Photography is a cruel master, forcing me to reach that bit further for the perfect picture, which nearly always seems to be just beyond my grasp, and so the quest goes on.".

RIGHT
"This was taken as part of a shoot for the outdoor clothing company Sprayway who sponsor Lucy Creamer, one of Britain's best female climbers—here, she's on an E3 in Pembroke /South Wales/. Conditions were against us, although you wouldn't be able to guess that from the picture. A thick bank of cloud was just about to obscure the sun, and the strong, gusty wind was making keeping the camera steady very difficult."
Details: Nikon F-5 + Nikkor 70–200mm on Fuji Velvia, 1/800sec at f/3.2

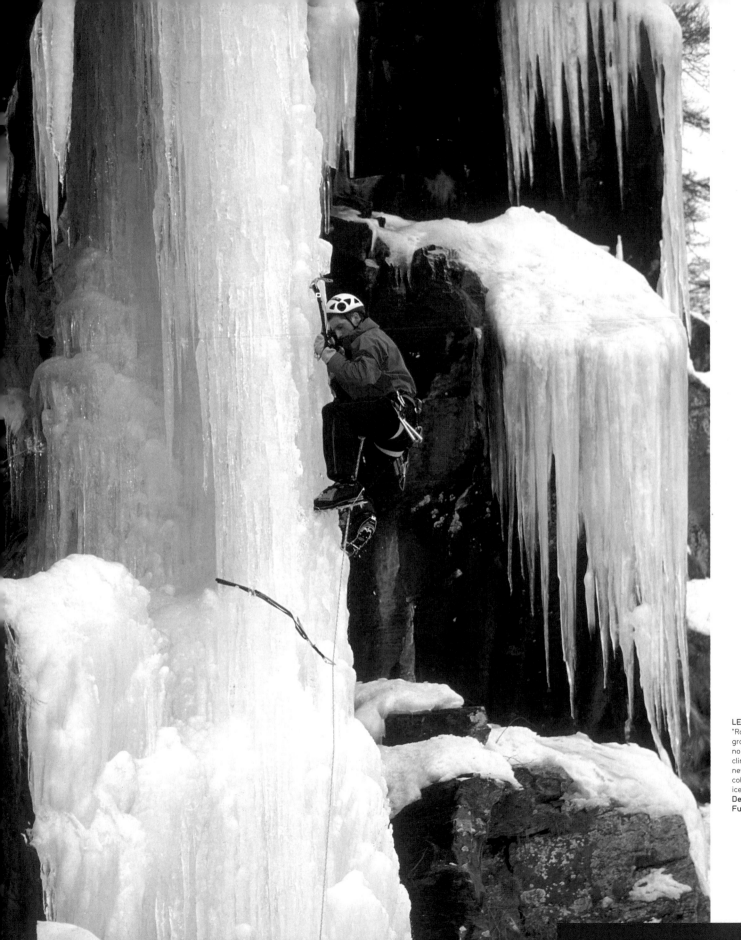

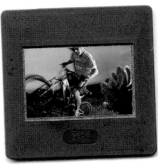

2.0CHRISWOODAGEBMXXPERT

MANY ACTION SPORTS ORIGINATED IN CALIFORNIA WHERE
THE FINE WEATHER, OUTDOOR LIFESTYLE, AND QUEST
FOR HAVING FUN ARE THE PERFECT INGREDIENTS FOR
TRYING OUT NEW IDEAS. A LOT OF THESE ACTIVITIES HAVE
EVOLVED INTO HIGHLY SKILLED, THOUGH POTENTIALLY
HAZARDOUS, COMPETITIVE SPORTS, WHERE
PERFORMANCE STANDARDS HAVE BEEN PUSHED WAY
BEYOND WHAT COULD POSSIBLY HAVE BEEN IMAGINED BY
THOSE WHO INITIATED THE SPORTS

2.0 CHRIS WOODAGE

BMX, or bicycle motocross, is a good example. It started off in 1969 when a group of kids—motocross fans who were too young to ride motorcycles—rode their Schwinn Stingray bicycles to Palms Park in Santa Monica, California, to race on dirt trails. The sport quickly developed and became very popular during the 1970s, when national championships were introduced. Since then, BMX has spread to many countries and there are now about 50 national governing bodies across the world. By the 1980s, BMX had gone way beyond dirt racing on tracks. Riders began to pioneer "freestyle" riding, using hand-built dirt jumps and home-built ramps. Some even started riding on the streets using flat banks, handrails, and stairs as obstacles.

Chris Woodage is a relative newcomer to professional sports photography. His career path is a notable example of someone taking control of his life, making tough choices, overcoming obstacles, and facing the uncertain path of the freelance. "I first took photography as a subject in school. My teacher was a bit of a crazy, uninspiring guy who stank of coffee and cigarettes, but I guess he sowed a seed of interest. I got into professional photography by accident. I was working as a chef in a Michelin-starred restaurant in London, and thought about taking up photography as a release from the pressures of the kitchen. It wasn't until two years later, after a move to Cornwall, that I found my camera while unpacking; it was unused at the bottom of a box. I started taking pictures of the local surfers, the beaches, my bulldogs, and my friends. I wasn't much good! By early 2000 I'd had a few pieces of work published, but I was still a rather enthusiastic amateur. It was at this time that fate pushed me into really reassessing my career path. I was on the stove one day and I felt like a huge cloud had descended on my head. I left the kitchen, never to return. About this time, I was left some inheritance money, so I decided to try to make a career out of the things I truly loved. I had no idea how hard it was going to be, but somehow, four years later, I find myself here doing the best job in the world. My main interests photographically are cutting-edge sports and the lifestyles surrounding them."

RIGHT
Steven Murray practicing before the CFB in Woodward West, California.
Details: Canon EOS1 DS + 50mm lens, 1/30 sec at f/3.6 with 3 flashes

FAR RIGHT
Jamie Bestwick. No hander at Woodward, Pennsylvania. This shot was taken at dusk.
Details: Canon EOS1 DS + 15mm fisheye lens, 1/15 sec at f/8 with 2 flashes

FURTHEST RIGHT
Steve McCann. No hander in Oververt Concrete Bowl at Woodward West, California. "I wanted to give this picture a strange quality; I used daylight film so that the lights would turn the scene green. I also wanted the curve of the bowl to lead into the image. The subject was lit by three flashes fired by radio slaves."
Details: 15mm fisheye lens, 1/15sec at f/8 on Fuji film

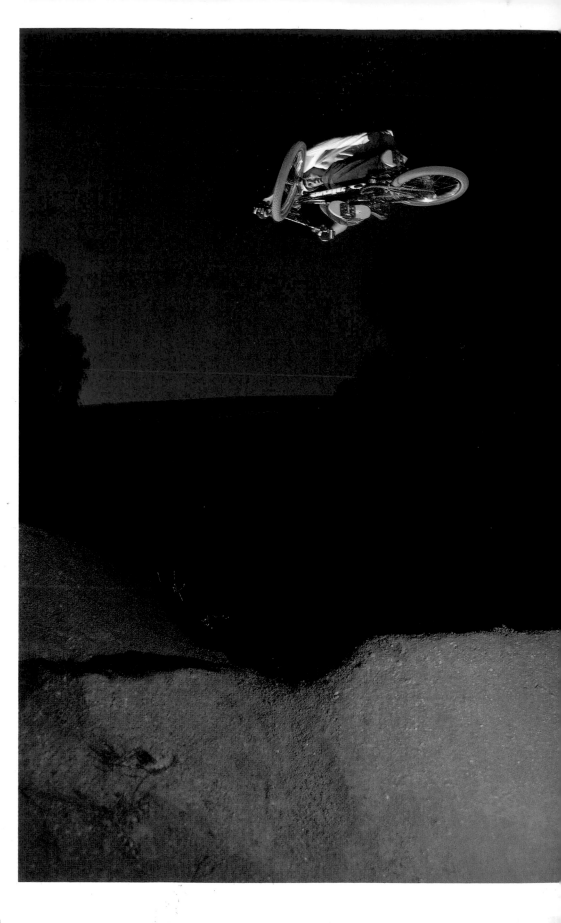

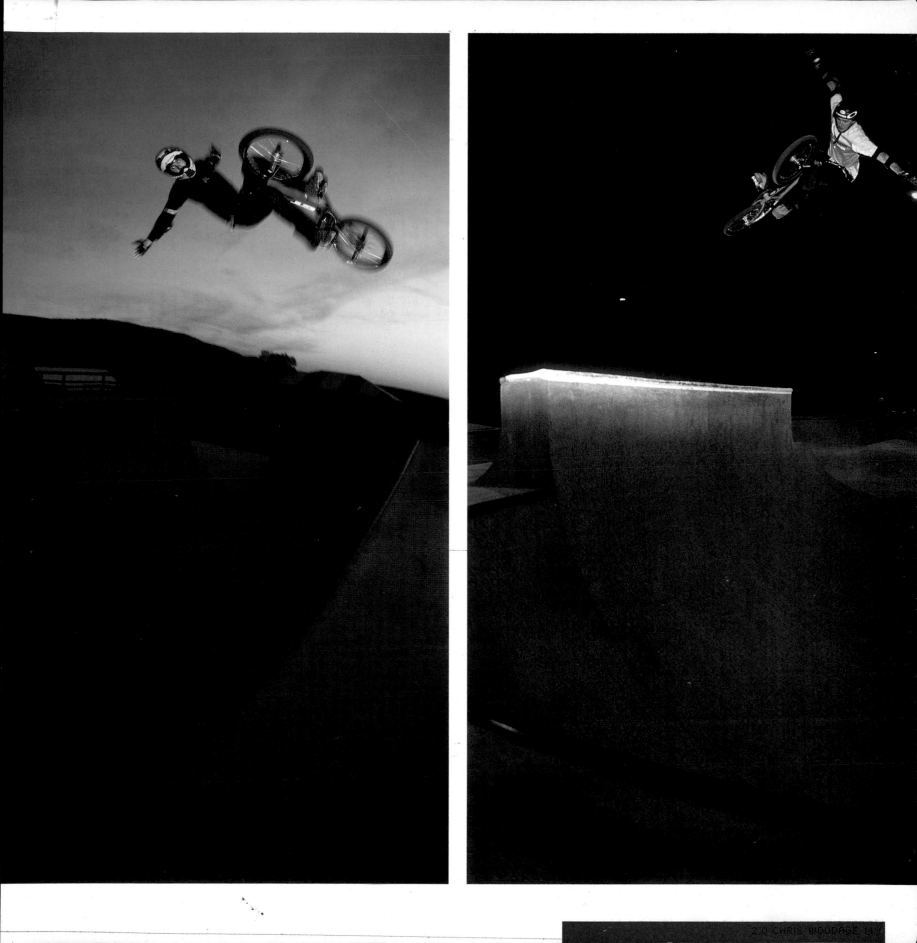

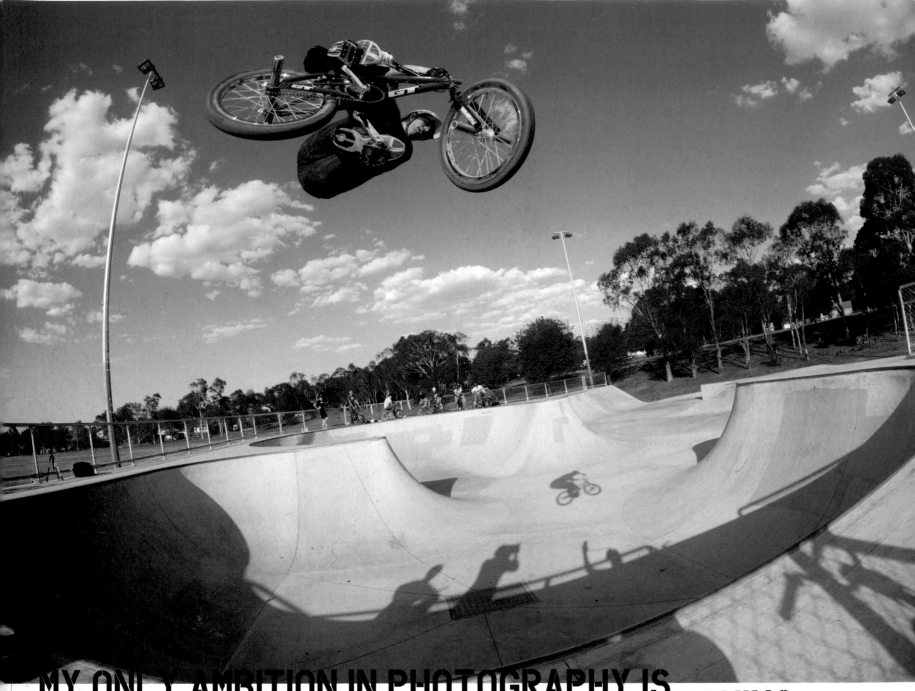

MY ONLY AMBITION IN PHOTOGRAPHY IS TO KEEP LEARNING, KEEP IMPROVING AND TO ALWAYS HAVE FUN.

"While I have become known as a BMX photographer, I also shoot many other subjects. I have had front covers on the *British Journal of Photography* with a skateboard image, and *Wavelength* surfing magazine, with images taken in Hawaii. I also shoot mountain biking, motocross, and various other subjects, including some fashion work. Basically, I will take pictures of anything that interests me. It could be a flower, a building, a homeless guy passed out in the gutter, or my bulldog Sprocket. As long as it's a subject that fires my interest, I love making an interesting picture of it."

As a photographer, Chris gravitated toward the subjects in which he had the most interest and experience—a good foundation for any photographic career.

"Getting into action sports photography was never a conscious decision; it just seemed to be a natural progression. I've ridden a BMX since 1982 and have always surfed, so it seemed natural to take pictures of things I knew about and was interested in. I could never see myself doing weddings or sitting in a studio in my home town taking pictures of families. That would drive me crazy, and I'd probably end up killing somebody."

The fast-action sports such as BMX present many photographic challenges, both technically and creatively. Split-second timing, lighting, and strong compositions are key ingredients for creating dynamic, powerful images that capture the skill, style, and sheer nerve of the top riders.

"My main challenges day to day are to come up with new angles and new looks to an image, but with changing conditions and impatient athletes you have to think on your feet. Lighting a scene is always a challenge. Gone are the days when you could simply use a flash mounted on the top of the camera. I currently use Canon EOS 1D and 1DS digital cameras. I actually sold my medium-format gear after I had used the DS for a few weeks, as the image quality is really just as good. I use a selection of the Canon L-series of lenses, and for lighting I use Canon 550s, Quantum Q flash, and Hensel Porty. My Pocket Wizard radio slaves are among the best investments I have ever made, enabling me to fire multiple flashes by remote control. Lowepro bags and Pelican cases keep all my gear safe. Digital capture hasn't really changed the way I shoot, but it has totally changed the way I can work with clients. I can now offer images to a client almost immediately, and can leave a job knowing that I have the image that the client wants, whereas before I would have been stuck in the lab all night, clip-testing rolls of film with my fingers tightly crossed."

Sports such as skydiving and rock climbing have obvious, fatal penalties for serious equipment failure and human error, but BMX must rank with horse racing as the ultimate hard knocks sport. Landing a bike from 30ft (9m) in the air takes a degree of sheer physical courage and determination, and the willingness to risk all sorts of painful injuries.

LEFT
Jamie Bestwick. Taken on the last day of the Australian tour in Tuggeranong skate park.
Details: Canon EOS1 DS + 15mm fisheye lens, 1/2000sec

RIGHT
Tim 'Fuzzy' Hall. Can can out of a wall ride in Woodward West, California.
Details: Canon EOS1 DS + 50mm lens, 1/400 at f/6.3 with 2 flashes

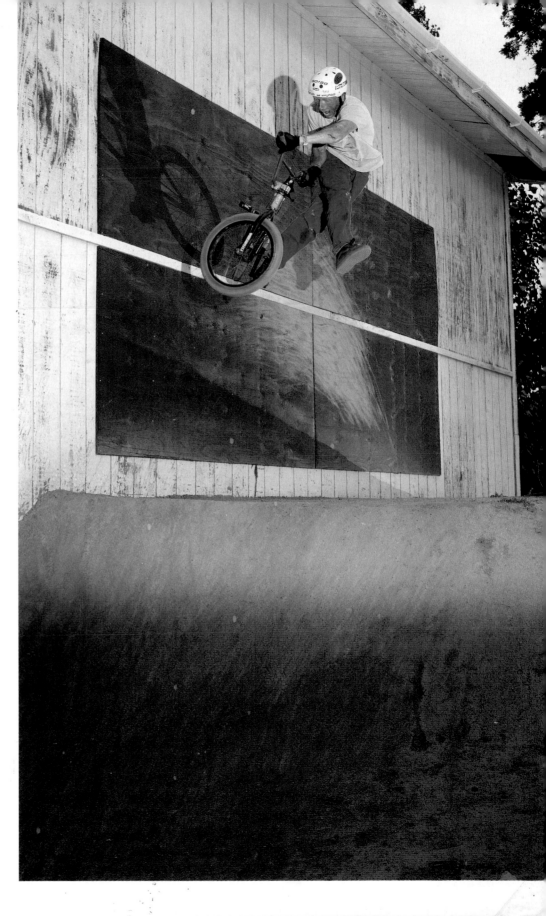

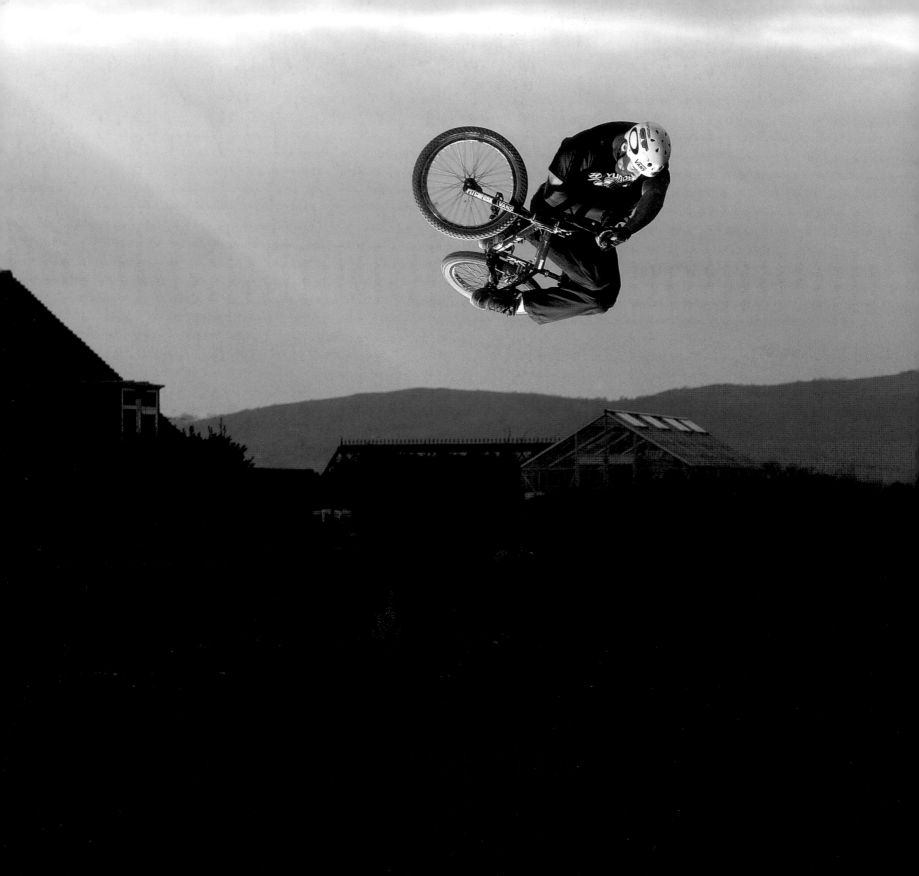

Steven Murray. "This shot looks like it was taken in California, but it was actually taken at the end of winter in Upton on Tees in the UK. I left the background underexposed and the subject was lit by two flashes underneath the rider fired by radio slaves."
Details: Canon EOS1 DS

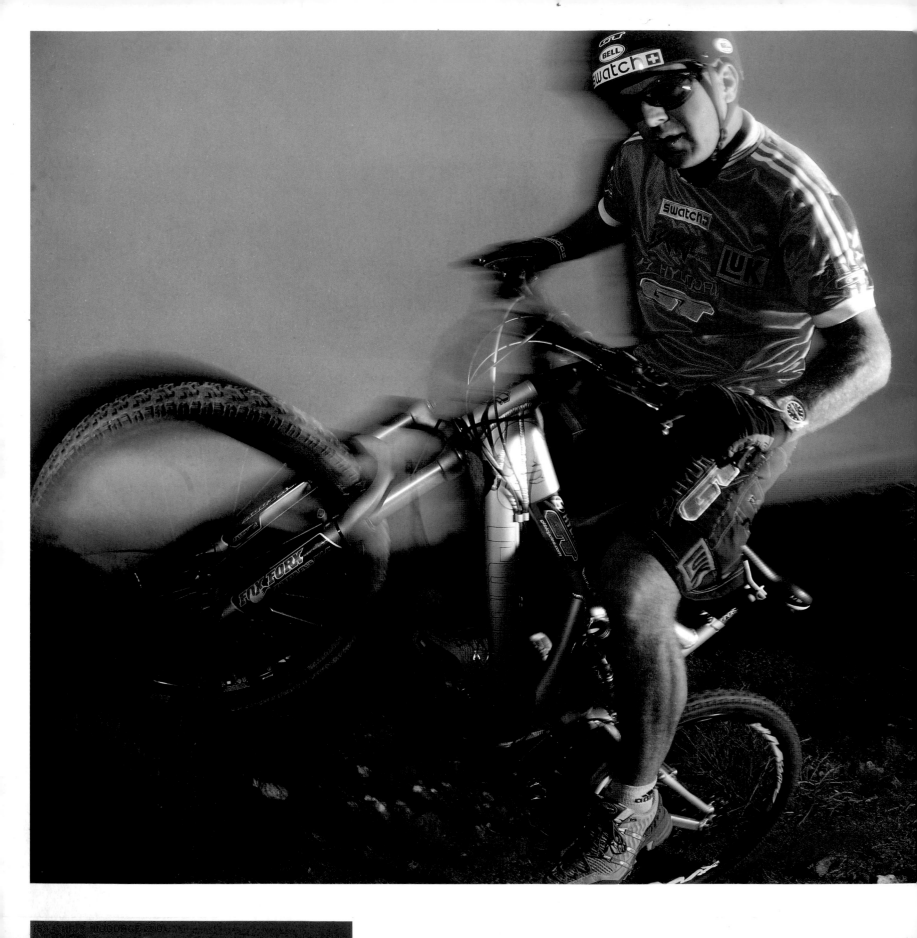

Chris himself is no stranger to the consequences of mistakes. "When I'm behind the camera, I'm generally fine. It's when I participate in the sports that I get hurt! My injury list includes two broken ankles, broken fingers, a broken hip, reconstructive surgery to rebuild a broken elbow, plus countless other concussions, cuts, and bruises. I did a shoot with Shaun Baker, a kayaker, from halfway down a cliff with my foot in plaster. Climbing a cliff in a Day-Glo yellow plaster isn't easy and it got so wet that I had to cut it off myself. The doctor was not amused. I am just a kid at heart, but in an adult body. My mind tells me I can do something but sometimes my body has other ideas. Having said that, I pulled my first backflip on a BMX at the age of 32. I introduced myself to water photography at Waimea Bay in Hawaii. From the shore it looked to be big, but out in the line-up it was huge. I didn't take any pictures that day, as I was too busy trying to stay alive."

Broken bones or not, Chris has no regrets about leaving the relatively safe but frenetic environment of a busy kitchen for the rollercoaster of freelance sports photography. Chris has quickly acquired the photographic and business skills that are essential in order to succeed in a competitive market, and has boundless enthusiasm and motivation. Above all he loves his work. "My only ambition in photography is to keep learning, keep improving, and to always have fun. There are so many different subjects and so many different conditions and locations that I don't think I will ever become bored. Eventually, though, I want to move more toward the portraiture/fashion side of things. There are many opportunities for totally different images, but if you go too far off the beaten track they cease to be of commercial value. Somewhere I heard the old adage 'shoot the common subject uncommonly well, and shoot the uncommon subject with commercial relevance.' That's definitely something to bear in mind as a freelance action sports photographer."

LEFT
Hans Ray freeriding in the Arizona
desert. Lit by three flashes fired by radio
slaves.
**Details: Canon EOS1 DS + 17mm lens,
1/30th sec at f/8**

ABOVE
Judd Devall. Portrait shot on an
abandoned sofa in the Arizona desert.
Lit by three flashes fired by radio slaves.
**Details: Canon EOS1 DS, 1/100th sec
at f/8**

PHOTOGRAPHERS DIRECTORY

TIM BARNETT
www.timbarnett.com
www.digitalphotosonline.com
Email: tim@timbarnett.com

DOUG BLANE
www.dougblane.com
Email: pictures@dougblane.com
Agencies:
Buzz Pictures (www.buzzpictures.co.uk)
www.MtnPix.com
www.BASEJumping.co.uk
www.MountainBikingAdventures.com
www.ExtremeSportsPhotography.co.uk

DAN BURTON
www.underwaterimages.co.uk
www.freedivingimages.co.uk
Tel/Fax: +44 (0) 1392 875446
Cell: +44 (0) 7767 446250
Email: dan@underwaterimages.co.uk
Agencies:
Buzz pictures (www.buzzpictures.co.uk)
Nature Pictures (www.naturepl.com)
Sea Pics (www.seapics.com)
ImageState (www.imagestate.com)
Wildlife Bildagentur GmbH (www.wildlifebild.com)

JOHN CARTER
Email: JCa3165669@aol.com
Address: 32 Lake Common, Lake, Isle Of Wight, P036 9HP, UK
Tel: +44 (0) 1983 404697.
Cell: +44 (0) 7968 090915
Agency: Buzz Pictures (www.buzzpictures.co.uk)

SEAN DAVEY
www.seandavey.com
Address: PO Box 1033, Haleiwa, HI 96731, USA
Tel/Fax: 1 808 293 7771
Cell: 1 808 375 2724
Email: sean@seandavey.com
Agencies:
Australian Picture Library (www.australianpicturelibrary.com.au)
Buzz Pictures (UK) (www.buzzpictures.co.uk)
Surfpix (UK) (www.surfpix.co.uk)
Aflo Denshi Co Ltd (Japan) (www.aflo.co.jp)
Photobroker (USA) (www.photobroker.com)
A-Frame Photo (USA) (www.aframephoto.com)
Publication: *Oceans: The Photography of Sean Davey* (with Dan Raymond), ISBN 0967033926

SIMON FRASER
www.simonfraserphoto.com
Email: simon@simonfraserphoto.com
Tel: +44 (0) 1434 220647
Agency:
www.sciencephoto.com
Science Photo Library
327-329 Harrow Road
London W9 3RB
Tel: +44 (0) 207 432 1100
Email: info@sciencephoto.com

NICK HAMILTON
Email: nickphoto@hotmail.com
Agency: Buzz Pictures (www.buzzpictures.co.uk)

NEALE HAYNES
www.nealehaynes.com
Address: Buzz Pictures, 14 Shanklin Road, London N8 8TJ, UK
Tel: +44 (0) 208 374 2569
Fax: +44 (0) 208 374 1716
Email: neale@buzzpictures.co.uk
Agency: Buzz Pictures (www.buzzpictures.co.uk)

STEVE JACKSON
www.ximages.co.uk
Cell: 0770 2203352
Email: steve@ximages.co.uk
Agency: Buzz Pictures (www.buzzpictures.co.uk)

TIM MCKENNA
www.tim-mckenna.com
Email: tim@tim-mckenna.com
Address: B.P 380617, Punaauia—Tamanu 98718, Tahiti, French Polynesia
Tel: + 689 79 92 30
Fax: + 689 85 38 68
Cell: + 33 607877210
Agencies:
Buzz Pictures (www.buzzpictures.co.uk)
Corbis, New York (http://pro.corbis.com)
Presses Sports, France
MaxPPP, France (www.maxppp.com)
Mmimagebank, Australia (www.mmimagebank.com)
Tahiti-Photo.com, Tahiti (www.tahiti-photo.com)

JON NASH

www. jonnashphotography.co.uk
Address: Suite 1, 76A Marine Parade,
Brighton, East Sussex, BN2 1AE, UK
Tel/Fax: +44 (0) 1273 691586
Cell: 07793 228187
Email: jon@jonnashphotography.co.uk

DEAN O'FLAHERTY

Email: doflaherty@cfl.rr.com
Agency: Buzz Pictures (www.buzzpictures.co.uk)

BEN OSBORNE

www.benosbornephotography.co.uk
Address: Sunningdale Cottages, Pontesford
Shrewsbury, SY5 0UN, UK
Tel: +44 (0) 1743 791982
Email: ben@benosbornephotography.co.uk
Agencies:
Getty Images (Stone) www.gettyimages.com 0800 376 7977 (UK)
Oxford Scientific Films www.osf.uk.com +44 (0) 1993 881881
Nature Picture Library www.naturepl.com +44 (0) 117 974 6720
Publications
Life in the Freezer (Alastair Fothergill et al), BBC Books, 1993,
ISBN 0563364319
Antarctic Encounter: Destination South Georgia
(with Sally Poncet), Prentice Hall & IBD, 1995
Mountain Wildlife, Oxford Scientific Films, 1989
Antarctic Wildlife, Oxford Scientific Films, 1989

MIKE SEARLE

www.orcasurf.co.uk
Email: mike@orcasurf.co.uk
Address: Orca Publications, Berry Road Studios,
Newquay, Cornwall TR7 1AT, UK
Tel: +44 (0) 1637 878074
Agency: Buzz Pictures (www.buzzpictures.co.uk)

LEO SHARP

Email: sharphoto@yahoo.com
Agency: Buzz Pictures (www.buzzpictures.co.uk)

SANG TAN

www.sangtan.nildram.co.uk
www.britishpressphoto.org/sangtan
Email: st@sangtan.nildram.co.uk
Agency: Buzz Pictures
(www.buzzpictures.co.uk)

GEOFF WAUGH

www.waughphotos.com
Tel: +44 (0) 1992 534704
Fax: +44 (0) 1992 534711
Cell: +44 (0) 7831 866100
Email: waughphotos@ntlworld.com
Agency: Buzz Pictures
(www.buzzpictures.co.uk)

ALEX WILLIAMS

www.alex-cam.co.uk
Email: alexcam@eclipse.co.uk
Cell: +44 (0) 780 2412279.
Agencies:
Buzz Pictures (www.buzzpictures.co.uk)
Impact Photos (www.impactphotos.com)

RAY WOOD

www.raywoodphotography.com
Address: Arwelfa, Dinorwig, Caernarfon,
Gwynedd, LL55 3ES, UK
Email: info@raywoodphotography.com
Agency: Buzz Pictures
(www.buzzpictures.co.uk)

CHRIS WOODAGE

www.chriswoodage.com
Email: chris@chriswoodage.com
Cell: 07773 766009

ACKNOWLEDGMENTS

I would like to thank all the photographers whose work appears in this book, for enthusiastically sharing their experiences and expertise, and meeting deadlines despite busy work schedules. Special thanks are also due to Neale Haynes and the staff at Buzz Pictures; to the team at RotoVision, especially Kylie Johnston, Nicola Hodgson, Jane Roe, Luke Herriott and Gary French; and to Steve Price at Plan-B Studio.

INDEX

INDEX